IN
TUSCANY

IN TUSCANY

BY

FRANCES MAYES

WITH

EDWARD MAYES

PHOTOGRAPHS BY
BOB KRIST

BROADWAY BOOKS NEW YORK

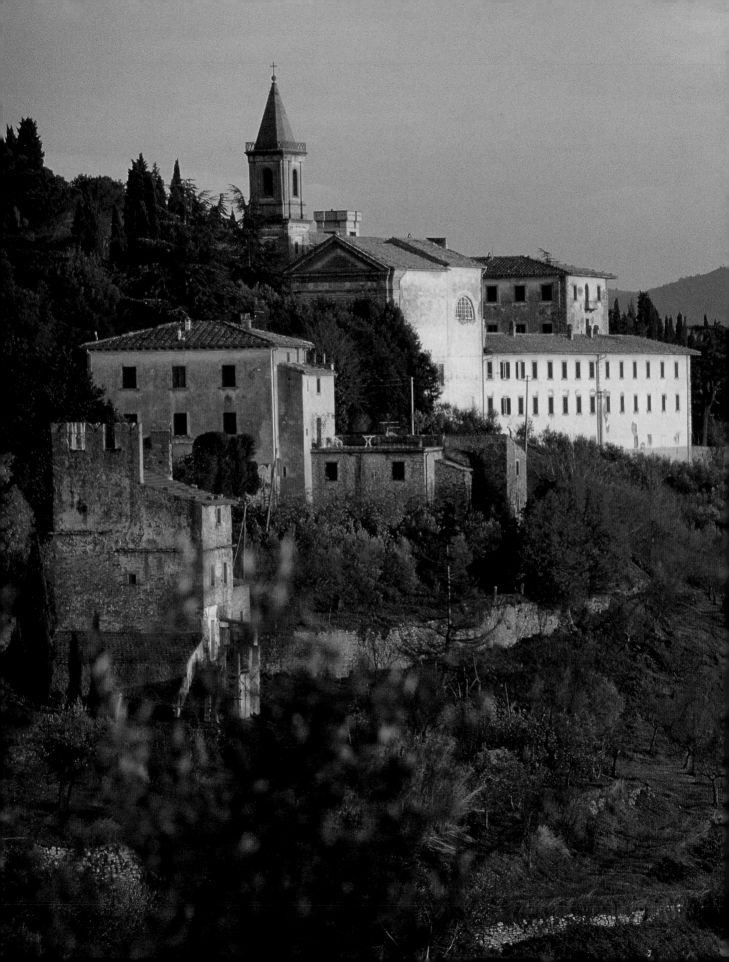

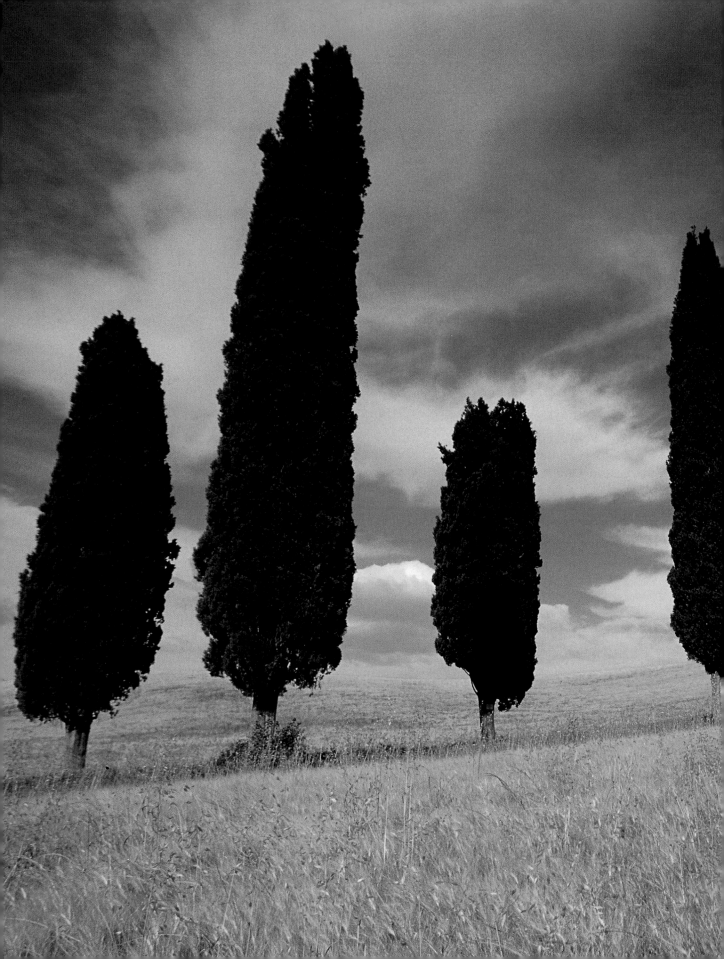

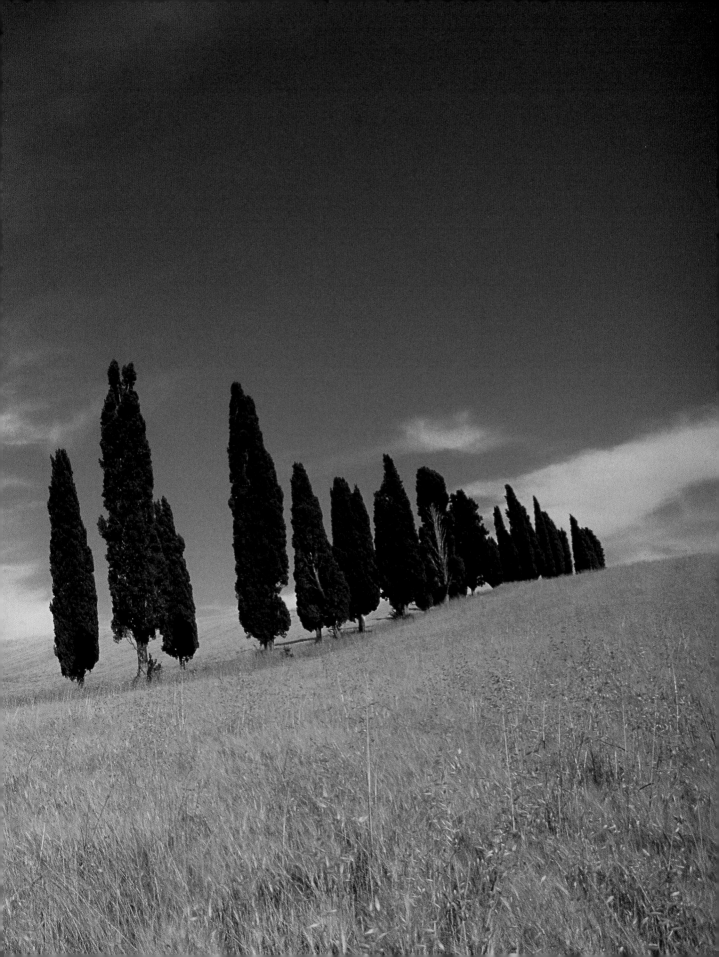

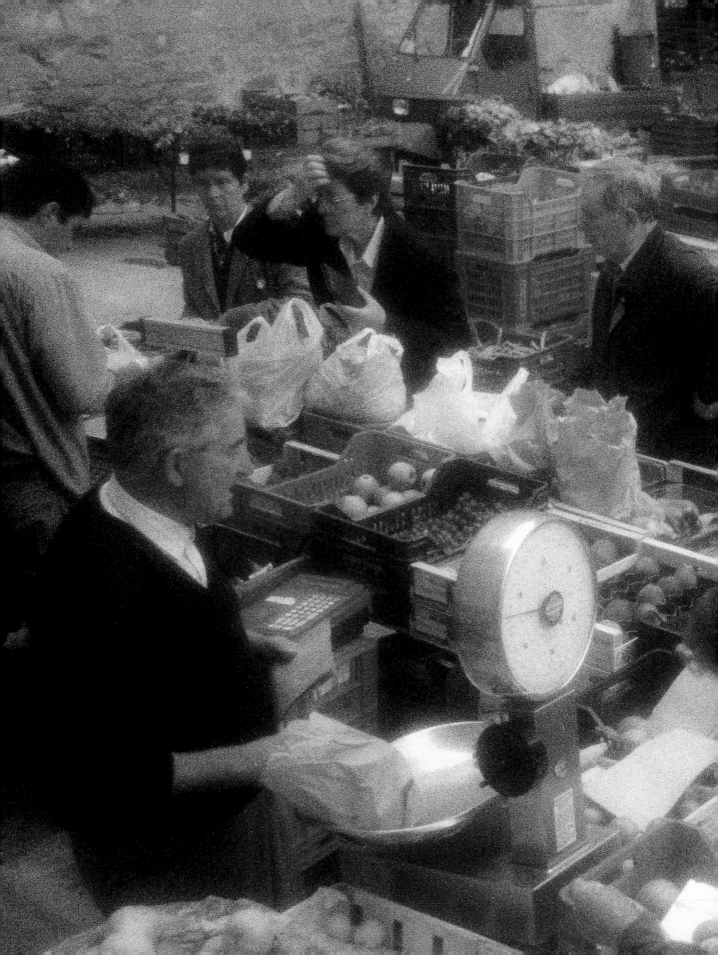

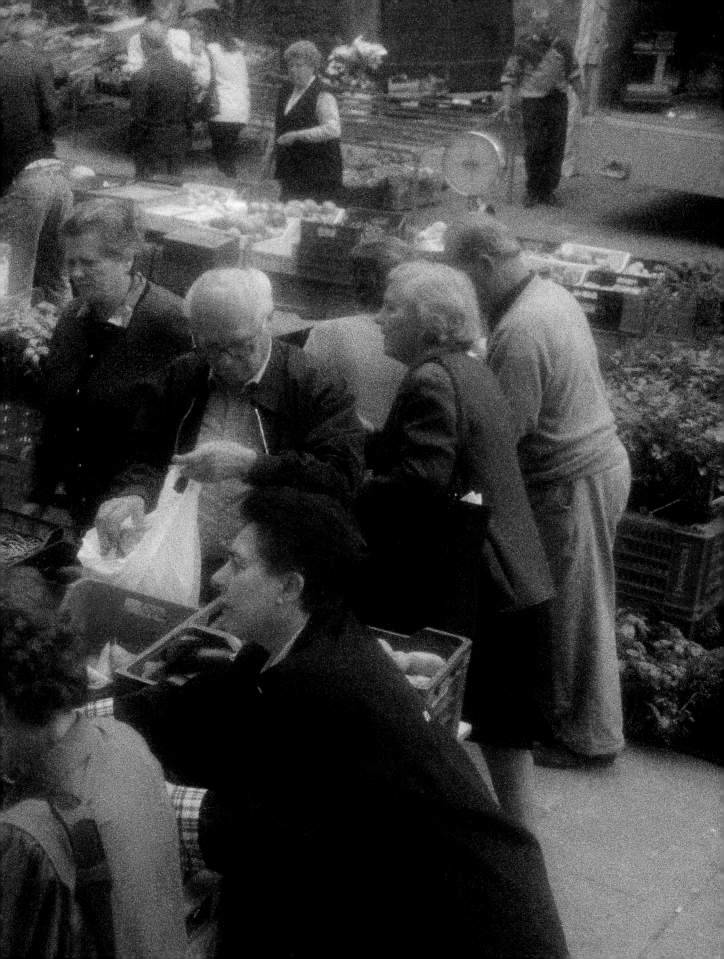

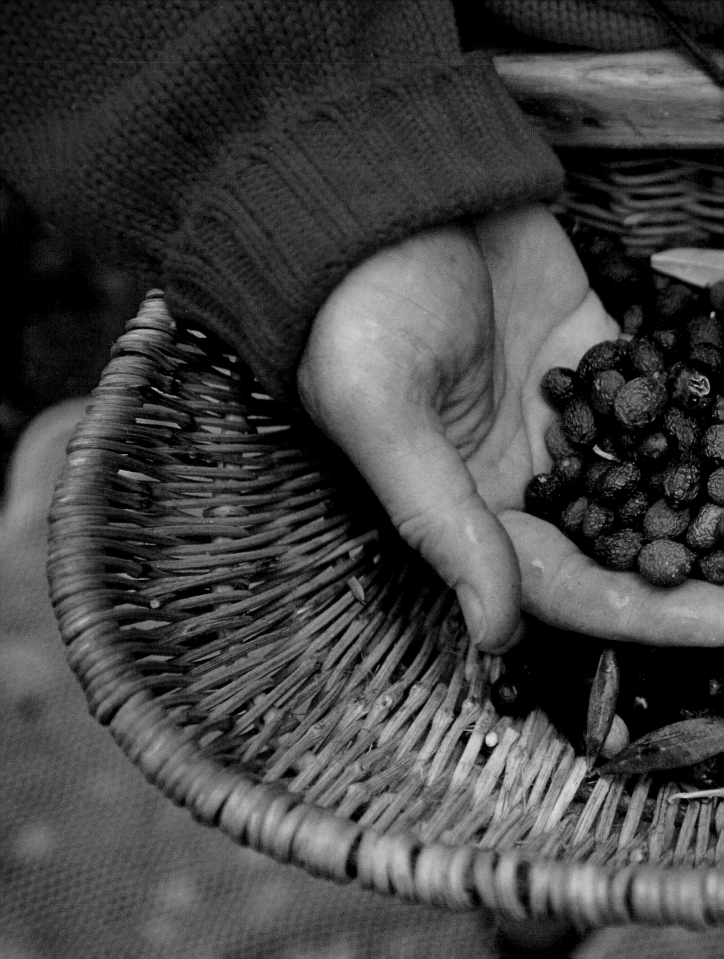

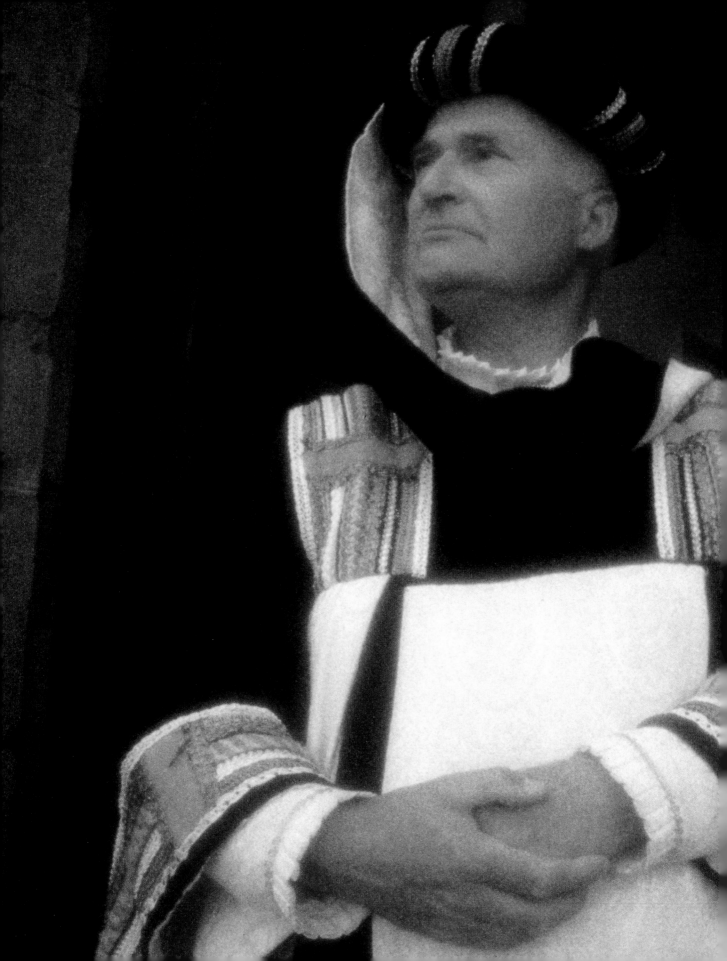

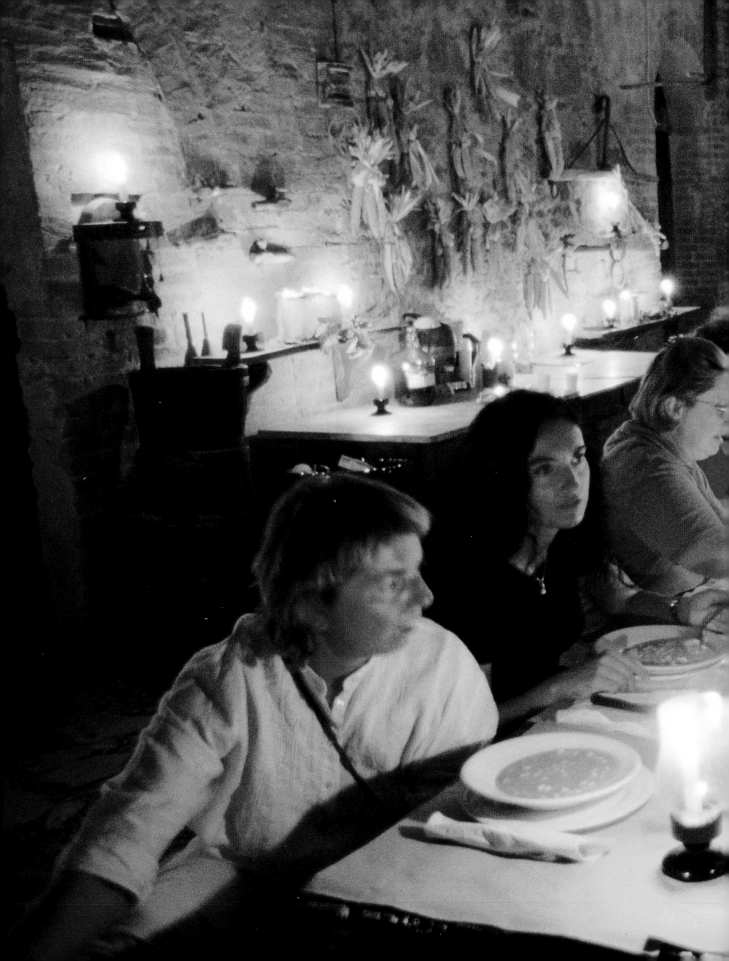

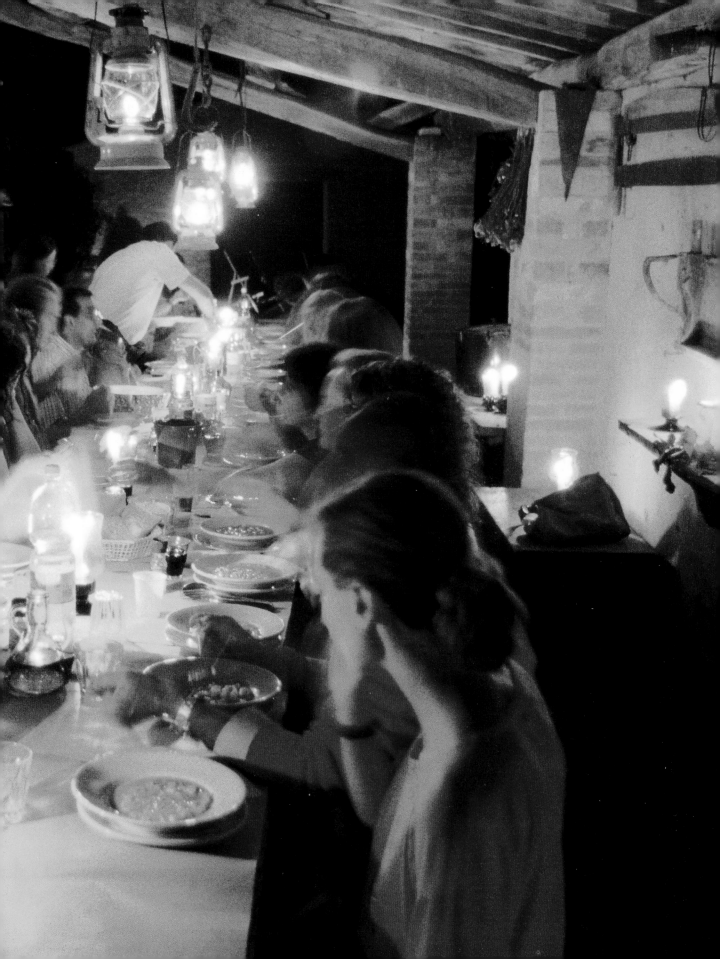

BROADWAY

Except where noted, all photographs copyright © 2000 by Bob Krist.
Photographs on pages 23, 26, 28–29, 30 (top left and bottom right), 57, 60, 62, 64–65, 66, 67 (top),
95, 117 (top left and center right), 169, 178–179, 191, 212–213, and 259 by Frances Mayes.

*Photo captions, preceding pages: Ornament at the entrance to Cortona's park (page 1); near Radi, south of Siena (pages 2–3);
Cortona hillside overlooking the Val di Chiana (pages 4–5); flag of a Siena neighborhood (pages 6–7); cypress allée near Radi (pages 8–9);
Saturday morning market in Cortona (pages 10–11); Ed's late harvest olives in special handmade basket (pages 12–13);
at the patron saint festival in Cortona (pages 14–15); rustic dinner in Buonconvento (pages 16–17).*

Broadway Books titles may be purchased for business or promotional use or for special sales. For information,
please write to: Special Markets Department, Random House, Inc., 1540 Broadway, New York, NY 10036.

BROADWAY BOOKS and its logo, a letter B bisected on the diagonal, are
trademarks of Broadway Books, a division of Random House, Inc.

Visit our Web site at www.broadwaybooks.com

Library of Congress Cataloging-in-Publication Data
Mayes, Frances.
In Tuscany / Frances Mayes ; with Edward Mayes ; photographs by Bob Krist. — 1st ed.
p. cm.
ISBN 0-7679-0535-0
1. Tuscany (Italy)—Description and travel. 2. Tuscany (Italy)—Social life and customs.
3. Mayes, Frances. 4. Mayes, Edward Kleinschmidt.
I. Mayes, Edward Kleinschmidt. II. Krist, Bob. III. Title.

DG734.23. M379 2000
945'.5--dc21 00-036037

FIRST EDITION

Designed by Jennifer Barry Design, Sausalito, California
Layout Production: Kristen Wurz
Painted Backgrounds: Muriel Schmalberg Ullman

00 01 02 03 04 10 9 8 7 6 5 4 3 2 1
Printed in Japan

CONTENTS

The more you know,

the more you love, and by loving more,

the more you enjoy.

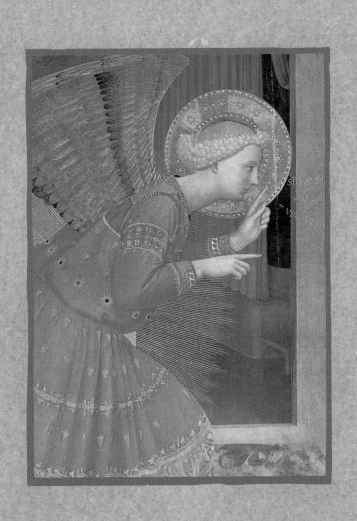

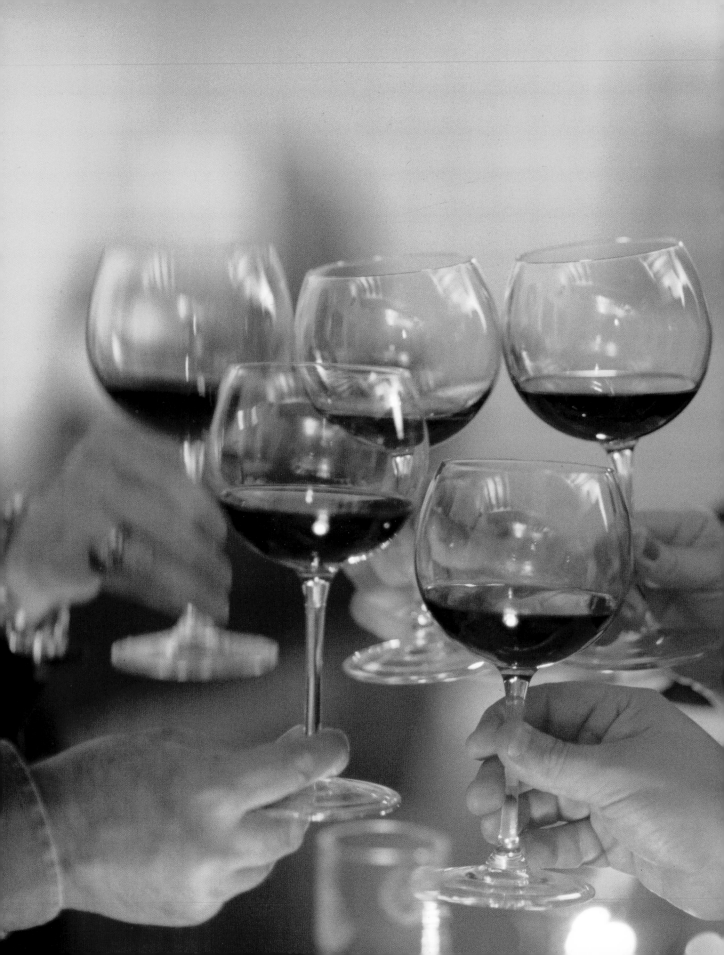

BACI
(Kisses)

Tuscany is a world; Italy is a universe. "Five lifetimes would not be enough to explore it," I once wrote. Change that to five times five. After ten summers, six winter holidays, a sabbatical year, various quick spring breaks, and this year six months here, I would have predicted, if I'd had telescopic vision, that by now I would not be dazzled by the place—but Tuscany keeps unfolding. I find more to love on every visit.

I only recently came upon shafts of sun piercing the December fog in the valley—shafts an Annunciation angel might ride. Until last week, I'd missed the white road into Sogna and dinner by the fire in this medieval *borgo.* And the spotted truffle

dog, followed by a puppy-in-training, sniffing through the woods, my boots sinking in the loamy forest floor. There is a man way in the mountains who weaves baskets from osier. In the country, honey-colored churches sweetly lie inside the pleats of hills. Sometimes the caretaker who lives next door will show you martyrs' relics or ask you into her house, where swags of onions, corn, and peppers are drying, and her 100-year-old mother gives you a big toothless grin and a bone-cracking handshake. The wrong turn in a Chianti village takes you to a two-street town where superb wine is made and cherished. The aristocratic vineyard owner welcomes you like a friend. There's tripe to try at outdoor stands in Florence, after visiting the Museo La Specola, which displays eighteenth-century anatomical wax models, or the Museo di Storia della Scienza, home of Galileo's telescope. The sense of discovery enlarges—after ten years of intense travel and attention, I've seen so little.

After the famous Piero della Francesca trail from Arezzo to Monterchi to Sansepolcro to Urbino, the trails of Signorelli, Sasseta, and Sodoma are still waiting. I love Fra Angelico, who worked in Cortona and left us a sublime Annunciation painting, but it was the cover of this year's telephone book that led me to his *Marriage of the Virgin* at the Monastery of Montecarlo in San Giovanni Valdarno. The arrival of the messenger-angel, heralded by golden trumpets, is painted in some of the loveliest mauves, pinks, sages, and blues ever to sink into wet plaster. (Imagine that the telephone book is graced with regional art every year!) Small towns perform living Nativity scenes around Christmas, and many, such as Montecchiello, stage original plays with local

Dinner begins at Le Antiche Sere in Sogna (left);
Bramasole (above); near La Foce, home of Iris Origo, who
immortalized this land in her books (following pages 24–25).

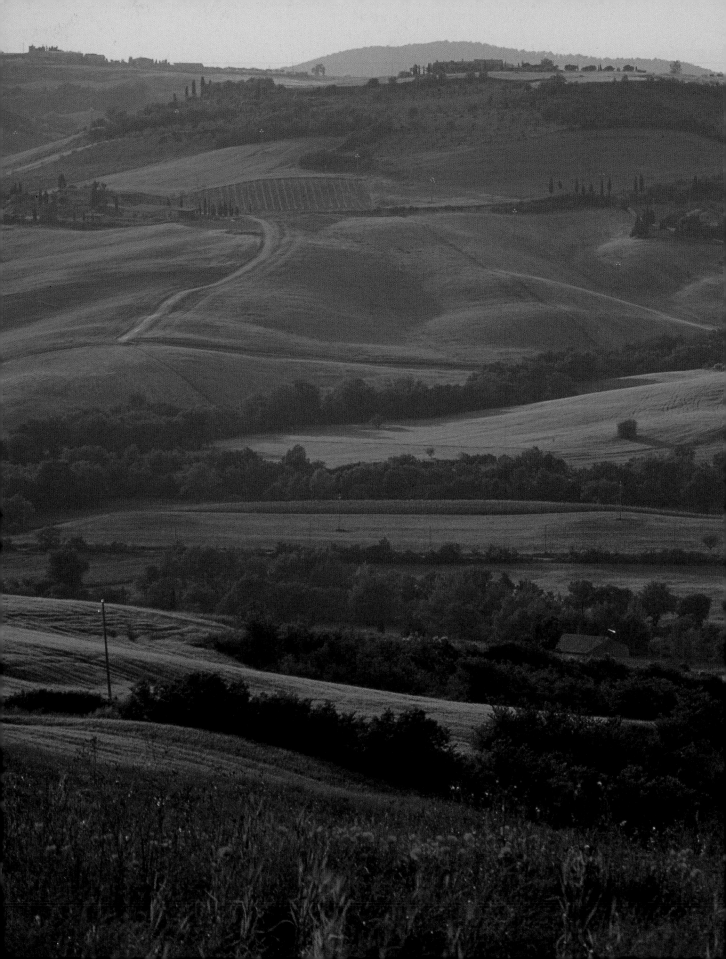

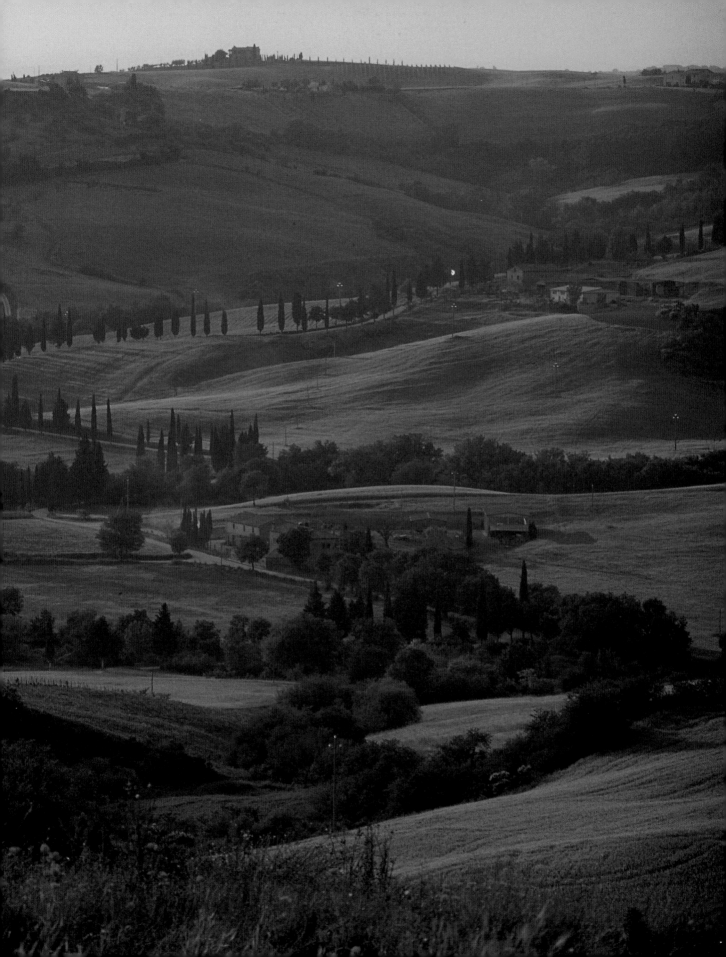

actors in the summer. To happen upon these events gives a strong impression of the life of a place. Who is playing the fool or the Madonna? In your town, would the hunchback be given a part? In a courtyard in Pienza, summer concerts send baroque airs up into the palatial apartments where a pope used to stay. I like to flip time over and imagine him still drowsing over illuminated manuscripts while we shift uncomfortably on the folding chairs in the courtyard. The Benedictine chants at Sant' Antimo near Montalcino begin at dawn for *lauds,* praises. Have you stood on the Roman bridge at Buriano? On up the road in Poppi, it's hard to resist knocking on one of the doors under the arcaded sidewalks. The ancient art of *ferro battuto* has left a legacy of

impressive door knockers in the shapes of sphinxes, gargoyles, mermaids, and lions. Poppi's paradigm castle looks out over the broad Casentino region, a bucolic land to explore.

Many Tuscans consider the Val d'Orcia to be the most beautiful part of Tuscany. To read *War in the Val d'Orcia* by Iris Origo, then to visit, is to see it with your own eyes and also through Origo's experiences there in World War II, when she and her husband sheltered dozens of children from the bombing in the north of Italy. When the war came close to home, she recounts their march across the countryside to the relative safety of Montepulciano, that perfect landscape—

the serpentine cypresses wending up the hill, the cut hay rolled into wheels, the pale fields clumped with plowed dirt like the bottom of some antediluvian salt sea. On the tombstone of Iris Origo, you read a quote from St. Catherine of Siena: *Chi più conosce più ama, più amando più gusta.* The more you know, the more you love, and by loving more, the more you enjoy. A great piece of wisdom for a foreign woman who lived here for so many years. After reading the book, you look twice as hard at the sweep of hills. And where are the children?

Each time I return, I feel a rush of joy as we drive from the valley toward the hilltown of Cortona and my house. Ed, my husband, and I whiz past the grand volumes of the Renaissance church just below Cortona, pass a broken watch tower, glimpse the machicolated tower of a *palazzo,* then the Cortona walls rise on the right, Etruscan at the bottom, layered above with Roman, medieval then modern stones. Through the three town gates flashing by, I see quick slices of the town. We round the curves, with an eternal line of cypresses to our left keeping us from flying off the road, then pull into our driveway, where the shrine to Mary welcomes us. Someone has left a red votive candle, an artificial blue peony, a peacock feather, a clump of yellow oxalis. When I get out of the car at Bramasole, even the fresh, pine-scented air feels like a gift. *Home,* an instinctive sense, a sense to trust and follow.

Bramasole roses survived thirty years of neglect (above);
Bramasole's madonnina, *shrine to Mary (right);*
the front terrace at Bramasole (following pages 28–29).

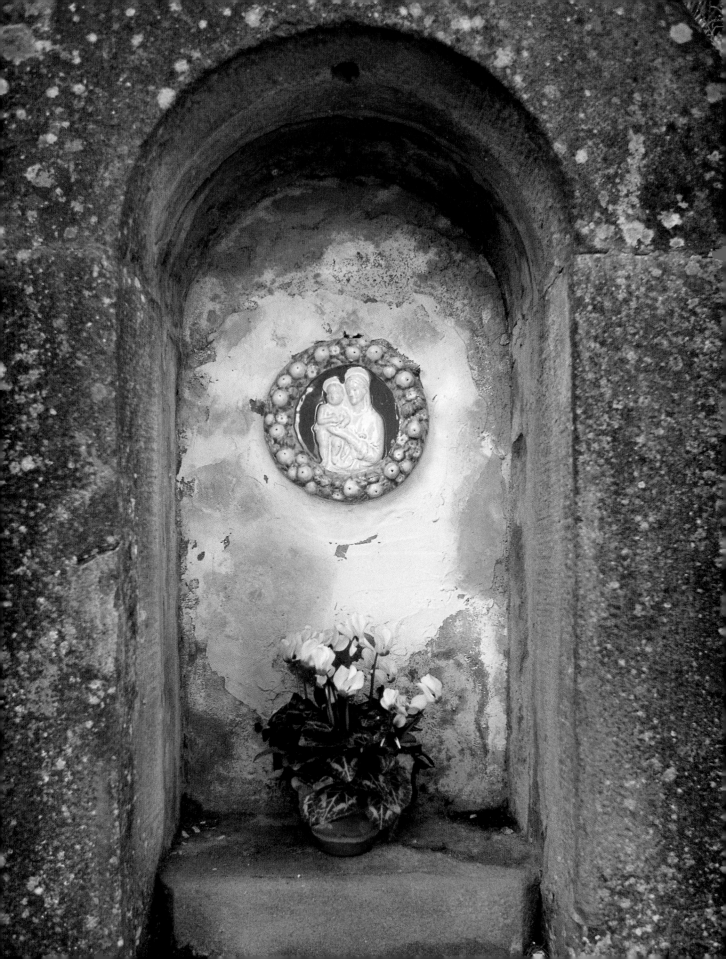

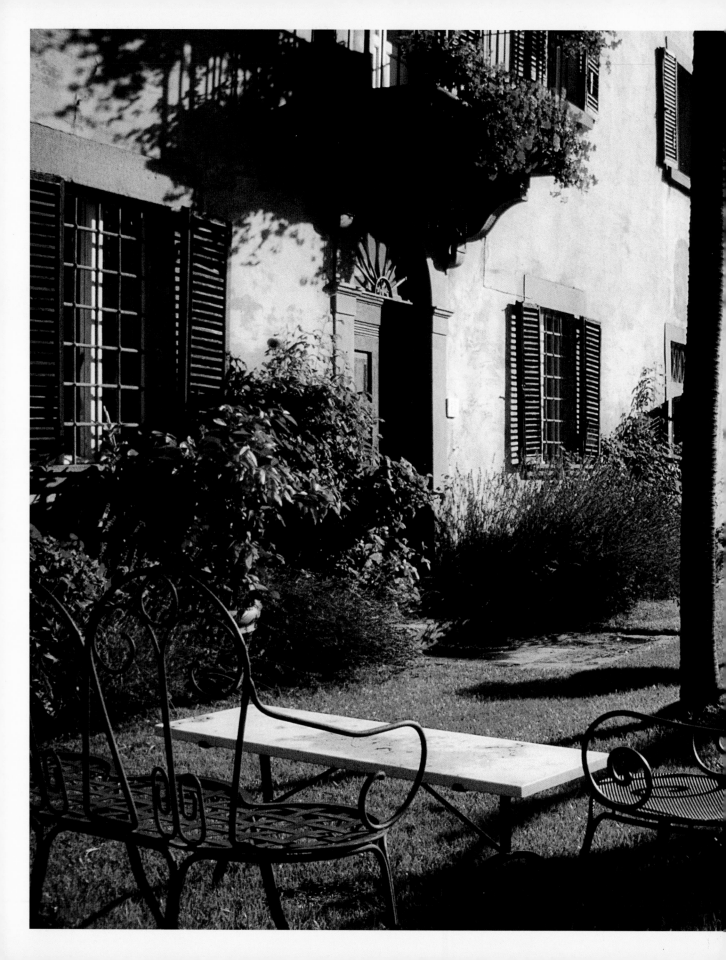

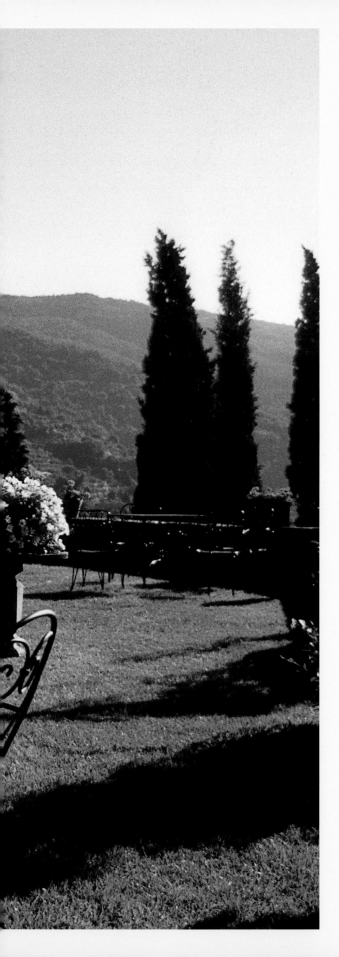

When I bought Bramasole ten years ago, I looked up at the peach and rose facade and thought it looked completely exotic and foreign. I also thought: *my house.* Although I was a stranger, the house was not. I wrote two memoirs, *Under the Tuscan Sun* and *Bella Tuscany,* about our first nine years here. *A stranger comes to town:* One of the world's basic plot lines but always new. *I'm a stranger here, myself:* One of the oldest greetings to other strangers but reinvented constantly. The two books chronicled the restoration of a long-abandoned house, the land around it, and the pleasures of new friends, work, food, and travel.

We still see the house and land in transparent overlays: before, during, and after. "Remember when the big wall was a heap of stones?" Ed asks, and a thousand images cross my vision like a slide projector gone mad: the Polish workers digging out an enormous stump, the blackberry jungle, the Italian workmen cooking pasta on a Bunsen burner. Then, the rose garden appears along the top of the wall—we're planting in a snow flurry, they're opening fully in the sun, then they're cut to the nub by our friend Lucio, who insists we prune too timidly. "Why did it take us three years to open the living room wall to the other room?" we say, then remember when we opened a wall in the dining room, the rumble of stones made all the workers fly out of the house shouting and praying.

Inside and out, the restoration still feels close. Slowly, slowly, we've found antique racks and cupboards at markets, we've painted waves and borders on walls and around windows, and have brought, piece by piece, discovery by discovery, authentic Tuscan furniture into the house. Once in place, the corner cabinet, the curvy iron bed, the dressing table seem inevitable.

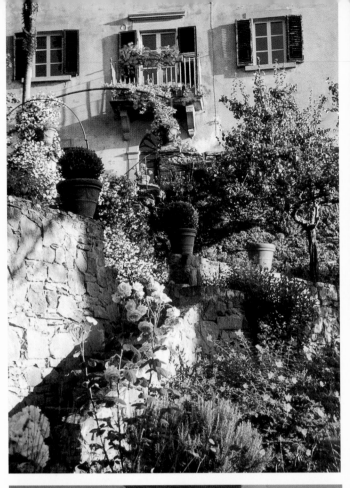
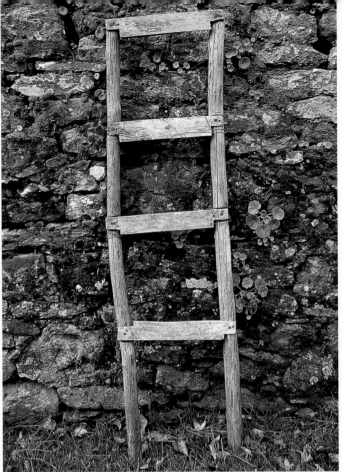
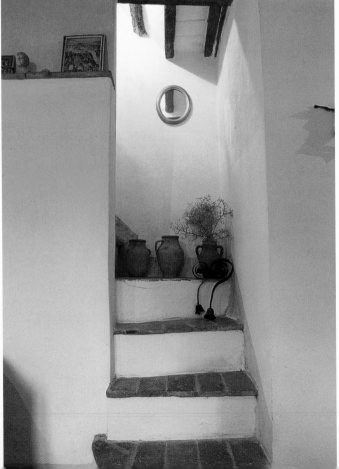

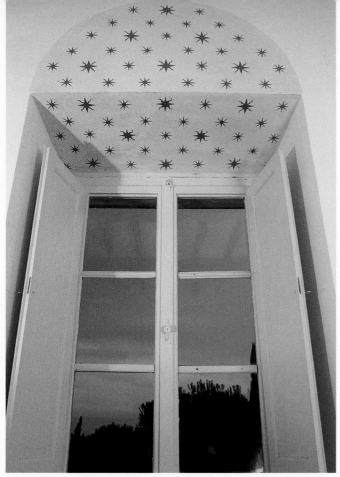

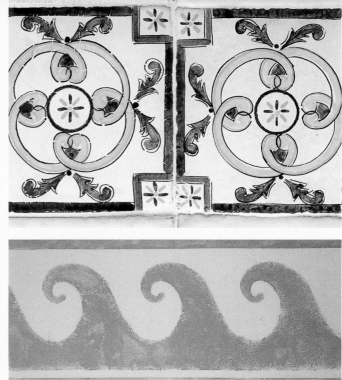

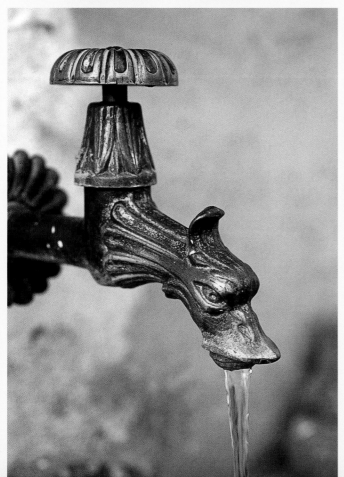

At Bramasole, facing page, clockwise from top left: Stairs from lower front terrace to rose garden; fruit tree ladder; original sink found buried in the yard; back stairway with jugs and antique farm dinner bells. This page: Giotto's gold stenciled stars in a guest room; Sicilian hand-painted bathroom tiles replaced pink butterflies; painted Etruscan wave design in a bathroom; candles for a sybaritic moment after olive picking; dragon faucet over stone sink.

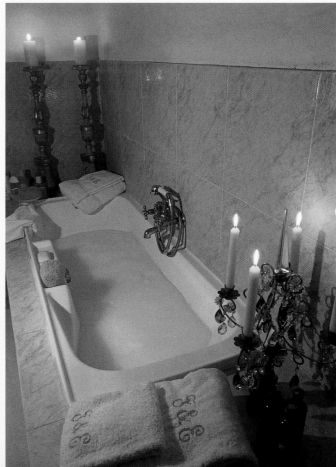

In writing the two memoirs, the inner story interested me most: how place changes you, how it shapes those who live there. What *is* at work on all of us, both strangers and Tuscans born to the taste of pasta? I continue to be amazed that I can feel both so at home and, simultaneously, that I've just arrived. Will I always be new? I've come to think so. I discover more and more that the quick friendliness of the Tuscans comes from a deep reservoir of warmth. I've travelled; I find them the most welcoming people on the globe.

"What makes the people so friendly, no, not just friendly, so genuinely kind and generous?" I ask my friend Roberto Gnozzi.

He gives me a typical Italian answer: "We have the inheritance of the Etruscans and the Longo-

bards," he explained without explaining. "Now consider, in contrast, the Sardinians. They are Punic. They don't want you on their land. But you can walk across my land." Well, there's an answer, a very old one, even though I am not that familiar with the personality characteristics of the Longobards and Carthaginians.

"I feel good when I see you," Edo says to Ed. "I just feel good." Men kiss. Children kiss. Boys swagger down the Rugapiana arm-in-arm. The *piazza,* longest running play in the world and the crux and crucible of Italian life, shows kissing scenes all day. Teenage girls give other girls little kisses at the bus stop. (You kiss to your right first, to avoid collision.) As groups break up after dinner, the goodbye kissing takes twenty minutes. This accounts

for some element of joy in the culture; you are kissed and kissed from the moment you are born. In churches, people kiss the foot of a sacred statue, cross themselves, kiss their own fingers and place them on some part of the Madonna, or blow this kiss toward the crucifixion. Rings and rosary beads are kissed. So the kiss, not only spontaneous affection, thanks and blesses. This intimate expression keeps alive the joy we all are born with. Even letters are signed, *baci, baci, baci,* kisses, kisses, kisses.

"*Ciao,*" Chiara says into her telephone, "*un grosso bacione,*" a big, big kiss.

At the same time, Tuscans are ribald and sharp in their humor, fatalistic, private, and fazed by nothing. Symbiosis with the land runs deep. Meet even the slickest fashion designer or magazine reporter or video cameraman and the talk soon reveals a passion for the way food and wine are made: a homing instinct toward the land. I always find a fierce territorial attachment in Italians. In the country, the connection is vital. The constant gift-giving is an exchange of bounty from the garden. Italy is a world leader in the number of ecological, organic farmers. This springs not from a recent Greenpeace promotion, but from a natural feeling for the right way to grow things, the way Vergil and Cato and Varro knew.

When I'm back in California, my life is radically different from that of these anciently landed people. I begin to think of Tuscany as "fairy lands forlorn," an Atlantis, a kingdom in a dream. Continually discovering

Tuscan iron bed and antique linens at Bramasole (left); Frances's desk (above); a quick bacio *(kiss) in Siena (following page).*

the Tuscan people, how different they are, how differently they live in this astonishing place—that's the life-changing adventure. The capacity for celebration perhaps astonishes me most. "We are going an hour south of Rome because I want to share with you this amazing place to eat," Riccardo announces. "We will bring over our new wine," the other Riccardo says, "it's a time to celebrate." A christening calls for a dinner for fifty, a wedding for your life savings. And when Nonna turns ninety, the restaurant puts all the tables end-to-end. Each year at Edo's birthday bash, around eighty come for dinner and dancing. Who could count the courses, except at the end when two men haul out the birthday cake, and, while everyone is singing *"Tanti auguri a te . . . ,"* waiters emerge from the kitchen with twelve more tarts and cakes.

"Why do you Tuscans serve many things within a course—why two pastas? In America we serve one meat with a dinner, except at Christmas or Thanksgiving sometimes there are two. But, three, four? Why?" I asked Giusi.

She looked puzzled and then smiled. "We like to make the guest feel welcome. Only one would mean we were not glad to have you." So much to learn. I think backward to see if I have been inhospitable.

The anniversary of a wedding that took place three hundred years ago prompts a yearly *festa* and crossbow competition in Cortona. Every food seems to have a *festa* of its own somewhere in Tuscany, even the lowly snail. Italian cookbook author Marcella Hazan says, "Eating in Italy is one more manifestation of the Italian's age-old gift of making art out of life." Exactly.

Tuscany is superendowed with earthly wonders. Other places have natural beauty, and/or history, art, and cuisine. But *everything* comes together here. Beyond the famous destinations of Florence, Siena, Pisa, Lucca,

San Gimignano, and the Chianti country are hundreds of places to discover, each with particular treasures, pastas, breads, festivals, character, and architecture. I find unexpected pleasures in remote medieval hermitages, abandoned houses to explore (and buy?), sacred trails named for saints, castles, towers, and farms open for guests, a network of country inns called *agriturismo*. I'm far in love with the Romanesque churches hidden in the countryside. The word *pieve,* parish, in tiny print on the map, often leads you to a church whose bells called to the faithful in the eleventh century. Our local castle outside Cortona looks like a paper cutout silhouetted against the sky. It was built by Englishman John Hawkwood, whose band of mercenary soldiers, the White Company, fought on one side, then the other, all over Italy. His life would make a bloody wide-screen movie. On the other side of Cortona, another castle, Rocca La Pierle, suddenly rises out of the hills, a crumbling tower and jagged walls, looking like a Piranesi engraving of itself. In the fog it's not of this world. I would not be surprised to see Rapunzel letting down her golden hair, or knights on horseback thundering out of the gate.

The landscapes, recipes, portraits, celebrations, and descriptions in this book are all "for instances." Thousands of other places and people could have been portrayed if we'd taken another turn, ordered another dinner in another place, met other people. Tuscany continues to open and open—to Asciano, Lucignano, Murlo, and Poppi, to a chaotic donkey race or a chance to taste the first olive oil of the season, and to the joys of travelling off-season. No reservations to make, easy trains, exhibitions and churches to yourself, and particular seasonal culinary delights. As fall progresses, the cornucopia overflows—new wine, truffles, chestnuts, *funghi porcini.* Winter is a revelation. For every day of

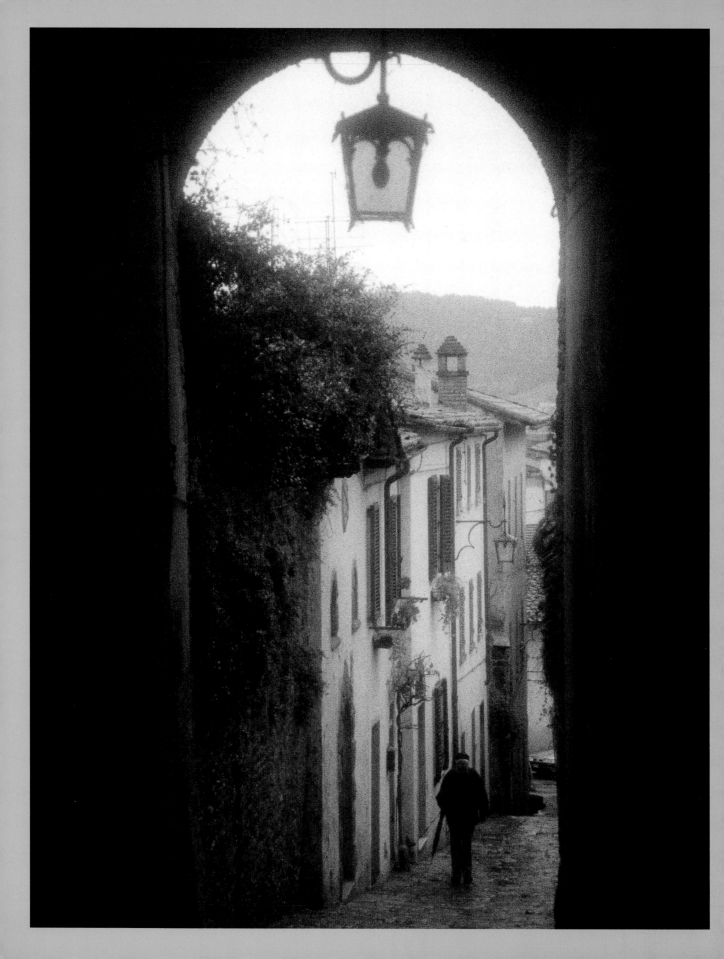

horizontal flurries, there are several crystalline, invigo-rating ones. Almost all of Italy's 1.5 million Vespas go silent because of the cold. *Trattorie* bring out the *tortelloni* with wild hare sauce and *pappardelle,* the wide pasta, with wild boar. Shop windows display gorgeous boots and the softest scarves to loop around your neck when that arctic *tramontana* blows.

Florence and the Chianti country—the most popu-lar tourist areas—return to themselves off-season. Although even during the summer months if you go to the small museums, out-of-the-way *piazze,* and early morning markets, you'll discover that the real place was there all along. Many guidebooks make it sound as though foreigners have taken over Chianti. But the region is large, fully Tuscan, and I've found that most of the foreigners who settle in a place usually love it deeply and respect the culture. If you meet expatriates, they're usu-ally happy to chat, and might direct you to the best place to find the area's cheeses, or to a ruined tower whose shade is perfect for picnicking above the spectacular vineyards. The English have had a presence in Florence for centuries. They don't just perch there and complain about the tea, as some critics would have you think. They contribute to the arts, join choirs, write books, tutor children, work to protect the monuments, and all the other activities of simply living in a loved place.

Shopping is a pleasure off-season. In uncrowded markets and stores, the owners are more likely to talk

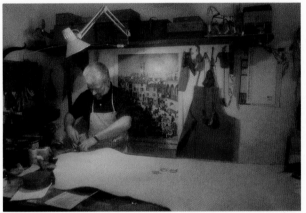

with you. Tuscany, historical center of art, also has been a historical center for merchants. Even men who loathe shopping sometimes go a bit wild and hand-carry home a gigantic La Pavoni espresso machine topped with an eagle, or a leather jacket that calls out for a motorcycle. Those with severe shoe fetishes should perhaps stay away. In addition to the handmade papers, blank books, shoes, and clothes that everyone discovers on early trips, kitchenware brings out the designers' sense of play. It's fun to fill a bag with toylike pasta spoons, blue spatulas, lime green measuring cups, a space-capsule lettuce spinner, a scale that looks like a merry-go-round, fanci-ful bottle stoppers. Cut-lery shops sell serious bone-handled knives and sculptural truffle slicers, cunning curved blades for cutting grapes, elegant scissors. Italian sheets, pajamas, and nightgowns are irresistible. All these objects are simply in a class by themselves. Why? These Tuscan artisans and manufac-turers have inhaled a heritage of fine craftsmanship. Gold jewelry, coats, ceramics, ties, art books, watercolors—so many discoveries to make by browsing in tiny, personal shops between stops at the great and small sights.

My best shopping takes place in narrow streets where gold-leafing and buhlwork are in progress, along with repairs of armoires and paintings, and at the many antique markets around Tuscany, especially the big granddaddy market in the Piazza Grande in Arezzo. I'm not a very happy bargainer but on expensive items

A street in Arezzo (left); a leather worker in Pienza (above);
collection of ex votos and parts of saints at Bramasole
(following pages).

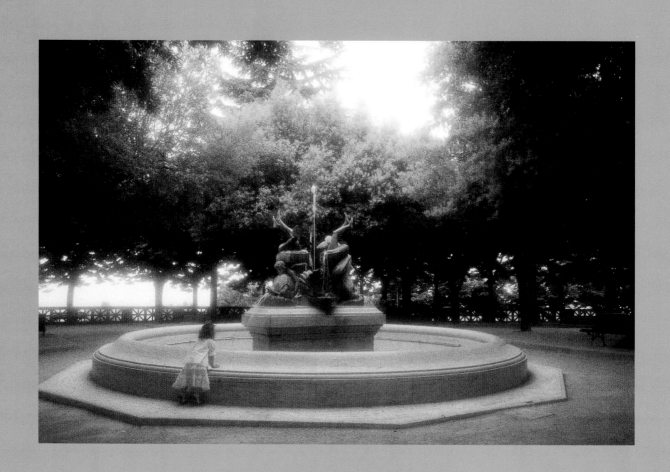

I've learned to offer half ruthlessly and settle for a third less. On small purchases I save myself the discomfort and just pay. After I moved to a different house in San Francisco, I found and shipped home a bed, a desk, and vintage brocade curtains to throw over tables and bannisters. My daughter lugged back sconces, primitive ex-votos, candlesticks, and a stack of musty, claret velvet draperies, bought for eighty dollars, that now hang in her bedroom. She'd never before shared my passion for fabrics. There's no American duty on furniture or art, and even with the cost of shipping Tuscan antiques can be reasonable. In many towns, I've been taken around the corner by the owner to his *magazzino,* storeroom, or down lanes and through backstreets to his garage at home, where I've seen throne-sized gilded chairs, priests' wardrobes, marble sinks, and museum-quality paintings. These excursions surpass mere shopping to become unforgettable experiences.

Seasons turn dramatically. Toward Christmas comes the traditional appearance in towns of Sardinian shepherds, playing their pipes and dressed in skins and shoes that turn up at the toes. In Cortona, they appear at dusk, as if out of time. Everyone comes out to hear the mournful music and to drop coins in their baskets for good luck. At Easter festivals, the reenactment of the Passion is staged all over Tuscany. One of the holidays most revealing of the culture is All Saints Day, November 1, when people travel to their places of origin to make sure all their dead are remembered. For days before, flowers are sold from fields. The *camposanto,* cemetery, always full of flowers, for this holiday is laden. Every little infant Irma or Fabrizio who died of influenza in 1918 sleeps under a mound of roses. Imperial chrysanthemums are the flower for the dead. Bundles of yellow, gold, and white face-sized blooms are heaped on every grave, or are stuffed into the vases adorning the walls of drawerlike graves. No grave is bare; everyone who lived is thought of again on this day. I like to walk in cemeteries, especially here where the comfort of memory still lives. Maybe memory is kept alive because each grave has a photo of its occupant. There's Benedetta, toasting with a glass of wine; Rocco, the mad painter, looking back at you with I-told-you-so eyes; all the weathered and worn *contadini* in black suits or dresses. When I tot up their ages at death, I see they were in their forties or fifties. On one grave I read, "Time obliterates everything but memory."

In spring, the exotic *upupa,* the hoopoe, reappears, along with millions and millions of wildflowers. It's worth the plane trip just to see the roadsides and hills turn into idealized watercolors. A red blur in the distance becomes a field of poppies. My album of wildflower photos started one April. As each new bloom appeared on the land, I took a picture, but finally the profusion stopped me. From now until summer, brides seem to be everywhere, with photographers placing them romantically against fountains and in ruins where their images will be captured forever. With almond and fruit trees blowing in the soft wind, at times you almost see through a bridal veil of blossoms yourself. Way in the country, the cuckoo and nightingale will wake you and sing you to sleep.

Tuscany is blessed with beneficial waters, not only at the popular Montecatini Terme and Saturnia spas but at countless other "well-being" centers. "Let's make a tour of hot springs," I say to Ed. "San Casciano dei Bagni has forty-two springs." That afternoon he brings home an entire book on the Tuscan *terme.*

The playful dolphin fountain in Cortona's park (left);
countryside near Pienza (following pages).

In our living room we have one bookcase stuffed with books on Tuscany. Open any one at random—some alluring place. On back pages I note other trips yet to come:

~ All the Last Supper paintings in Florence

~ The Medici villas of the Mugello region above Florence

~ The walk from Radda to Parco San Michele, stopping at the abbey at Badia Montemuro then through the village of Volpaia

~ San Pietro a Grado near Pisa, where St. Peter might have alighted on his trip from Antioch to Rome. [But wouldn't this have been out of the way? says this skeptic.] The eleventh-century church incorporates Roman columns and remnants from the sixth century.

~ Collodi's classic Italian garden

~ Prato to see the Virgin's girdle displayed in the *duomo,* and the Frederick II castle, to eat potato and *porcini* tarts, taste Carmignano, the wine very particular to the place, and to see the great fresco of Filippo Lippi

Pescia, Artimino, Pontremoli: My list grows. I've never even seen Pistoia, but I'm going next week.

Tuscany—more is *left* to see than I've seen so far. The stranger comes to town, and comes again and again. Tuscany remains undiscovered country. And there's Elba—and then other Tuscan islands, those sunken mountains in the sea . . .

LA PIAZZA
(Piazza)

When you find the piazza,

you're in the heart of the heart of the place.

All lives and affections and events

flow out from right there.

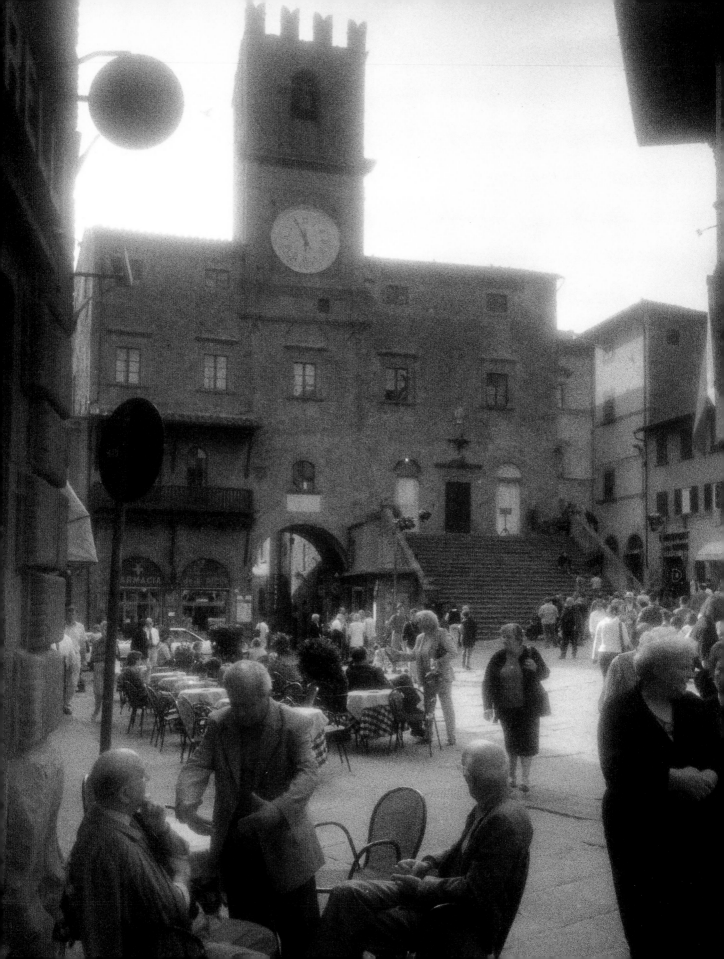

LA PIAZZA
(Piazza)

Marco insists his truck will go by my house in fifteen minutes, delivering all the cheese, olives, wine, bread, *prosciutto,* and salami I've bought in his mom-and-pop-sized shop on Piazza della Repubblica. "No need to carry all this around with you," he says, as I hoist the sacks and start to leave.

"Oh, thanks! Just leave it by my gate—and *grazie.*" I wave my arms like wings.

"See you tomorrow," he says. And he will. Like everyone else, I'm in town every day, hunting and gathering and visiting. Everyone comes to the *piazza.* Even the FedEx and DHL couriers assume this because often they simply leave my packages at Giorgio's photo shop or Giulio's bookstore.

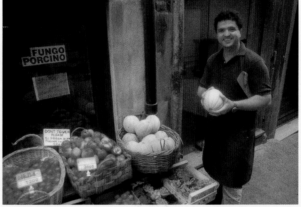

Eleanor Clark, writing about a *piazza* in *Rome and a Villa,* says, "It is like a party all the time; nobody has to worry about giving one or being invited; it is going on every day in the street and you can go down or be part of it from your window; nobody eats alone in the cafeteria, reading a book."

The *piazza,* crucial to the Tuscans' friendliness, intense sense of community, and physical connectedness, is a birthright. It imparts these qualities even to the visitor. The Polish writer Zbignew Herbert, travelling in

Tuscany, writes, "This is my last evening in Siena. I go to the Campo to throw a few lire into the Fonte Gaia, though to tell the truth, I have little hope of returning. Later, having no one to talk to, I say *'addio'* to the Palazzo Pubblico and the Torre del Mangia. *'Auguri, Siena, tanti auguri.'* Returning to the Tre Donzelle, I have a great desire to wake the maid, to tell her that I am leaving tomorrow, and that I felt fine here. If I were not afraid of the word, I would say that I was happy here."

I, too, am happy here. I go in town, even when I have no shopping, because I like to see the *piazze* on market day or in the *buio,* dark, of a January night. I walk in one gate and out another, stopping to visit for a moment with people in the shops—Isa with her collection of antique fans, Ivan, who sells those long Tuscan cigars made to be cut in half—an unlit one is not an uncommon fixture on the lips of some men we know. I chat with Anna and Viola, whose shop's shelves are filled with platters decorated with lemons, and fragments of Etruscan feet and hands. Carlo, in his gleaming bar, has my particular swirled pastry on a plate so it won't be sold before I come in. A doughnut and a croissant are set aside for other regulars. A slender man who has sunk into the confusion of

Piazza Grande, Montepulciano (preceding pages 44–45);
Cortona town hall facing Piazza della Repubblica (left);
at the frutta e verdura *right around the corner (above).*

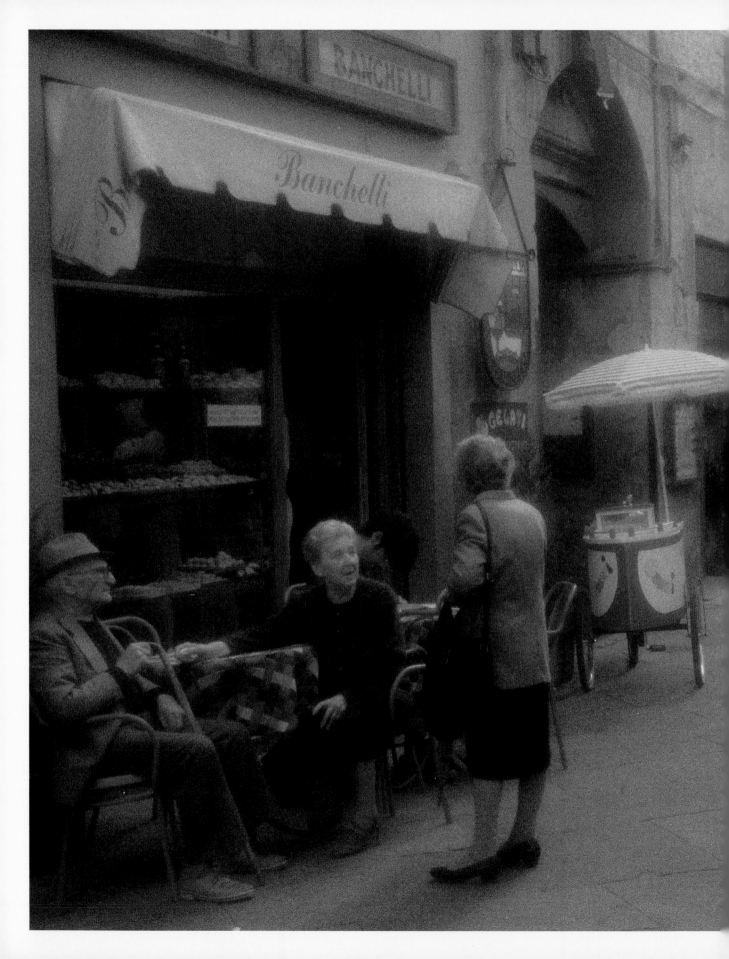

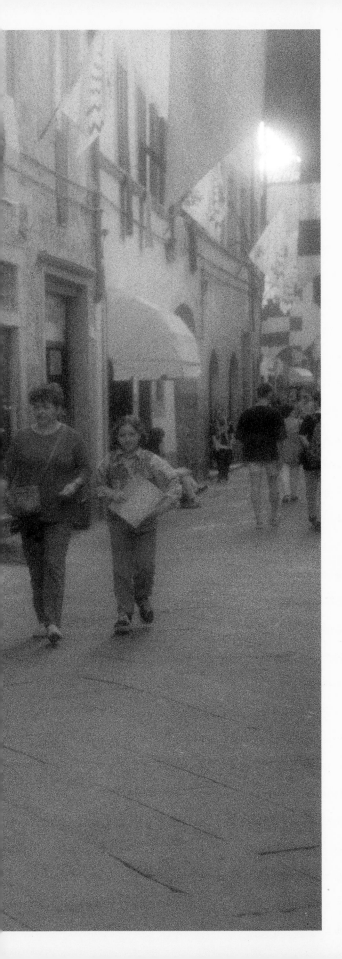

dementia is flanked by two women who walk him about. His face is grave. Is he consoled by the familiarity of one step in front of another on stones his shoes know? From the half-underground *frutta e verdura,* Roberto has just brought out into the light a box of translucent golden gooseberries, shiny blackberries, and figs so ripe you need to eat them on the way home.

Others are about, just walking, too. The last *marchese* in Cortona, a venerable man in his late eighties, gave up driving only last year. Formally dressed in an impeccable suit, he emerges twice a day from his great *palazzo* door, which bangs behind him, releasing him into the street where his cane precedes each step and he slowly makes his way uphill into the *piazza.* "*Buon giorno, marchese,*" everyone says and he gravely nods, a royal shadow from the past falling behind him.

Old people, babies, workers, the notable town dogs—all converge at least once a day at this navel of the world, the center of the hometown. Like San Gimignano, Cortona is unusual in that it has two main *piazze.* Piazza Repubblica is dominated by the town hall, with its clock tower facade. "*Buon giorno, avvocato,*" Good morning, attorney, I overhear. The broad flight of stairs leading up to the town hall adds the dimension of theater—a place to sit with your grocery list and watch four men gathered around a tractor on market day, a baby at the center of a swarm of admirers, the handsome Sebastiano in his red espadrilles, and a Dutch tourist earnestly reading a guidebook. Sometimes in the evening, *ragazzi,* kids, sit together on the steps and sing. A narrow elbow connects this *piazza* to the more somber Piazza Signorelli, dominated by the austere Palazzo Casali and the Palazzo Laparelli, now a museum and a bank, and enlivened by the umbrellas and pink

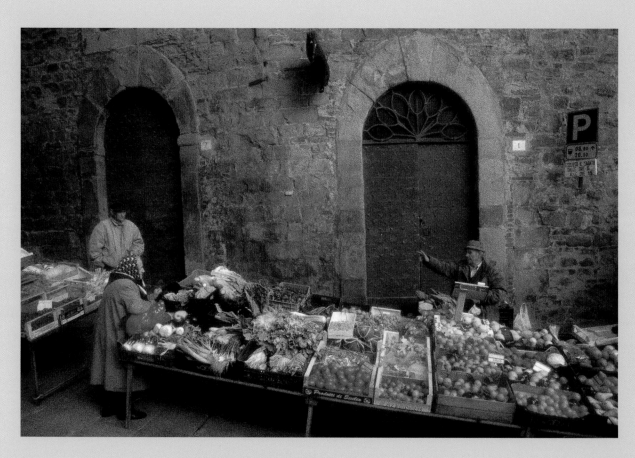

Saturday morning market in Piazza del Duomo in Cortona (above);
outside Cortona's pastry shop (preceding pages 50–51).

tablecloths of the bars and *gelaterie.* I wait outside while Ed goes in the bank to make a cash deposit. He comes right out. "Computer is down; she said just leave the money and she'll deposit it later. She didn't even count it. That's not going to happen at the B of A, you know."

Shops about the size of one-car garages line both of Cortona's *piazze*—a hat, umbrella, and shoe shop, pharmacy, toy store, *profumeria,* tobacco store, art gallery, the one dry cleaner, and two shops selling prints and ceramics. Mario's flower business, spilling onto the sidewalk and brightening the somber stone, is most active on Saturday, when everyone selects gladiolas and asters to take to the cemetery for Sunday. If what you want is not right here, it's just off-*piazza* on one of the radiant medieval streets. People buzz in and out, pick up a paper, and hear Doriano's daily weather forecast. "Do you think it will rain?" Ed asks.

"Yes, starting this afternoon. The man on TV said no, but then he realized he was reading from last week's forecast," Doriano laughs. "And he wasn't even right that time." We head uphill to the post office, or follow the scent of baking bread to the *forno.*

These shops seem to have everything we need. Small is the charm. One person, usually, manages quite easily. The partner may be taking the air in a chair just outside. After becoming used to the superefficient small grocery store, I have the hardest moment of culture shock when I return to the U.S. and enter a forty-aisle market. All we need and more waits on the shelves at Marco's family store.

We're all *en route* to the barber, or to the hardware store, the wine shop, or the *frutta e verdura. Buon giorno, professore, ingegnere, architetto.* If you have a profession, you have a title: Good morning, teacher, engineer, architect. Your role is sanctioned a hundred times a day. The owner of the *pasta fresca* shop hurries toward a restaurant, holding aloft a tray of *ravioli.* A circle of five *signore*

take their coffee at a table outside every afternoon, catching up on what has transpired since yesterday. A woman points at the black-edged death notices posted on the wall and calls to someone to come and see. Shop owners lean in their doorways or wander next door to chat. The retired electrician reads his newspaper in a slant of sun, and we pop into the Antica Drogheria to buy a few ounces of just-ground dark roast because we've been told that coffee goes stale if it's more than four days old. If you would like to dash in town, peacefully read your paper over coffee and exit, too bad. You're going to talk, talk, talk.

Michael, a well-known black *bastardino,* mongrel, with a cropped tail trots to the butcher's and posts himself outside the door until a handful of scraps comes his way. As the butcher's hand disappears behind the flycurtain, I glimpse a skinned lamb hanging by his forelegs from a hook. Tootsie sleeps in the sun outside Patrizia and Massimo's jewelry shop, and black-and-whitespotted Arturo has stationed himself on the loggia wall of the former fish market. The town dogs sometimes have owners but feel themselves to be citizens. An eroded lion of San Marco on a pedestal may be the official icon of the town but the lively dogs watch over it, too. They make their rounds like everyone else, even accompanying someone they fancy for an hour or so before returning to their usual spots for a nap. One sleeps under the statue of Santa Margherita in the *duomo piazza.* Eerily, he looks exactly like the dog (her attribute) at her feet.

Under an arcade, a covey of women select vegetables from wooden crates, watch as their bunches of carrots and beets are weighed on a handheld scale. Now and then someone swoops up an armful from buckets of zinnias, asters, and roses the gardener has brought from his yard. And everyone stops in one of the bars for a quick coffee. You're greeted as you enter—*Buon dì*—the local familiar good day, or the more universal, *Buon giorno.*

Patrizia's Coniglio

Stuffed Rabbit

Walking down the main street of Cortona, you suddenly pick up a scent from Paola and Patrizia's rosticceria—
potatoes and roasted duck, or pizza and panzarotti, bread cooked around sausage or ham or various vegetable stuffings.
"Save some boned rabbit for us," we ask on the day it is featured. In the time of the Caesars, people dined on
similar stuffed rabbits. The recipe is easy if you have a butcher who will bone the rabbit for you.

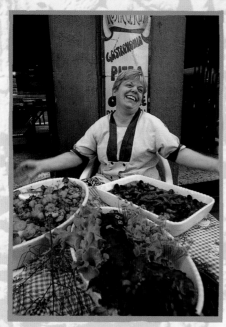

Patrizia Falomi

One 3- to 4-pound (1.4- to 1.8-kilogram) rabbit, boned
¾ pound (340 grams) ground turkey
¾ pound (340 grams) ground pork
¾ pound (340 grams) ground chicken
¼ pound (110 grams) *parmigiano*, grated
A handful of bread crumbs
1 egg
2 cloves garlic, minced
A few sprigs of rosemary and sage, chopped
1 small black or white truffle, or tube of truffle paste
Enough milk to moisten the stuffing,
 approximately ½ cup (120 milliliters)
White wine and olive oil
Salt and pepper

Wash and dry the boned rabbit. Combine the turkey, pork, and chicken with all the other ingredients except the wine and olive oil, just moistening with milk to make a well-blended stuffing. If you use a truffle, mince it and add to the stuffing. If you use truffle paste, add several good squeezes of the tube to the stuffing. Stuff the rabbit, then sew it closed with cooking thread. Salt and pepper the outside. Place the stuffed rabbit in an oven pan, bathe it with white wine and olive oil, and cook for 1½ hours at 350°F (175°C). Turn it at times, being careful not to break it, bathing the rabbit also with the sauce that forms during the cooking. If necessary, add some broth. Allow the rabbit to come to room temperature, then slice it thinly. Serve overlapping slices, with the cooking sauce, on a platter. *Serves 6.*

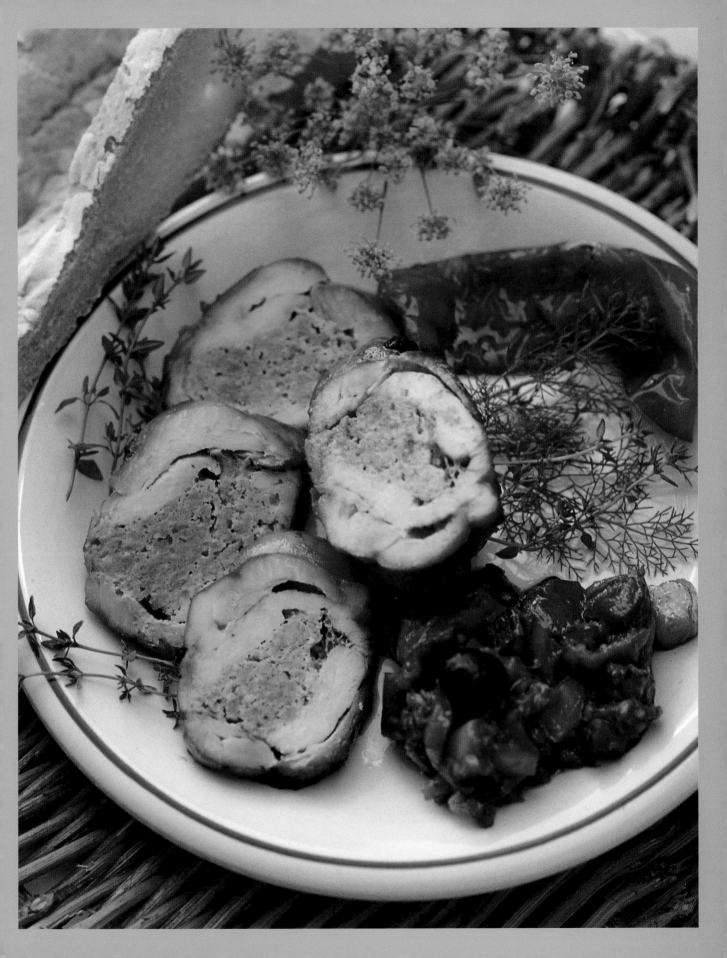

Gnocchi di Spinaci e Ricotta della Rosina

Spinach and Ricotta Gnocchi

At La Grotta, a family-run trattoria in Cortona, Giancarlo knows when we sit down that for the primo course we will split an order of gnocchi di ricotta e spinaci. Sometimes called malfatti, badly made, because of the patted-together shape, these gnocchi are quick, easy to make, and always a hit to serve. I like to use chard sometimes, mainly because chard has overtaken our garden and we've never planted spinach.

Rosina's little puffs of ricotta are much lighter than gnocchi made with potatoes. A fresh tomato sauce, barely cooked, can be ladled over the top. Peer into the kitchen at La Grotta in Cortona as you go in. They're having a big time.

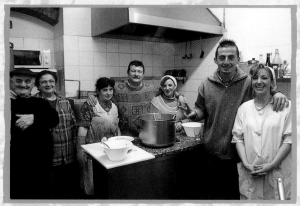

Staff at La Grotta

4½ pounds (2 kilograms) spinach

1 pound (450 grams) ricotta, preferably
 sheep's milk type

1 egg

Salt, pepper, nutmeg

Flour, as much as is needed

Clean the spinach in several washings, boil or steam, squeeze almost dry, and chop finely. Boil salted water in a pasta pot. Place the ricotta and spinach in a bowl, mix and add the egg, combining it well. Season as you like with salt, pepper, and nutmeg. Add just enough flour to attain the firmness that allows you to form small balls. Drop the balls into boiling water; they rise to the surface when they are done. Remove with a slotted spoon to a warmed platter. Top with fresh tomato sauce or butter and sage. *Serves 4.*

Zuppa di Cipolle Aretine

Onion Soup in the Arezzo Style

Soup you eat with a fork. On a rainy day in Arezzo we ordered this at the wine bar La Torre di Gnicche; Lucia Fioroni told us it is a soup locals have been enjoying for hundreds of years. She quickly wrote the recipe. We made it the next day, and now it's a cold-weather necessity.

Onions at the Camucia market

6 yellow onions (about 2 pounds, or 1 kilogram), sliced
2 ounces (60 grams) butter
1 quart (1 liter) vegetable broth
Salt and pepper
20 slices Tuscan-style bread
8 slices Fontina
Parmigiano, grated, to taste

Sauté the sliced onions in butter until soft. Add the onions to the broth and simmer for about 10 minutes, adding salt and pepper. Butter two loaf pans. Line the bottoms of the pans with the sliced bread and spoon in a layer of onions and broth. Add four Fontina slices to each pan, then another layer of bread and broth. Sprinkle generously with *parmigiano*. Bake in the oven for 30 minutes at 350°F (175°C). It's even better the second day. *Serves 8.*

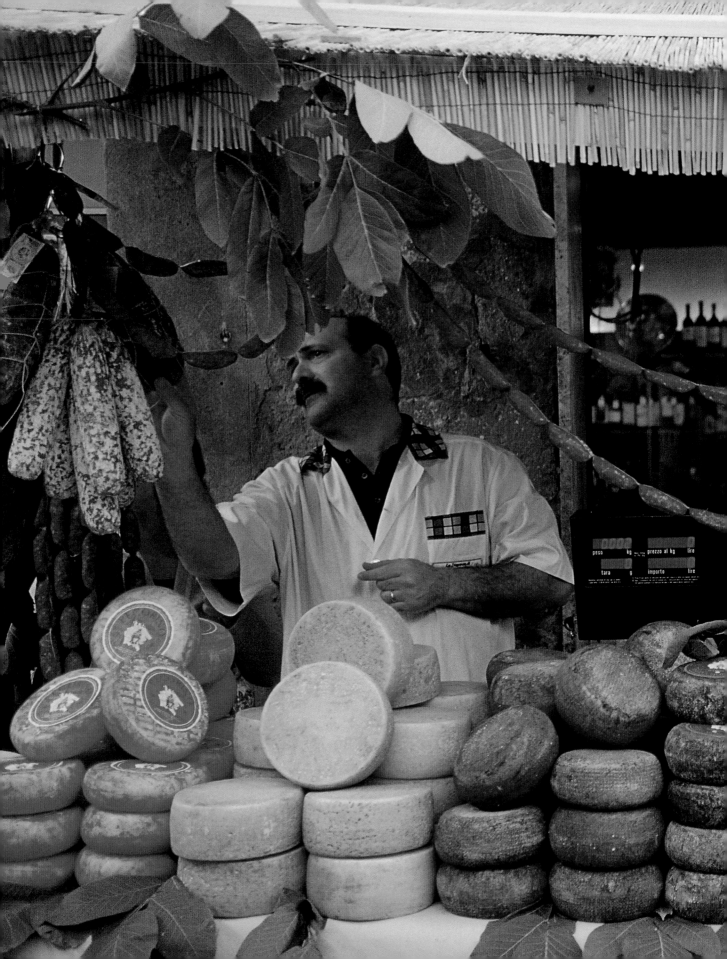

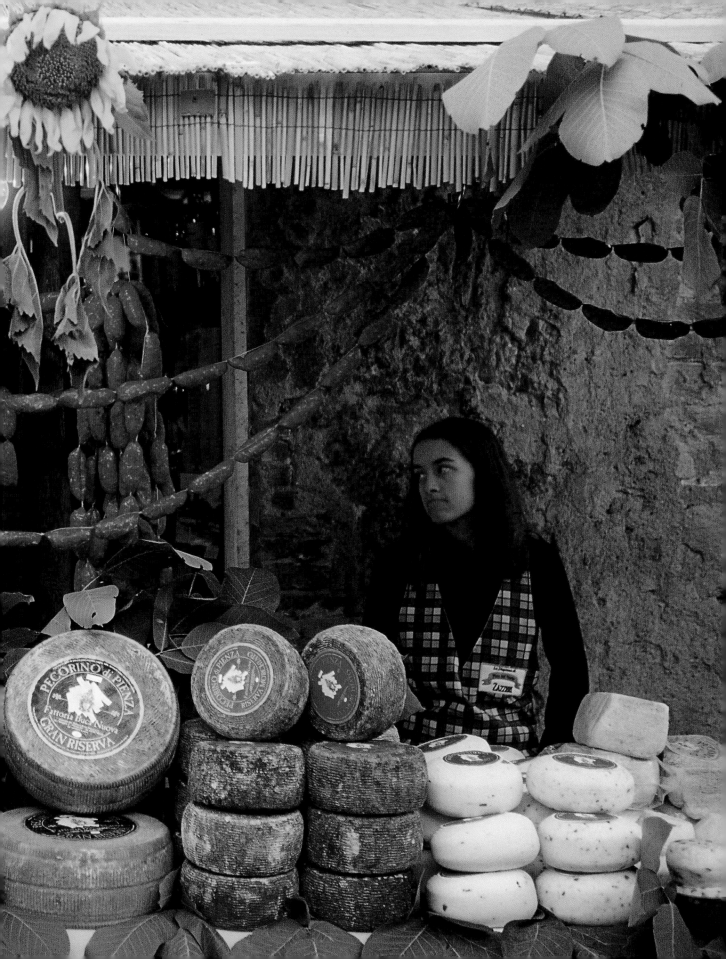

Even though no cars are allowed in the *centro*, a red Ferrari stands outside the perfume shop and ten men circle it slowly, kneeling to examine the wheels, cocking their heads for a good angle on the paint finish. A Dalmatian carries his mistress's plastic water bottle in his chops as they head toward the park for her daily jog. Even her short shorts do not distract the men from the shine on the Ferrari. Ed walks over to marvel, too. Our favorite town dog, Tappo, a smart little terrier who looks as if he could speak if he wanted to, leaps with joy when we approach, circles around us, then leads us through town.

The intense sense of community I experience in Italy comes from this daily encounter session in the *piazza*. Everyone is known and greeted— you are recognized for exactly who you are. Each shop's identification is the owner's face. Praise the Madonna, there is *no* corporate mentality. No anonymity, except for the tourists, who often seat themselves on the steps of the town hall and watch the spectacle with fascination, especially on Sunday afternoons, when people swarm to Cortona for the *passeggiata*, a grand weekly procession through town once, twice, maybe three times. Everyone you want to see, plus the girl who got the boy you wanted in high school, your black-sheep uncle, everyone you've known all your life, and probably sworn enemies and old bores as well, meet and greet during these two hours of strolling. At seven-thirty sharp, it's as though the carriage is about to turn into a pumpkin: everyone suddenly disappears. Time to go home.

At all hours, the *piazza* is a hive. On summer evenings the *gelateria* draws us. Hazelnut, peach, coffee, all piled on one cone, the ice cream melting fast. American girls, art students from the University of Georgia program, are flirting wildly with Italian boys, while the Italian girls walk with arms linked, looking on until they must go home, long before the American girls even begin to think of turning in.

On winter nights, the closed doors of the bars fog over with the breaths of everyone inside drinking *grappa* or hot chocolate and playing cards. Once in a while the *piazza* is crusted with snow and the golden lights falling from shop windows gild the streets. Even on those nights, we're out. Especially on those nights, because then the town returns to its secret medieval self, and those out walking could be San Francesco, Santa Margherita, or Fra Angelico, making his way back to his tower after painting the popsicle-orange hair of the Annunciation angel. The nine o'clock bell begins. *Din-don-dan* the bells say, instead of ding-dong.

Walking home late, Ed tells me, "The *piazza* reminds me of the skating rink in Winona. From December through March it was *the* place. We skated in circles, big hoops, skirting the edges of the banks made by the snow plows. We'd stop for a rest at the warming house. We'd skate in groups and someone would spin off to another group. We'd play games. We'd fall in love."

"Oh," I answer, "I think of it as a big plate that keeps getting passed around. Yes, I believe I will have some more. Each time it's passed something different and appealing turns up."

This is *piazza* life, gliding by. This is the feast of life.

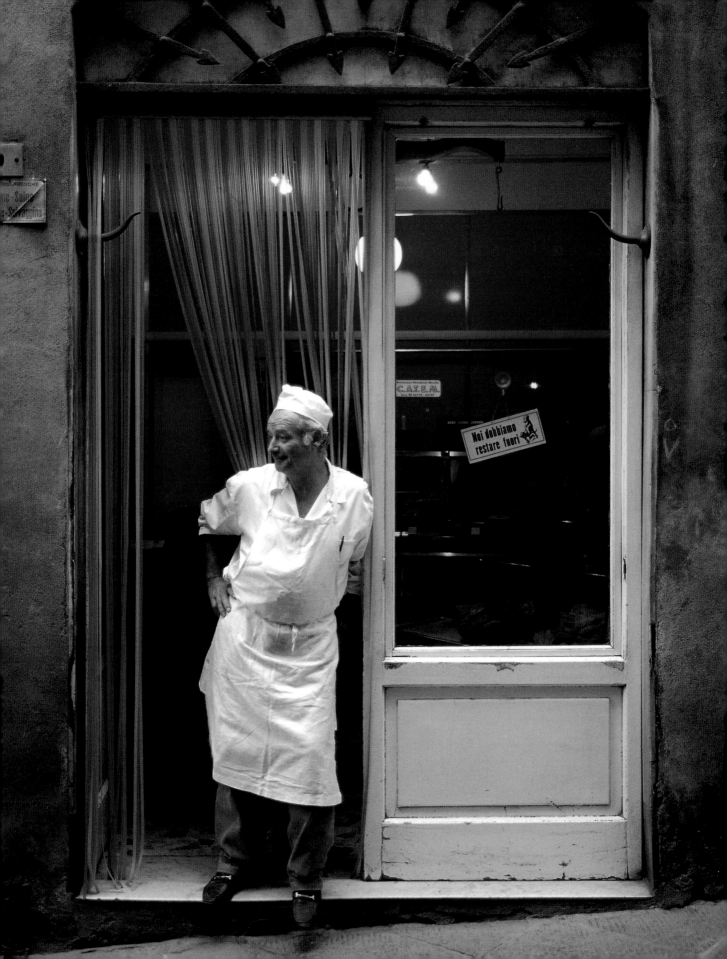

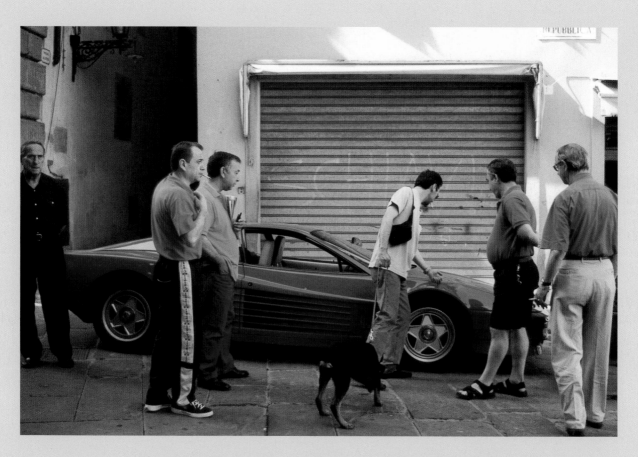

The magnetism of a red Ferrari parked in Cortona (above); the special pecorino *cheeses of Pienza (preceding pages 58–59); Tootsie, a Cortona town dog who lives outside a jewelry shop and a butcher pausing in the doorway of his Siena shop (preceding pages 60–61).*

CARS YOU CAN'T HAVE

I used to be indifferent to cars. If I couldn't have a navy blue Alfa Romeo or Jaguar, what did it matter what I drove? As long as a car would *go* and had air-conditioning, I didn't notice it. Ed's passion for racy, high design gradually pulled me around to seeing the car as he does—an object of pleasure. Not status but pleasure. He likes many types, not just the Alfa Romeo, so taken for granted in Italy, or the Testarossa or the Lamborghini Diablo, those *macchine* whose speedometers begin at 100 mph.

Some of his favorites are the Cinquecentos made by Fiat, especially those of the sixties. Their designers must have loved toys. Ed covets a friend's red one, even though he would have to roll himself like a pair of socks to get in. A local count he admires drives a thirty-year-old Jeep with right-hand steering, zippered doors flapping. "That's style," Ed says, as we climb out after a jouncing ride over a dirt trail. We love the Fiat Pandas—their high chassis will go over any rough road. The three-wheeled Ape, bee, with a small truck bed, took the place of donkeys in Italy. Bright red, green, yellow, and aqua, they brighten the roads as their owners haul demijohns of wine or piles of wood or enormous flowerpots. They announce themselves proudly and loudly, a small marching band of children pounding dishpans. An Ape-load of sand plus an Ape-load of stones plus an Ape-load of cement equals one wall.

Back in the U.S., Ed looks with contempt at my pearl-gray standard-issue car, suggesting sadly that the Asian imports in America have dulled almost to extinction our sense of style. The current trend toward the sports utility (isn't that an oxymoron?) vehicle points to something more dire—the indication that we need to drive a Brink's truck in order to drop off the kids at soccer practice or go to a movie. You may not *be* what you drive, but as a cultural sign, isn't the style-sameness of the average American freeway lane a little depressing? Where's the fun?

Who made it impossible to buy Fiat, Alfa, Lancia in America? And what happened to Rover, MG, Peugeot, Citroën? In Europe, there are many more pretty and playful cars to choose from. The Italians and Renault and Opel make cars and little vans with great *brio*—Twingo, Tigre, Elefantino Blu (Blue Elephant), Multipla, Kangoo. Even Ford in Europe created the jazzy Ka. Fiat and Alfa sports cars make even

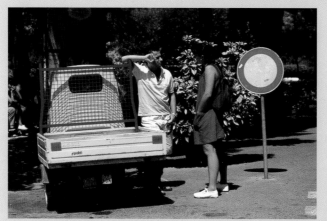

me long to take a yellow convertible on the curvy roads, top down, picnic basket and a big dog crowded in. Very quietly, the electric Torpedo and Micro-Vetts zip around. There are five kinds of miniature town cars you can drive *senza patente,* without a license—great for running errands and parking. Why can't we have them in America?

We go to exhibits and races of the Italian vintage cars. In parking lots, Ed always checks out the fabulous Mini Minors and Mini Coopers, Super Giulias, Autobianchis, the humpbacked Citroëns, and the vintage Lancias with names like a counting-out rhyme—Flavia, Fulvia, Beta, Gamma, Delta, Thema. Waxed and loved, they have personality and glamour.

My Aunt Hazel loved Lincolns in the fifties and sixties. She loved them so much that she never sold one. When she wanted a new car—always cream-colored with tawny leather upholstery—she simply parked the old one forever in her backyard. "Hazel, why don't you get rid of those cars?" we asked.

She gazed out the window, as though looking at someone pulling away from the curb forever. "Honey, I *loved* those cars," she explained.

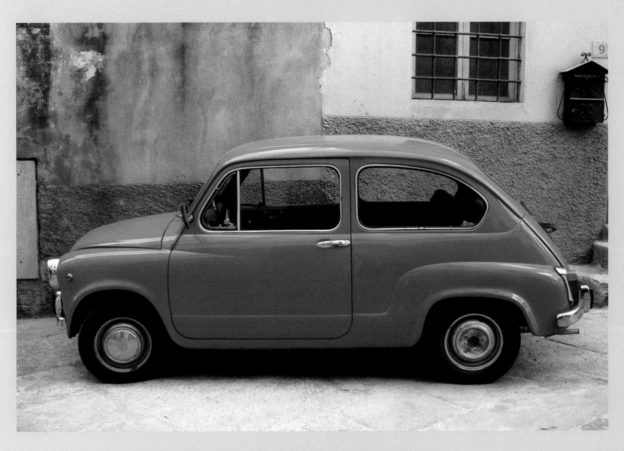

*The workhorse Ape on a break in Pienza (left); someone's prized
Fiat Cinquecento in Sansepulcro (above).*

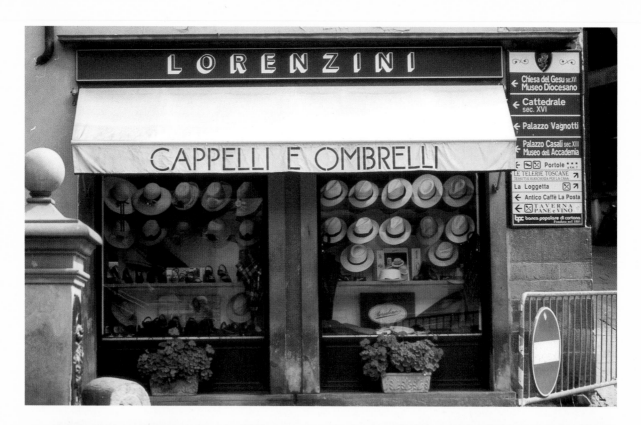

Hats and umbrellas on the Piazza della Repubblica in Cortona (top); inside a fabric shop in Arezzo (above).

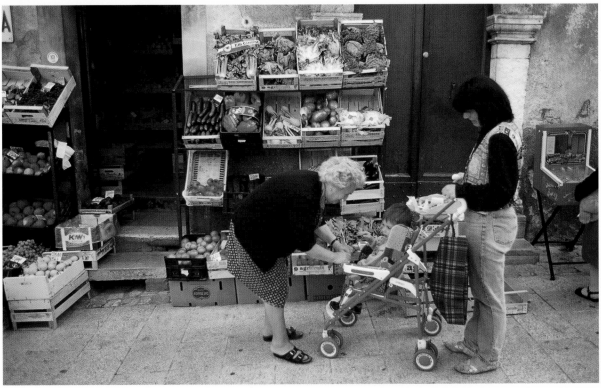

Montepulciano shop signs (top); a buon giorno *in Siena (above).*

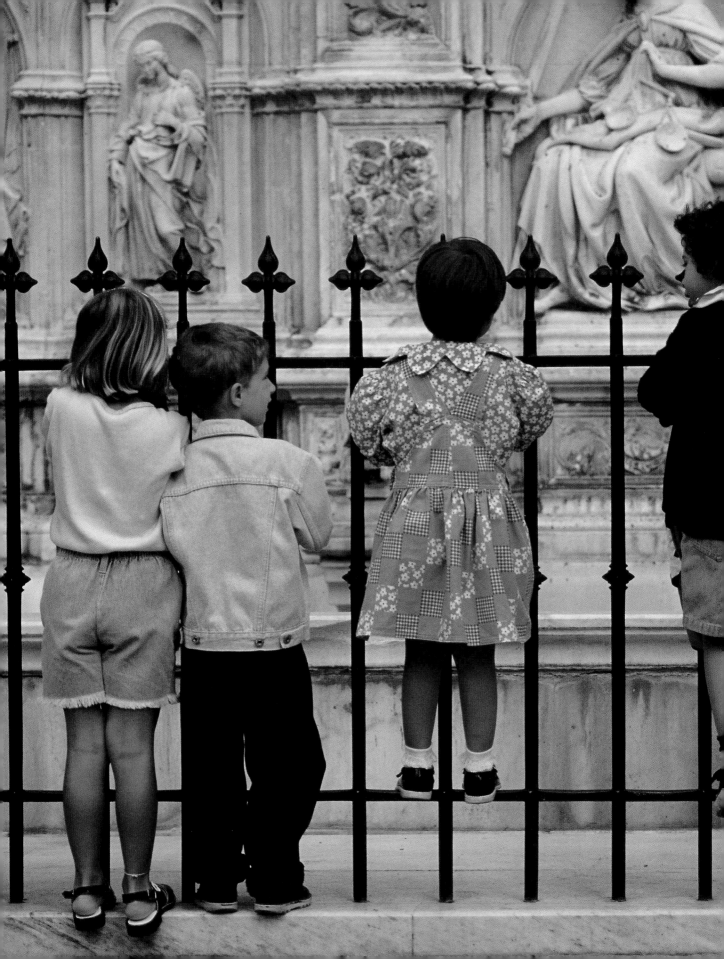

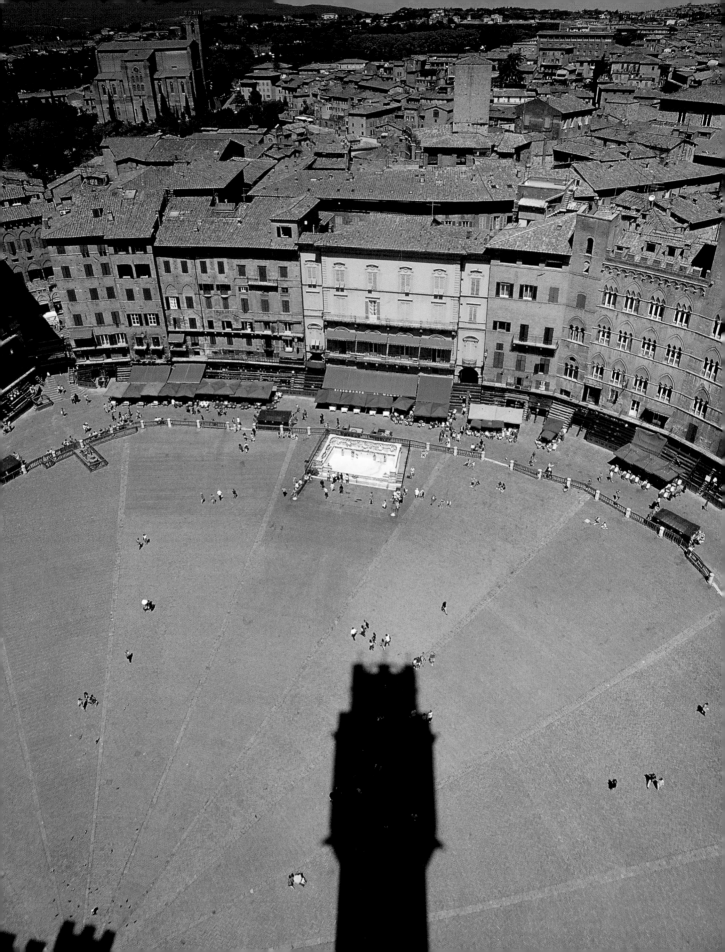

Where is the most beautiful *piazza* in Italy? That would be a fine quest. I can imagine driving around for a year. Sicily, Sardenia, the Dolomites, Umbria, the fascinating south with flamboyant baroque Lecce, the castles built by Frederick II, the mysterious Matera with its cave houses—and Naples, another fantastic country in itself. A walk around the perimeter of the amazing heart of Ascoli Piceno in the Marche, then Trieste in February, Bergamo, Emilia-Romagna, Torino. What a grand tour.

I asked friends in Cortona, "Where is your favorite *piazza* in Tuscany?" One and all they answered, "Cortona." A few mentioned Siena and Lucca as an afterthought. Nothing compares to one's own *piazza*. When we're travelling, we follow the signs pointing to a town's *centro*. The symbol—a circle with a large black dot in the middle—says to me that the *piazza* is the *ombellicus mondi*, true navel of the world, the particular world of a small Italian town.

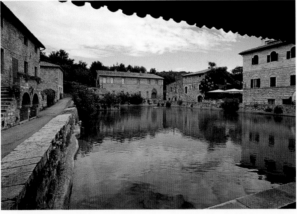

Occasionally, a *piazza* in the *centro* is a dusty parking lot with the life of the town taking place elsewhere, but, typically, the town center is a place of beauty. The local character seems encapsulated in the choreography and backbeat of the *piazza*. A lunch, a coffee while looking at the map, a little rest under the full moon—even a brief encounter fills you with a lively impression of Bagno Vignoni's *piazza* of water, or Pienza's intimate Renaissance square lined with travertine benches, or mysterious Etruscan Chiusi, or the ghost of the Roman amphitheater in Lucca's Piazza Anfiteatro.

Siena's *Il Campo,* the first *piazza* I ever saw, remains at the top in the beauty contest. This shell-shaped *piazza* looks especially splendid in the rain because the bricks, canted for the water to run off, shine and you watch a blur of yellow, blue, and striped umbrellas. There must not be a more noble surround of buildings anywhere. At all hours, the light changes, with the tower acting as a sundial to those who count time in their own way. To have a tall lemonade at a café, looking at the gothic windows and crenelations against the sky is to lose yourself in a timeless zone. A little surge of envy comes over me as I watch children chasing a cat. What must it be like to take your first steps amid such beauty?

Another great town center is Volterra's Piazza dei Priori. Many travellers don't make it to Volterra, although, after Siena and San Gimignano, you need just another push toward the west, through countryside often described as barren. I think of it more as a landscape that has eroded down to essentials, so that a large sky looms over the pure shapes of hills. Nothing is superfluous. Around Volterra, eroded cliffs, Le Balze, have swallowed cemeteries and abbeys over the centuries. Land dangerously on the move gives Volterra an uneasy atmosphere. Inside the town, you forget the crumbling cliffs because of the splendor of the place.

Il Campo, the grand piazza of Siena (left); Bagno Vignoni's piazza is a thermal pool (above); climbing for a better view in Siena (preceding pages 68–69); typical Tuscan café scene in late afternoon (preceding pages 70–71).

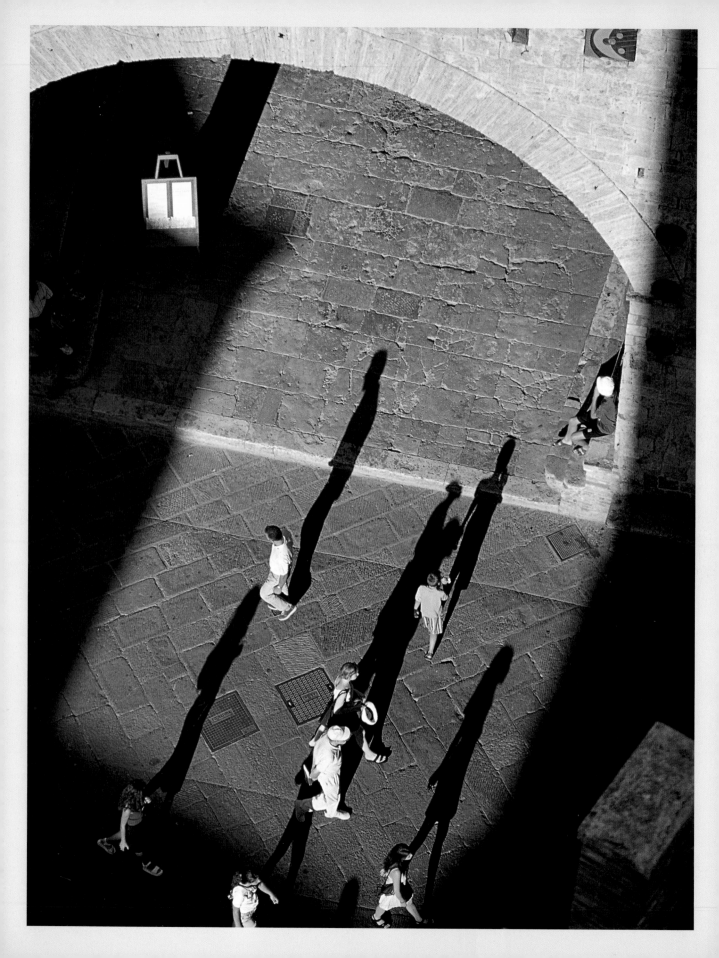

One summer morning I saw the *piazza* almost empty, with two men conversing, casting needle-thin shadows exactly like the form of Volterra's famous Etruscan treasure, *Shadow of Evening,* a startling elongated bronze male figure that lets you know right away what influenced Giacometti. There's a mighty feel to this *piazza.* You sense noisy rallies for medieval battles, with trumpets and drums, but actually you mostly see alabaster workers, hats rimmed with white dust, catching a coffee at the bars, and tourists exiting the many shops, having bought luminous sconces and soap dishes they will love holding up to the light. The workers are the distant descendants of the Etruscan alabaster craftsmen, whose designs, on display at the museum, still inspire the local art. "The main square is almost sullen in its severity," one guidebook claims. How anyone can look at all that golden stone and feel sullen, I don't know. The *piazza* is noble and expansive. As I cross it, I feel myself in proportion to the surrounding palaces. Others, more used to the spatial relations, simply greet each other or stop to talk, turning their faces up to the sun.

Volterra, like Cortona, was a primary Etruscan stronghold. Also like Cortona, Volterra began collecting its Etruscan art in the eighteenth century. Although six hundred or so carved funeral urns in the Museo Etrusco Guarnacci can become a blur after awhile, each one is worth a close look. Many depict angels, or, at least, winged beings who may be good or bad demons. Who knew they thought of angels in the third century B.C.? Everyone's stunned by the two people sculpted on an urn cover, a couple who seem to be lovingly connected. She looks at him and he seems to gaze directly at Death. You almost want to look over your shoulder to see if Death is creeping up. Those Etruscans! So much of what is left of their culture centers on death. But what is more revealing of a civilization than the way they bury their kin? I don't recall carvings of couples in positions of intimacy on tombstones I've seen in the old New England cemeteries. No, I remember dour warnings to the onlooker, something like, there you stand but you'll be underground in no time, so there.

The urns show an immense range of activity and feeling, from dancing to fighting, from mythology to portraiture. Never were a people so lively in death. The sturdy bodies play the pipes, receive bowls of wine, and feast constantly, a legacy we still enjoy in Tuscany today. The art frequently depicts olive trees, meadows, fish, birds, horses, even wild boar, revealing how closely they lived in connection with nature, another legacy that still lives. Women seem to be just as present as men, suggesting a rare, enlightened society.

The Pinacoteca e Museo Civico is empty. In a crowd, I see and record but don't actually react. Today, I can take out my notebook and write a little, wander, stand as long as I please in front of Signorelli's gorgeous *Annunciation:* Mary has dropped her book and thrown up her hands as the angel lands in a swirl of motion, the sensuous folds of his crimson dress painted with such pleasure. I examine closely the Romanesque carvings taken from various buildings in town, and feel a flash of Taddeo di Bartolo's love in his Madonna's face. We're stopped by Giambattista di Jacopo's *Deposition,* a tender, tragic painting of the Madonna cradling to her body the deposed Christ. They are face-to-face, her eyes open, his closed, and her dark dress envelops him as though she would absorb him into her body again. I'm reminded of many Madonna and infant paintings where a somber look in her eyes works as a preknowledge of the

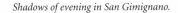

Shadows of evening in San Gimignano.

Crucifixion. This museum has its famous Ghirlandaio, but the collection of so-called minor Tuscan masters is exquisite, too. Minor painters, major experience.

Volterra pulls you back in time and gently releases you into the present. A woman elbows me as I consult my guidebook. "If you're looking for a place to eat well, go to Il Sacco Fiorentino." We go. Ed asks the waiter what the name means and we get a history lesson. They've named the *trattoria* in memory of a massacre of the citizens in 1472. The city was sacked and burned in a conflict we can't quite work out between the Medicis and the Duke of Urbino. "It's the Italian way," Ed says. "They pull an event out of history and place it right here. At this table. Nothing ever disappears completely." The menu lists usual Tuscan specialities but also pork loin with black olives, and rabbit in a sauce of *vin santo* and garlic, and pigeon with radicchio and *vin santo*. We order lamb marinated in *agrodolce,* sweet and sour, and roasted with mint and tiny raisins. The woman was right and we raise a toast to her. Ed has a sublime—to him—dessert of goat cheese with honey. I order only coffee, a hit of caffeine to propel me back into the full afternoon ahead. I take a last look at the menu, resolving to come back for the *gnocchi* with wild herbs. Ed regrets not trying *pecorino grigliato in camicia di pancetta,* grilled pecorino cheese wrapped in *pancetta*.

You can walk a whole day in Volterra, feasting your eyes on the great Etruscan heads on the Porta all'Arco, the medieval tower houses, cool green and white marble, the *Duomo*'s polychrome wooden statues, gilt and silver, and everywhere, alabaster, terra-cotta, mosaic, and iron. My camera is clicking, picking up the details of angles, shadows cutting across the lanes, a fine mailbox, three men all gesturing wildly, a child and a dog looking out a flower-festooned window.

On the edges of town, we come upon a Roman amphitheater and the Rocca, the fortress, which gives the strong impression that they meant business about fortification back in the twelfth century.

The cup of life is upside-down on the Etruscan urns; in Volterra today, it's upright and overflowing.

～

We live in the province of Arezzo, another Etruscan city. Now it's famous for Piero della Francesca's fresco cycle, *The Legend of the True Cross,* which recently emerged from fifteen years of restoration wraps, and for its monthly Antique Fair. Initially I was not charmed by Arezzo. Parts of the city were bombed in World War II and the replacement concrete is not a pretty sight. I associated the town with standing in line for my annual *permesso di soggiorno,* permission to stay in Italy. Always we were missing some vital document. The arriving multitudes of Nigerians and Albanians seemed to have more of a grasp of what was required and more determination to get to the head of the line than we did. We couldn't wait to exit Arezzo, even though each time we got lost. We still get lost, but now we don't mind, because we know Arezzo well enough to know exactly how lost we are or are not. If quite lost, we get to see Vasari's aqueduct or the town walls.

The first time I saw Arezzo's Piazza Grande, every inch was covered by the mirrors, iron gates, beds, and bric-a-brac of the antique dealers. Every month I'm in Tuscany, I go to the Arezzo market, which retains the flavor of a medieval fair. (I wrote a chapter about it in *Bella Tuscany*.) Eighteenth-century engravings show the *piazza* crowded with merchants, too; always it has been a place of trade. Emptied, on a December morning, the

Roman ruins in Volterra (right); coats of arms decorate Arezzo's library facade with Medici shield above the door (following pages 78–79).

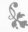
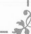

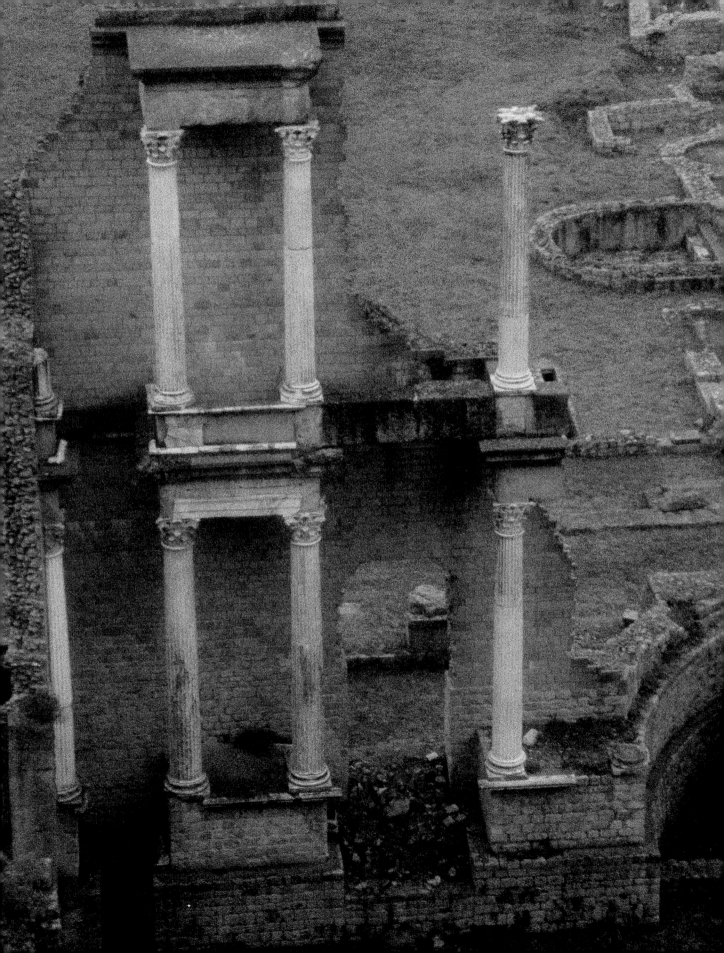

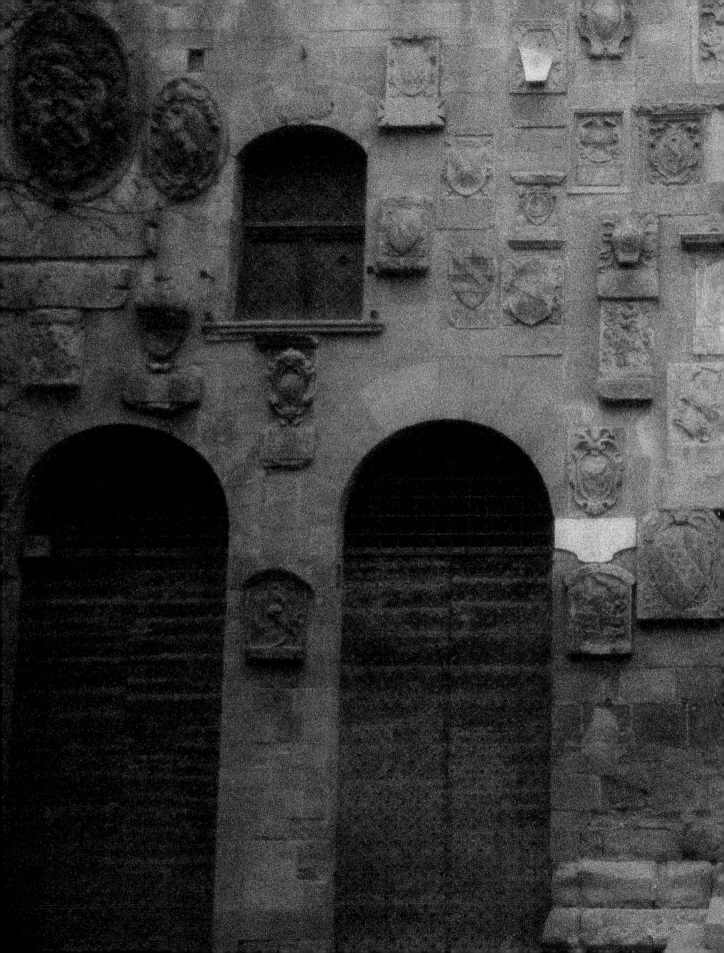

vista suddenly transposes you in time. Here is a stupendous *piazza,* open and capacious. It slants down to a fountain. Medieval houses line one side, the arched loggia of Vasari, echoing his aqueduct, anchors another. Opposite the loggia, there's a row of antique shops. The fourth side shows *palazzi,* the rounded apse of Pieve di Santa Maria from the twelfth and thirteenth centuries, and a half-moon flight of steps where you can rest for awhile.

Arezzo is changing quickly. Wine bars and *gastro-nomie* are opening, high-style clothing and jewelry shops seem to pop up every month. Luxurious intimate apparel, house-wares shops, and pastry cafés lure us from the country into town. Endless antique shops and bottegas for restoration reveal things I had no idea

you could buy—carved library walls, altars of gold, sunburst monstrances, mirrors that must weigh a ton, tables where thirty could dine. And in between: artisan bread stores, fresh pasta shops, clothing stores for workers, so many bookstores, tile and hardware stores, and endless jewel-box-sized shops selling lace and buttons and handbags and candy.

Arezzo is rich, the gold capital of this part of Italy. It seems to have a population mostly under thirty. At *passeggiata* time on Sundays from five until seven, they all are out in their hip clothes, swinging and smoking and looking fine. We're carried along with this groove and rhythm as it moves down the pedestrian Corso Italia, then back. There's a look, a proud look to the Aretini, especially

the youth. Their Etruscan ancestors dancing across the tomb walls seem just one genetic spiral removed: the curly black, black hair and straight noses, heavily drawn eyebrows, the healthy skin like a thin creamy wash over terra-cotta. There's the faun, there's the goddess, there's the warrior with the cigarette drooping from his lip.

Near the train station, two chimera fountains decorate either side of the street. They're replicas of an original Etruscan bronze (now in the Archeological Museum in Florence) unearthed in a ditch in 1555. The lion figure has doglike feet and a dragon—though it looks like a condor—for a tail. From inside its arched back rises a horned goat. The creatures of nightmare growl directly at you, ready to pounce. Only their sprays of water render them harmless. From what part of the imagination did he appear? Did the Etruscan sculptor like the Greek myth of Bellephon, who was sent to slay a similar creature? More mystery.

Besides the funerary urns and painted tombs, thousands of votive figures, mirrors, jewels, household items, and tools remain to give us clues about the Etruscan people in this area. The gold work here and in Cortona could lie in the case at Cartier's and outshine any jewelry on display. They obviously loved adornment. You sense their humor and whimsy on utilitarian items such as coal shovels decorated with human figures, handles shaped like legs, and bronze animals, which must have been made purely for fun.

Early evening in Arezzo (left); shop sign on Arezzo street (above); a bust of Vasari at the end of the loggia he designed in Arezzo and a bar in Arezzo at Christmas (following pages 82–83); tasting a great Brunello in Montalcino (following pages 86–87).

Nothing much in this world rivals Piero della Francesca's frescoes in the church of San Francesco, but Arezzo's other churches also have exciting paintings to discover. In the Chiesa di Badia, I find my favorite saint, Lorenzo, patron saint of cooks, almost in the dark beside the door. He's young, holding a book and quill, looking like one of the young men who stride along the Corso in black leather. Propped against his left hand is the iron grill on which he was martyred. While he roasted, he is supposed to have said, "Turn me over, I'm done on this side."

Off to the side in the *Duomo,* I find a less-visited Piero della Francesca fresco of Mary Magdalene. He captures a quixotic moment, as he does in his *Madonna del Parto* in Monterchi and his *Resurrection* in Sansepolcro. Mary Magdalene's hair is wet; she has just dried the feet of Christ and we glimpse her face at that instant.

This is what I look for, moments of connection—the dark church where I see that Lorenzo could have

been a hometown boy, see by the expression on his face that he had plenty to say and could have wisecracked to his torturers. And Mary Magdalene just after that momentous occasion—she's back to herself, carrying new knowledge, and the painter has left us this image of *her,* a switching of focus from the main character. Piero, an instinctive poet, chose to *still* the most protean images. His fresco cycle deserves a few hours of study before a visit. The restoration, to my eyes, is excellent. During the years it has been covered with green dust veils, I've often made an appointment and climbed around in the scaffolding. Slowly, I've seen the whole cycle, face by face, horse by horse, landscape by landscape. His *Annunciation*

is one of Ed's favorites. It overshadows the other one in the same church by the local painter Spinello Aretino, which has its own silence and beauty.

We often stop at the Museo Statale d'Arte Medioevale e Moderna. Hardly anyone is around, no crowds, ever. And it's full of marvelous things, including bits and pieces taken from the city gates and walls in order to protect them. You can reposition them mentally and see the power the Madonna held when she was positioned on an original gate to the city. Here's the place to get to know Spinello Aretino and also his son, Parri, as well as fascinating medieval scenes of Arezzo. Ed can pass right by, but I love the old ceramics on display. In my garden I've found dozens of cobalt, pale green, and earth brown fragments. I like seeing the tureens and plates whole, still ready to hold a big slice of *polenta.*

In a park, I come upon a statue of Guido Monaco, native boy who invented the musical scale, and in the old quarter, walk into both Petrarch's and Vasari's houses. So many writers and painters and patriots are commemorated with busts and plaques; coats of arms decorate the library, even shop signs are fun. We spot all the places where the Roberto Benigni's movie, *La vita è bella,* Life Is Beautiful, was shot, buy lamps in the regional majolica patterns, stop in the nineteenth-century cafés for pistachio *gelato* and real lemons stuffed with sorbet, and stay late for dinner at L'Agania, one of several excellent *trattorie* in the historical center. Arezzo—a place where people often pause for a couple of hours, when it could enrich all the days of a month quite easily. We move too quickly, and time in these places is long and languid.

The city of Arezzo is the bright center in a constellation of inviting places to discover. You can strike out, avoiding big roads, and the whole Casentino countryside reels by: Romanesque churches, calendar-ready landscapes, and villages that have cornered the geranium market. At nearby Buriano, mentioned in no guidebook I know, you find the Roman bridge that art historians believe is in the background of the *Mona Lisa*. Farther north, we explore Bibbiena, Poppi, and Stia. Approaching Poppi, one of the best secret towns, you take a slow looping road up and find a small village of arcaded sidewalks, wonderful doors, and a lurching road to a pristine thirteenth-century castle with a huge bust of Dante outside. Views of the Casentino scroll forever from this stronghold, and the shady park below has an outdoor bar, jammed in summer with families out for a stroll stopping for something cold. From Poppi, you can drive up to Camaldoli, where cloistered monks have meditated since 1012. I like their pharmacy from the sixteenth century. We go on endless spiritual trails in the area, breathing in the fresh, holy air. La Verna, too, is not far, another remote retreat, where San Francesco received his stigmata. These hills, mentally far from Arezzo, actually are close.

Toward the east from Arezzo, the towns of Anghiari, Monterchi, and Sansepolcro (already described in *Bella Tuscany*) deserve at least a day. Caprese Michelangelo, too, is near, in the middle of pastoral farmland. The woods in fall teem with mushroom and truffle hunters. It's simply a joy to drive. The gears of Ed's new Alfa get their training. At Rassina and Tala, we find eleventh-century churches and at Sovara, one even older. I want to roll down the window and sing. The birthplace of Michelangelo provides a place to stop, take a walk, and imagine that such an artist sprang from this particular place. You see the church where he was baptized and the very restored house where he was born. Too bad they don't have one of his great works blazing on the walls. They've tried their best with some photos and copies of his sculpture, but nothing gives any authentic sense of the artist or his magistrate father or his invisible mother. A few contemporary sculptures adorn the grounds. What a fine idea. Why not send out an invitation to sculptors around the world to donate a work? Who would not like to have a nude or torso standing on the grounds where the boy Michelangelo first breathed? There could be hundreds, lining the pathways and positioning the views over the fields.

South from Arezzo lie Cortona and the Val di Chiana, which rises on its western side to the towns of Lucignano and Monte San Savino. Lucignano's gifted citizens have protected the town from any invasion of ugliness. It is so very contained: from a magpie's eye view (there seem to be colonies of black and white magpies in the nearby fields) the town describes an ellipse, with concentric streets, surely a unique plan.

Approaching, you circumnavigate the walled town. Stone spikes jutting out of the wall provide residents with steps up to their houses, allowing them to leave their cars below. They look frightening; I'd hate to haul up three grocery bags. You enter town on foot through a double gate. This immediately strikes me as a place to live. The Piazza del Tribunale is a town planner's dream. The Palazzo Comunale, which houses the museum, dominates a *piazza* surrounded by pretty houses with pots of geraniums, starched-curtained windows and

handsome doors. Benches and trees line the *piazza*, where on spring nights everyone is out for a little walk and a visit with friends. The museum, only three rooms, has a Signorelli of San Francesco, and a goldsmith's fabulous tree with coral twigs and medallions holding relics. My impression of the high intelligence of the natives is confirmed in the anteroom to the museum. A first-grade class took a field trip during the olive harvest, and an exhibit of their detailed colored drawings of olive picking and the mill shows an astonishing precocity. "Are these really *six* year olds?" Ed asks the attendant. She does not seem amazed. I was drawing the square house and the smiling sun at that age.

Next door, the church of San Francesco is so beautiful—twisted columns, striped travertine and stone facade with a big door, weathered to a faded, cloudy shade of sky. Inside *The Triumph of Death* fresco looms. Death on horseback has garnered several skulls and looks intent on slicing off the next head. Outside, curving streets, impeccably clean, wind past several other churches, on to three town gates opening to the soft colors of olive groves.

Over the hills, Monte San Savino, just as ancient, loses a few points in charm because of surrounding development, not hideous, just thoughtless. And in town, the *piazza* is a parking lot. What a mistake. Most of the small Tuscan towns, by now, have banned cars from their centers. With plenty of parking outside, why does Monte San Savino let cars ruin the ambience? Subtracting them, you'd see a spacious *piazza* with a fountain and the sharp rise of a tower. Still, Monte San Savino is another one of those layered and layered towns; turn down any street and you find something to see,

something to contemplate. A fine steeple, a fountain with a lion, a stained-glass window, a carved door, a cloister. We happen upon the *ex-sinagoga* and read that the neighborhood, formerly a ghetto, had a Jewish community for two hundred years until 1799, when some Viva Maria movement drove them out of town. The synagogue is a ruin; who knows what's inside. Pitch darkness. On other streets, the churches blaze with real candles, even on a Tuesday morning. The famous architect Sangallo was active here, and Sansovino built the arched market, which now just stands empty on Corso Sangallo, an unusually wide main street. Leading into town, the several funky antique shops lining the roads are remarkable more for their eccentric owners than for their antiques. Oddly, on the other side of town several reputable dealers sell iron sconces, paintings, ceramics, and furniture at good prices.

⌒

We often strike out for an enchanted circle of villages less than an hour to the west of Cortona: San Quírico d'Orcia, Castelmuzio, Montisi, Trequanda, Asciano, Murlo, and Buonconvento, stopping at one or two for a look. Usually we continue to Montalcino for a visit to the *enoteca* in a castle at the end of town, where we sample the region's Brunellos. We ride out to Sant' Antimo to hear the Benedictines chanting in the travertine light, then stop for dinner at Poggio Antico, Il Pozzo, or one of the many authentic *trattorie* among these vineyards.

(Note: In *Under the Tuscan Sun* and *Bella Tuscany*, I wrote about other places in this area: Bagno Vignoni, Petroio, Montepulciano, Pienza, Montecchiello, Monte Oliveto Maggiore, and more about Montalcino.)

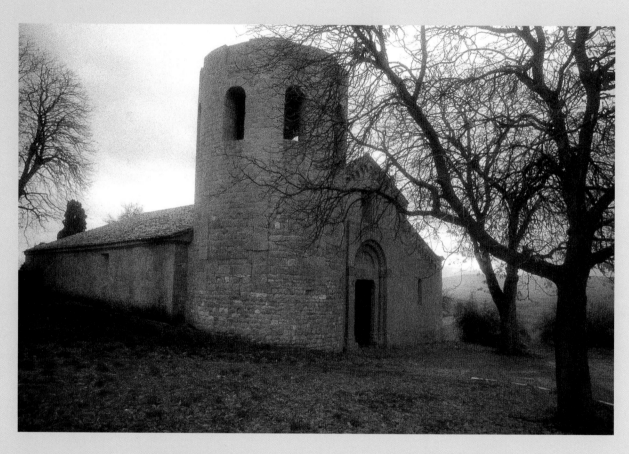

Pieve di Corsignano, Pienza (above); the translucent light inside Sant' Antimo and the church exterior, outside Montalcino (following pages 90–93).

ROMANESQUE CHURCHES

The Renaissance dominates Tuscan art. Unvisited, unheralded, and often ignored, the country Romanesque churches remain from an earlier, and more mysterious time. Their fanciful carved beasts and vegetal motifs seem closely linked to the pagan. The dates of the Romanesque era are roughly 1000 to 1150. When I see the word *pieve,* parish, on a detailed map, I take the turn. Often I'm rewarded with an untouched jewel of architecture, usually of regional stone with bell towers. Even glorious Sant' Antimo often is missed because it's out in the hills beyond the pleasures of wine tasting in Montalcino.

While hiking near Cortona, we came upon a ruin of an eleventh-century church. We lifted a stone circle with an iron ring and the sun's rays hit a skull and thin bones down in a crypt. Someone old and holy. Another day, driving around near Castiglion Fiorentino, we found an abandoned chapel and parish house. The Romanesque door lintel of the house was carved with a startling recumbent human body.

These simple churches, with rounded apses, stone altars, and bell towers stir basic and archetypal memories. The curves recall those of the time-immemorial brick bread ovens and of the *melone,* the domed Etruscan tombs. Mostly unadorned, the stark interiors leave room for one's own spirit to expand. I observe the *pieve* churches with much joy.

A few intimate places of long faith, and the nearest town:

Pieve di Corsignano, Pienza

Pieve di Badicorte, Marciano, Val di Chiana

Chiesa di San Michele, Cortona

Abbazia di Farneta, Val di Chiana, near Cortona

Pieve Socana, Rassina

Pieve La Castellaccia, Tala

Pieve di Sovara, Sovara

Pieve di San Pietro, Gropina

Pieve de Santi Ippolito e Donato, Bibbiena

Collegiata and Pieve Maria Assunta, San Quírico

Pieve di Rofeno, Pievina, near Asciano (under reconstruction as of this writing)

Pieve di San Stefano, Cennano, near Castelmuzio

Sant' Antimo, Montalcino

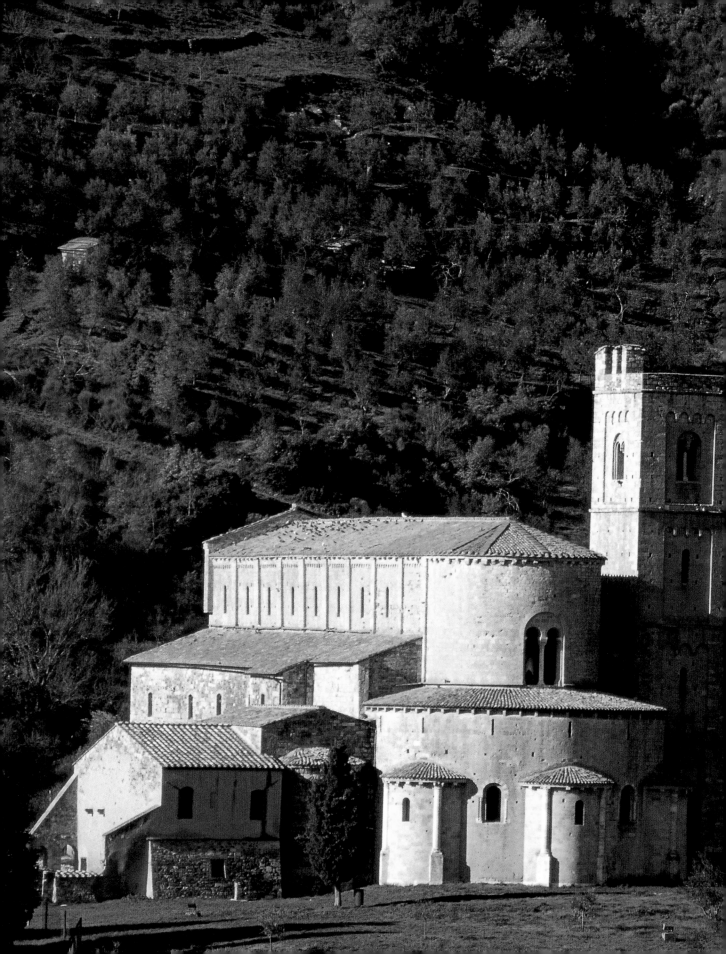

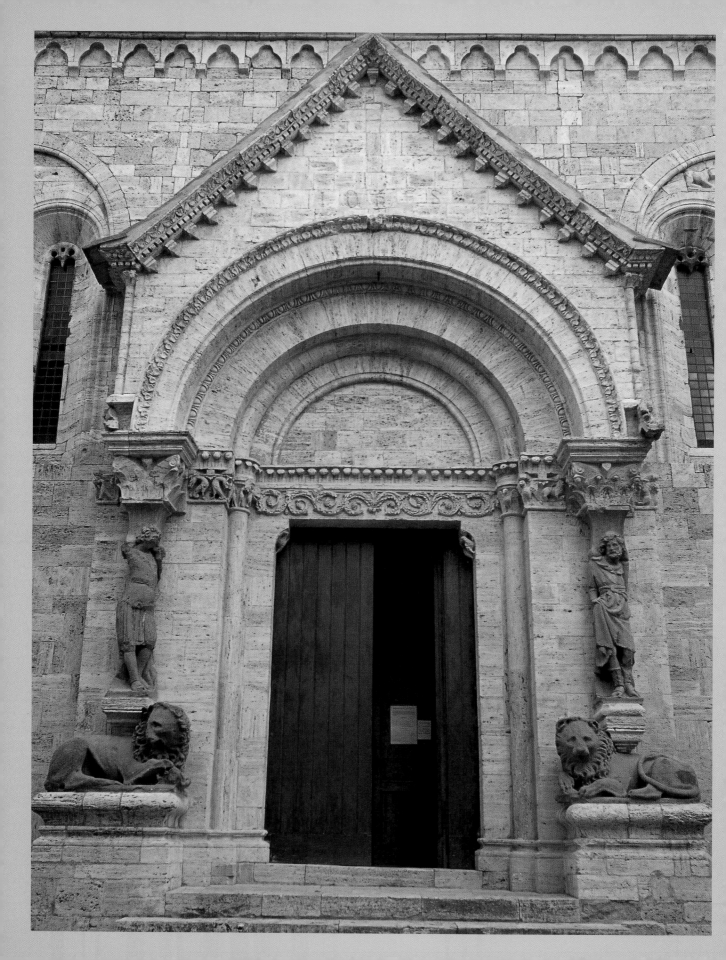

Who was San Quírico? His namesake is a lively town with a palette of mimosa yellow, limestone, ochre, sienna, and dusty-rose buildings. The central street, Dante Alighieri, has miraculous churches on either end. The Collegiata faces you near the main entrance to town. Over the main door, two winged crocodiles bite each other, or are they kissing? Whatever they're doing, they present a weird welcome to San Quírico. Much obsession with fantasy animals occupies the church's three entrances but somehow they blend with the recessed arches formed by columns. A magnificent work. At the other end of town you come upon Santa Maria Assunta, an austere little limestone church of the eleventh century, pure and simple, with a well outside, and a creature over the door who has devoured someone whole. The right leg still hangs from his jaw. A thirteenth-century hospital across the street, now a residence, has not seen a mason's trowel in the past few hundred years. I peer into a courtyard with a well. Better to imagine someone drawing water and hoisting the jug than to imagine the plague victims piled into the second-floor rooms.

In between these two marvels, the town exists, with card players filling the bars, ceramic studios, household shops displaying hammered copper pots, and easy outdoor cafés. The *piazze,* a rose garden, and Horti Leonini, a beautifully kept formal garden from the 1500s, prove how enlightened these beneficiaries of San Quírico still are.

At Castelmuzio we always check on the house we first wanted to buy twelve years ago. The owner was waiting for a sign from God—a bolt of lightning?—to see if she should sell. We had to leave before any sign was manifest. How would life have been different here? The farm still looks abandoned, and I thought I remembered a large oak shading the house. Castelmuzio feels like a market town. I pick up a small mirror in an antique shop and ask the price. Fifteen million *lire,* would I like the price in Euros? More than seven thousand dollars; I think not. Instead I drink Coca-Cola with lemon and we walk from one end of town to the other. A woman with a bag of greens mutters, *"Facista,"* as she passes a man with a muttonchop mustache. Old loyalties still clash.

Passing by Montisi, where we once rented a house, we mention an American woman who lives there. She learned Italian from sitting around with the women of the town at night, hearing dirty jokes and gossip. The ramparts of Montisi form the foundations of many houses. The one we rented felt as if it had grown out of its fortress base. I remember Federico, the owner, who brought us honey and eggs and, one night, the news that Peter, a close friend at home, had died. The call had come to his house and without a word of English, somehow he understood the bad news. We've been here long enough that small histories are accumulating, memories over a decade old, marking this place and that on our map.

*La Collegiata, San Quírico (left); a wild detail above
the doorway of Santa Maria Assunta, San Quírico (above);
San Biagio and profile of Montepulciano (following pages 96–97).*

This is sweet country. Hills dip and rise, take you on a ride and look as though they were formed by a large and gentle hand. In the distance you see villages crowning a hill or protectively stacked against a slope. Each one pulls me toward its altarpiece, special triptych, arched gate, gothic window, or fountain. Each one has its opinionated, eccentric, friendly, and intrinsic characters who make the place deeply itself.

We keep coming back to Asciano, such a small town with so many aspects to love. Two fountains on the main street lend notes of joy. At street angles frescoes of Mary and the baby suddenly appear, cats sleep on the hoods of venerable Fiats, four gnarly men in the *piazza* argue. One says, "I don't want to talk politics, I want to talk civilization."

"What you're talking is nonsense," another responds. We pass flower shops, a store selling medieval costumes, scarves, and flags of the *contrade,* neighborhoods. At Corso Matteoti 108, we enter a two-storey medieval courtyard, with its well intact, similar to the Ospedale in San Quírico. Blink twice because time has lifted its curtain. "Do you live here?" I ask a woman coming out with a market basket.

"Yes, *bella, no*?" she answers. "We can't systematize because we can't get permission." *Systematize* sometimes means something gets updated in a horrible way. "I like it like this," she continues. "*È autentico.*" We're astounded that the complex has remained untouched all these years. In these places, sometimes I experience a physical sensation of time; it feels as though time pours into my consciousness like water into hot sand.

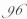

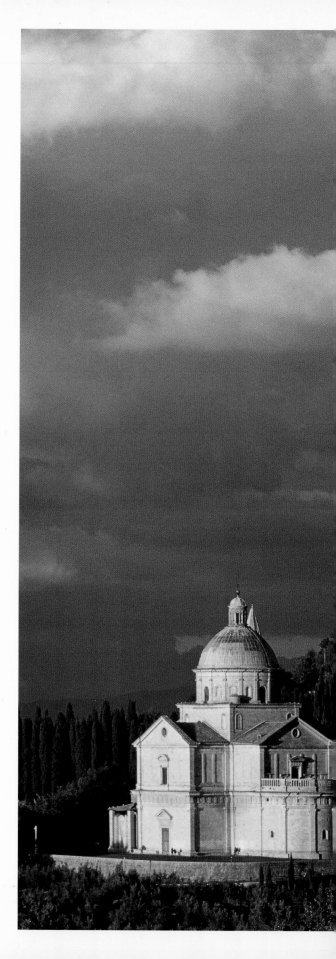

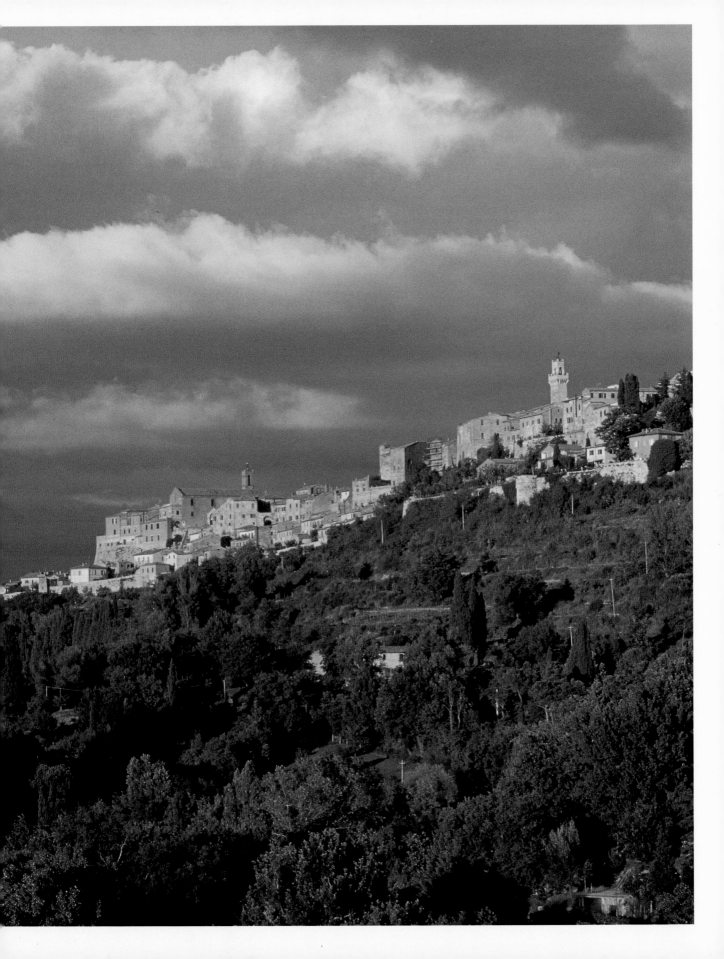

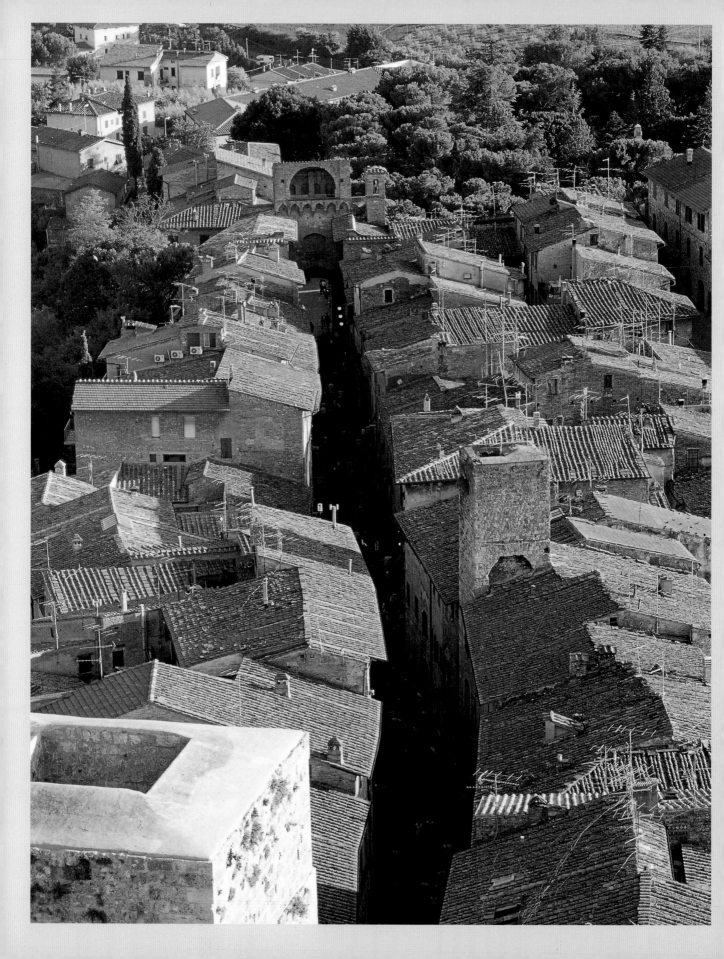

We visit the tourist offices in small towns because we often meet people who love the place. In Asciano's office we ask a few questions, and a volunteer locks the door and takes us over to the Museo d'Arte Sacra. Bubble-wrapped torso-sized bundles lie around on the floor. "The collection is about to merge with the Etruscan museum in a new location," our volunteer explains.

"When?" Not always a good question in Tuscany. What luck to see these paintings. Our guide stays beside us, filling us in on dates and the histories of the paintings. There are only a few—enough and more, when they're superb. *The Birth of the Virgin* stops you like a siren—one of the richest, most affecting paintings I've ever seen, right here in this tiny town. Once attributed to Sasseta, one of my all-time favorites, the painter is now identified as Il Maestro dell' Osservanza. The newly born Virgin infant is held close to the fire by a woman in a yellow dress while another woman kneels, holding a swaddling cloth close to the flames to warm it. In the arched doorway, a third woman enters, bearing a little bowl of broth and a *gallina,* a roast chicken, to revive the mother after the birth. Off to the side, the mother, Anne, is still in bed, being offered a warmed copper pot of water for washing. The painting taps at memories of births, giving me an iconic image of the ideal way a baby might come into the world. A touching scene, this company of women, all of surpassing beauty except the mama who looks a bit gray after her ordeal. The secondary subject of this painting is texture, dresses of soft yellow, pomegranate, and coral, a boldly patterned tile floor, fringed scarves, towels and shawls. A very tiny angel wings in, carrying a crown for the infant, who lies on a blue blanket.

On the opposite wall, *The Adoration of the Shepherds* by Pietro di Giovanni d'Ambrogio shows the *crete,* clay hills, we've just driven through in the background of the painting. It looks as if the birth of Christ took place in a shed hollowed out of the eroded hills. The guide astutely points out, "Instead of the adoration of the baby, as is usual, Mary and Joseph are turned toward the two shepherds." He's right; the story is different here.

Both of these paintings have a narrative clarity and grace. Moving into a dusty back room, the *signore* doesn't point out a canvas devoted to the symbols of Sant' Agata's martyrdom. Her two breasts, perfect cream puffs with cherries, are served forth on a plate. As we leave, I see a Madonna and baby by Duccio up high; in my infatuation with other paintings, I hadn't even noticed her regal face.

I always read about the museums in art and guidebooks, preparing myself. Sometimes, as in Asciano, I'm shocked by the powerful beauty from a painter I've never heard of. We read about the same painters over and over. Often what is most *personally* meaningful is the surprise, the fresh talent of the unknown artist, waiting all these centuries for you to discover him.

The volunteer waves goodbye and reminds us that there are *three* fountains to see, not just the two obvious ones. He joins a group of friends standing in a pool of sunlight. In the *piazza,* shaded by little trees, we find an artisan bakery. Because the world gets hungry at eleven A.M., we crowd in with others and exit with the best crunchy *brutti ma buoni,* ugly but good, cookies I've ever eaten. They make them in both chocolate and hazelnut so we try both. We also buy *ciaccini,* rounds of flat, fried crisp bread with salt, and a wafer-thin potato pizza to eat as we drive.

Medieval street in San Gimignano.

We must stop at Murlo, about the size of the palm of your hand, an intact medieval *borgo,* where Etruscan ruins continue to be uncovered—most recently a 197-foot square building foundation, which was decorated with human-sized terracotta sculptures. They have a surreal touch because the hats they wear look like Texas ten-gallon hats. No one knows yet whether the building was a shrine, a house, or a place for public assembly. Murlo is silent on the subject, and on most others. When siesta starts, not a soul is about, except for a cat who seems to be wearing authentic camouflage fur. She appears, then disappears in the weeds, and when she leaps down, hoping for some bits of pizza that we're finishing outside the car, we see she is spectacularly wild. Her coat is taupe, black, cream, and a strange green-gray I've never seen. She stalks, her muscular haunches propelling her twiggy legs. She's watched by a long-haired white cat, outstanding bait for a predator, who will not deign to ask for a crust. The cats of Murlo—lucky beings to live in this sunny enclave on olive slopes. We toss pieces to both cats and to a dog who has shamed himself by looking longingly as we chew. Hang dog. Tail curled under. Cats never apologize.

Buonconvento, a walled medieval town built of brick, has its stash of Sienese paintings in a Museo d'Arte Sacra. It's also pleasant just to wander around the town. We overhear two women of genteel appearance. "I spent all night trying to pass a kidney stone," one says.

I'm shocked to hear the other exclaim, *"Madonna lupa!"* Madonna-wolf, a crude curse.

The one Liberty (the Italian version of art nouveau) house stands out among its neighbors. On via Grisaldi the *forno* makes *ossi di morti,* bones of the dead, a meringue-based cookie. You might guess: They're tooth-cracking hard. I've somehow acquired a taste for them, although when I first tried them I thought they were made of calcified dust. *Sospiri,* sighs, are light almond sweets, much easier to love. The *forno* makes special almond treats of the Siena area, *ricciarelli,* curly cookies, and *cavallucci,* ponies, and also makes *brutti ma buoni.* They're not even ugly.

❧

Travels in the Tuscan countryside, for a day trip, weekend, week, year—a journey or a hike, a picnic or a ride: I go when I'm wanting *something.* Something endless, something new. Something with no memory of mine but with a memory of its own that reaches farther back than I can imagine. When you find the *piazza,* you're in the heart of the heart of the place. All the lives and affections and events flow out from right there.

"What's the best thing you saw today?" I ask Ed, wondering if he'll say the painting of the women in the warm-colored dresses.

"The Alfa when it came out of the automatic car wash," he jokes. "Aren't you glad we ordered the dark blue?"

Medieval festival in Murlo (above); Pienza al fresco (right); daily life beside black-bordered death notices in Montepulciano (following pages 102–103).

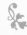
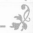

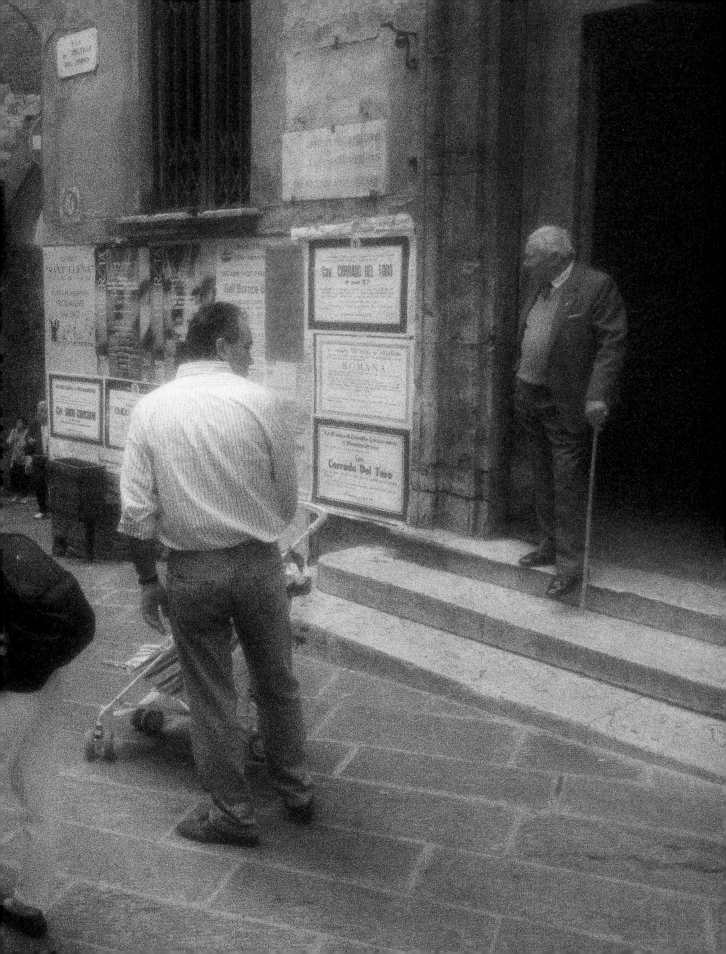

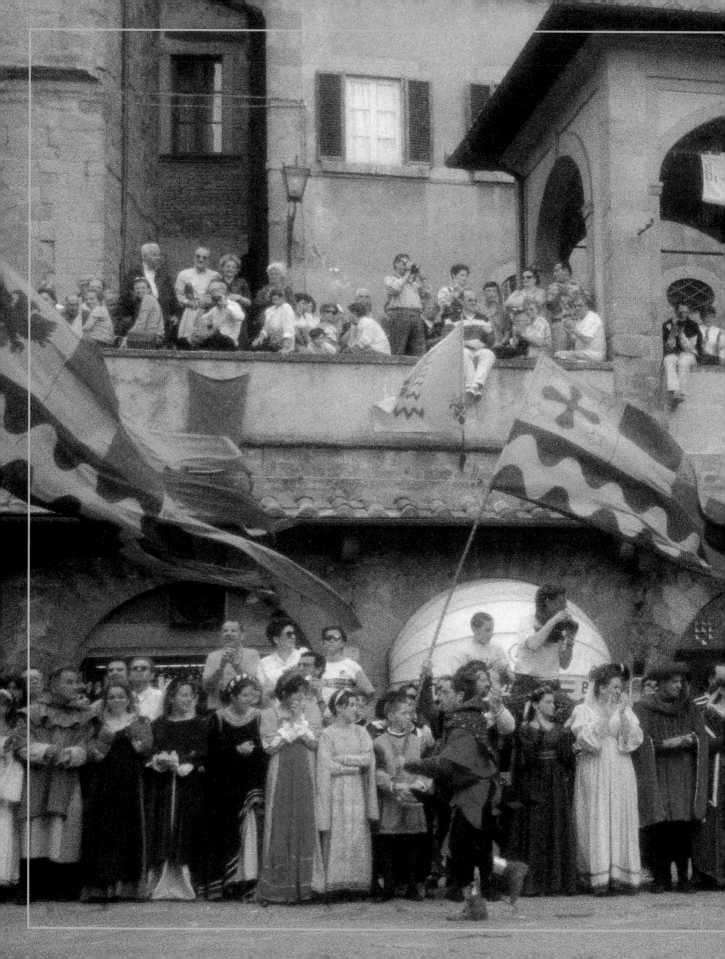

LA FESTA
(Celebration)

Time brings forward the joys of feasting,

thankfulness for the harvest, gratitude to the saints for

saving us from sore throats and droughts,

and also the recognition of miracles.

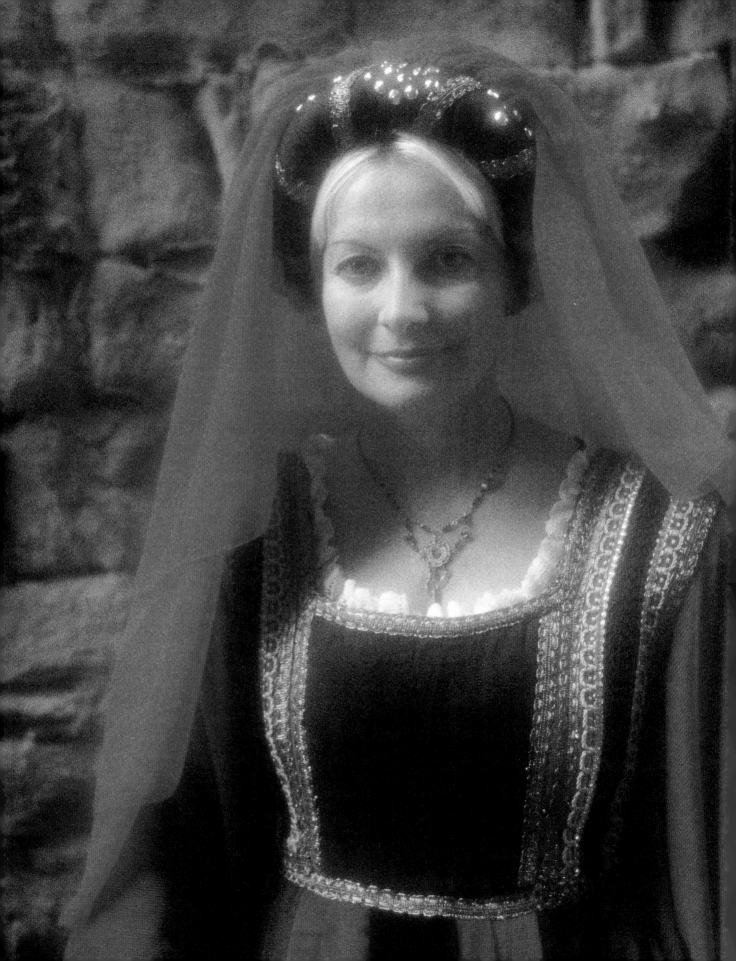

LA FESTA
(Celebration)

The singer and writer Lorenzo Cherubini, called "Jovanotti," lives in Cortona. All his rap/lyric CDs reach the top of the Italian charts. He recently wrote a hit song—a lullaby—for his baby daughter, Teresa. The song *"Per te,"* starts, *"For you,"* and then he imagines all that he wishes for her. *"And for you the sun burns in July . . . and for you the school bell . . . and for you the 13th of December . . . and for you the strawberry's red . . . and for you the perfume of the stars. . . ."* Listening closely to *"Per te,"* I hear him wish for his daughter *sabato nel centro,* Saturday in the center of town. Saturday in Cortona, of course, is market day, a weekly celebration. What a joy, that wish. So profoundly un-American.

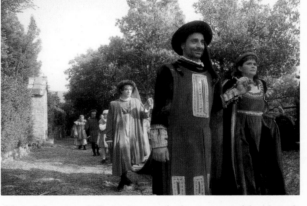

The ancient cities of Ninevah and Babylon had town squares. Each Greek city had a forum and the Romans continued that humanistic plan. The maps of Tuscan towns often show four gates, with the roads meeting at a *piazza*—crossroads, marketplace, living room, and a center for festivals.

All the towns I've described have a weekly market for food and household items, shoes and clothes. I love the lively September markets because all the barrels, nets, baskets, jugs, funnels, and brushes for wine-making and the olive oil harvest are for sale. At the nearby Camucia market, an extra field is opened for the exhibition of new tractors. Hundreds of men are visiting and inspecting, discussing the coming harvests. The September antique fair in Arezzo is also the largest. Even I could not make it through the entire market, which spreads out from Piazza Grande into parks and whole new neighborhoods.

The *piazza* encourages spectacle. During the summer and especially on New Year's Eve, concerts draw everyone together in the center. Centuries-old barrel races or archery and flag-throwing contests reoccur annually, relics are held aloft behind priests and bishops in procession, reenactments of battles and weddings are frequent.

The archery festival in Cortona (previous pages 104–105);
Iole Crivelli from Cortona in a medieval light (left);
the procession begins (above).

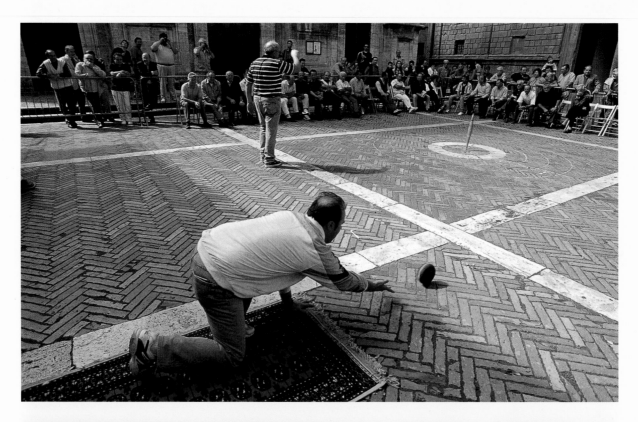

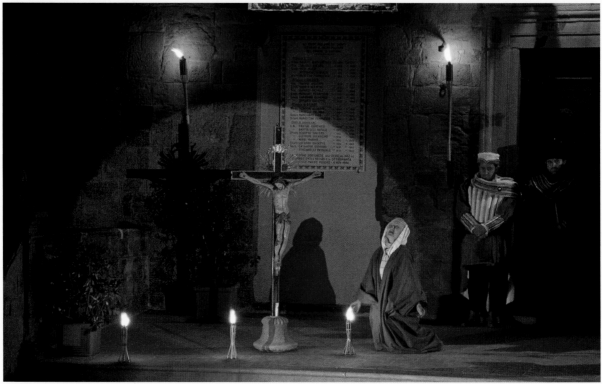

In Pienza rounds of pecorino *cheese are used even in games (top); pageant of Santa Margherita, patron saint of Cortona (above).*

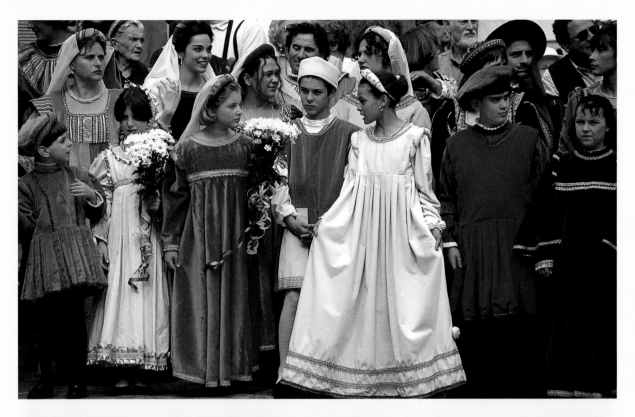

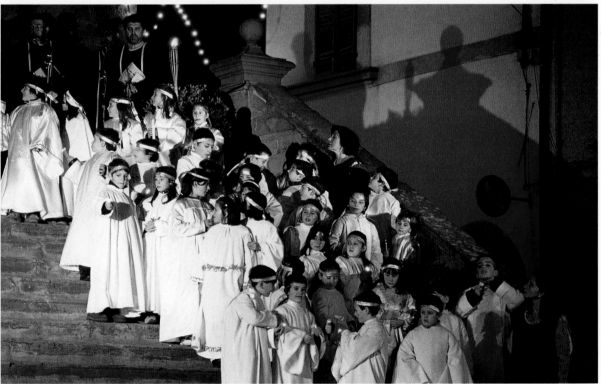

Cortona children at patron saint pageant (top); Christmas angels on the steps of the town hall in Cortona (above).

The *festa* you happen upon is not just a tourist attraction. Real passions are involved—or in flames over the event. Siena's Palio, the horse race around the *campo,* sends groups of young men marching through the streets singing strident songs and gathering at restaurants to chant and bang the table—football fever squared. If you arrive a day or so early, you can't help but fall into the excitement and competition among the *contrade,* neighborhoods. Some of the activities defy all reason. The horse raced by each *contrada* is led into the neighborhood church for a blessing, and it's considered good luck if he leaves a pile on the floor. Flags fly, bets are placed, jockeys are cheered on the street. You can feast at the many outdoor dinners held around town and develop your own loyalty to the Goose or Elephant or Porcupine neighborhoods. Siena always *looks* medieval; during the Palio you see the pageantry, passions, dress, and loyalties of medieval society come alive, too. The winning horse may have lost the jockey along the route. No matter. A song has been composed in advance and begins to blare when the race is over. If you don't like the crush of people,

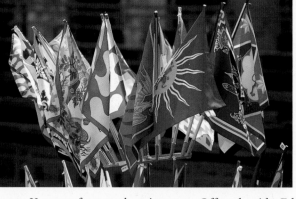

you can watch it on TV in a bar, then join the crowds afterward, when they spill into all the streets, singing and shouting, or weeping.

We happen on another Palio in the Siena province, at Montepulciano Stazione. A race course has been set up around a church in the fields. Double mattresses are tied to the corners, in case the riders should graze the edge of the building. Instead of the sleek and babied Siena horses, these crazy racers are donkeys who do not necessarily want to go. Boys ride them bareback, digging in their heels and shouting. Several get tossed over the heads of their donkeys when the beasts suddenly just stop. Off to the side, Ed misses winning a *prosciutto* by one centimeter. Someone else guessed exactly how far off the ground it hung. Free wine pours, a gift from nearby Vino Nobile vintners. Someone sells puppies from the back of a truck. Now and then, between races, a band in red-and-white uniforms marches out with majorettes twirling and high-stepping. We never figure out who wins but we have a big time. Soon everyone adjourns for dinner across the road.

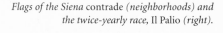

Flags of the Siena contrade *(neighborhoods) and the twice-yearly race,* Il Palio *(right).*

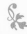

Palio dei Somari (donkey race), Montepulciano Stazione (top); Vino Nobile or everyone (above).

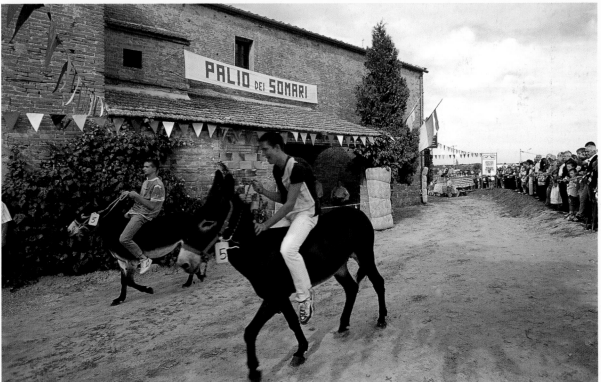

Between races, music and majorettes (top); an enthusiastic racer (above).

Besides all the festivals, every town has at least one *sagra,* a celebration of a particular food. I've seen posters and handmade signs pointing to a *sagra* for truffles, *porchetta* (wood-oven roasted pork), frog legs, cherries, tripe, chickpeas, potato, rabbit, goat, figs, pine nuts, cheese. I'd like to have gone to all of them, except the frog legs feast. Cortona has three, the Sagra della Lumaca, snail, in early summer, the Sagra della Bistecca on August 14 and 15, then the Sagra di Fungo Porcino in late August. The yearly town calendar lists eight more *sagre* in the environs. Just outside town, on the Feast of the Immaculate Conception, the parish church at Cegliolo holds the Sagra della Ciaccia Fritta. Ten women are in a shed, rolling rounds of dough they pass to men who toss them into a vast frying pan of bubbling olive oil. Eat them while they're hot— crisp rounds of fried bread with salt. The priest invites us to stay for the midday *pranzo* at his house. In Italy, they say to look for where the priests eat; they know food. We are about twenty-five at the table, ten priests, us, and those in charge of the poetry contest associated with the *sagra.* As the courses descend on us from a bevy of raucous volunteer women in the kitchen, the other guests begin to read aloud—with great drama—all the poems. The stipulation

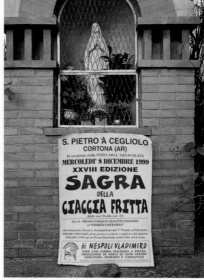

that the poems must be written in Val di Chiana dialect precludes us from understanding much. That's fine; we just eat, watching the priests enjoying themselves. After platters of *antipasto,* the women serve two pastas, followed by roast chicken, rabbit, duck, and veal. We keep pace with the priests, who stop to applaud each poem.

Feasting goes on all year. Even when there's no *sagra,* neighborhoods often have dinners for eighty to one hundred. Volunteers slave away and children help with the serving.

Around the *Ferragosto* holidays in August, everyone is entertaining and being entertained. "How many nights in a row do you eat out in August?" I ask Alessandra.

"Every night," she answers.

There is still so much Sunday in Tuscany. On Saturdays, everyone shops at the outdoor market, then visits several stores, picking up the fresh pasta and all the food for Sunday's *pranzo. "Buona domenica,"* you hear over and over, Good Sunday, a festival given to every week. An invitation to *pranzo* means a slowly paced dance of courses followed by coffee and visiting in the living room or under the grape arbor. By five, guests begin to leave because it's time for *passeggiata,* a stroll around town, a coffee or *aperitivo,* then home for a light supper.

Everyone's invited to the feast of fried bread (above); sagra *volunteers at San Pietro a Cegliolo preparing crisp, salty fried bread (right).*

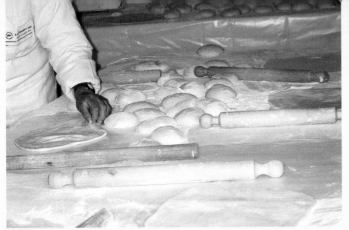
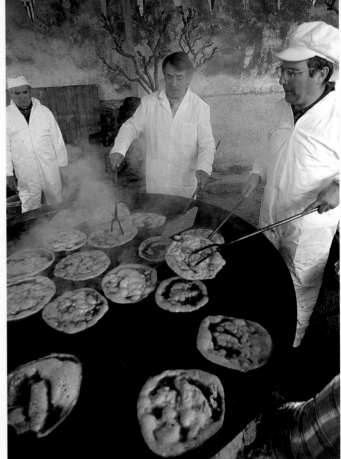
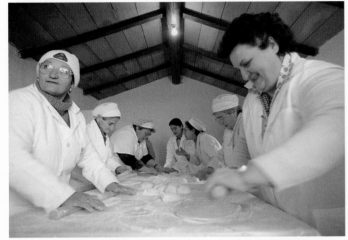

How did the Italians get to be the most hospitable people on earth? Every day is some saint's day. With such a complex history, every day is the anniversary of something that happened to someone, somewhere, and the event possibly retains just enough charge in the collective memory to cause the natives to reach into their closets for the Renaissance costumes and the trumpets. *We beat the bejesus out of Siena, back in 1401, let's celebrate.* Someone once served soup from a cauldron to pilgrims. Why not remember, make a minestrone and have a party in the *piazza?* Some celebrations probably reach back, back, back to the time of Cato and Varro, whose writings on agriculture describe the sacrifices the gods appreciate, and the necessity of paying respect to one's household god. All the oldest pagan festivals still crop up in various guises. In front of the very civilized cathedral in Pienza, a bonfire blazes on Christmas Eve. For days before, the pile of logs looks primitive, as though Savonarola might be burned at the stake. But those pre-Etruscans probably did the same thing around the winter solstice, the shortest day when we still feel the need for light, and still, people come out to warm their hands and greet their neighbors. Again the concept of time. Time brings forward the joys of feasting, thankfulness for the harvest, gratitude to the saints for saving us from sore throats and droughts, and also the recognition of miracles. Or maybe they just want, this time, to raise some money for the soccer team or for a kidney transplant for a ten-year-old girl.

In America, our holidays are so few. Often we take the wrong things too seriously. I now take seriously the shooting stars on San Lorenzo's special night, when we put two tables end-to-end and eat roast goose and zucchini fritters and peach tart, and songs will break out spontaneously, and someone will give sparklers to the children, and we'll take a walk out on the hill to see brilliant sprays of light long spent somewhere else. For too many years I did not have the pleasure of celebrating this patron saint of mine, San Lorenzo. Now August 10 is marked on my calendar.

∽

We're leaving the *piazza* and run into Caterina. "I'm going in your direction, let's walk together," she says. "I'm going to buy some *tortellini.*"

"For *tortellini in brodo?*" I ask. I always say *brodo,* broth, whenever possible; it sounds so fundamental to the world.

"*No, con salsa.*" She proceeds with her recipe for a light tomato sauce, and by the time we are at the door of the *pasta fresca* shop, we are invited to dinner. We hardly know her. I'm amazed.

We're a little late to another dinner with people we've broken bread with three times this week. We're greeted as though we have not seen each other in months. Again, I'm amazed. I always will be amazed.

Winter Sunday lunch with neighbors at Bramasole.

HOTEL
S.MICHELE

B
A
R

NATALE

We are invited to our nearest neighbors, the Cardinali family, Placido, Fiorella, and their daughter, Chiara, for their Christmas feast. Behind the table, set for twenty-five family members and the two *Americani*, the fireplace sizzles with roasting birds and meats. In age we range from one-year-old Teresa to the ninety-year-old matriarch of the clan. The feast begins with Placido at the head of the table welcoming the family and recounting some of the big events of the year. Applause and toasts. The *antipasti* arrive—platters of *crostini* ("little crusts" with various toppings), molded vegetable salad, and sliced veal with a tuna sauce. Then Fiorella's traditional *tortellini in brodo* slows us down, as we sip the delicious broth made from "an old hen" and break open the pasta lightly scented with nutmeg. Placido grills wild pigeon, chicken, and pheasant with chunks of bacon. Then he begins tossing steaks on the grill. Everyone keeps

Crostini Toscana

Insalata Russa

Vitello Tonnato

Tortellini in Brodo

Colombaccio, Pollo Arrosto, Fagiano

Bistecca alla Griglia

Spinaci, Sformato di Formaggio

Insalata Verde

Frutta Fresca e Formaggi

Panettone, Serpentone, Pan Forte, Torrone, Cantucci

getting up to give someone a present and exclamations and shrieks follow. The aunts help serve. After a pause and more gifts, we all attack the cheese platter and peel a tangerine or an orange. *Panettone,* a great tradition at Christmas, seems to be the dessert of choice—a cultural thing, this plain breadlike cake sometimes with candied fruit inside, sometimes glazed with white icing. *Serpentone* also is typical, a snake-shaped *torta* filled with almond paste and nuts. The flat, spiced medieval cake, *pan forte,* and *torreone,* a candy, and *cantucci,* very dense almond cookies, are more traditional in the Siena area, a full half hour away. Suddenly men light cigars and Placido pours homemade *grappa.* I try *liquori di anici,* a fennel-based liqueur sold in the Vatican pharmacy, and quickly have to drink a glass of water. After *pranzo* ends, we take photos in the garden, the goodbye kissing begins, then Ed and I fade away. *Buon Natale!*

Christmas lights in Cortona (left); bonfire on the winter solstice in Cortona (following pages 122–123).

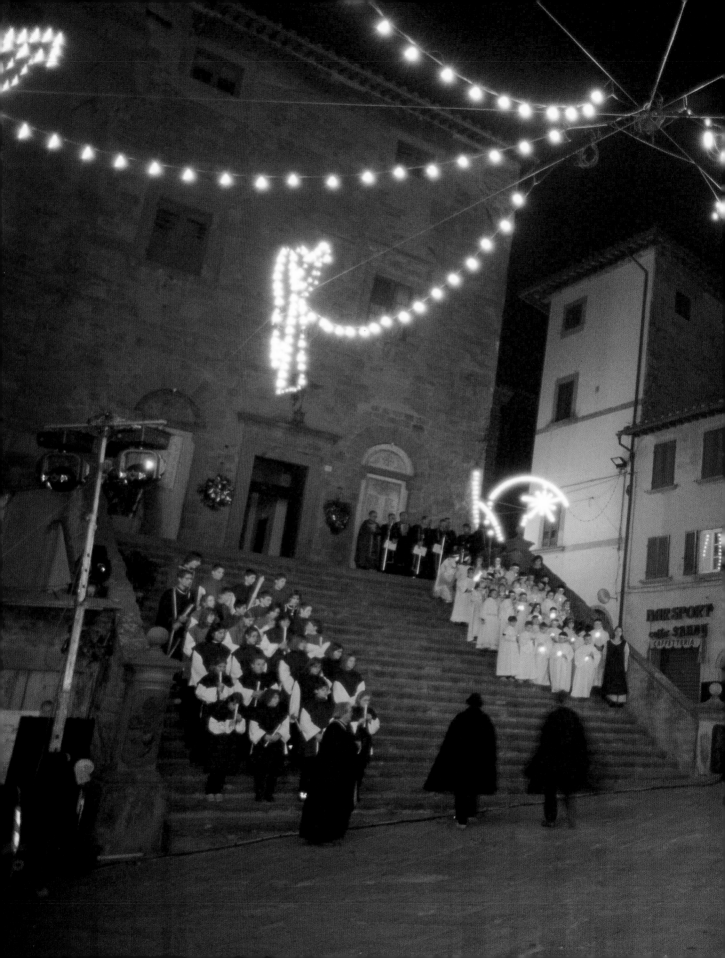

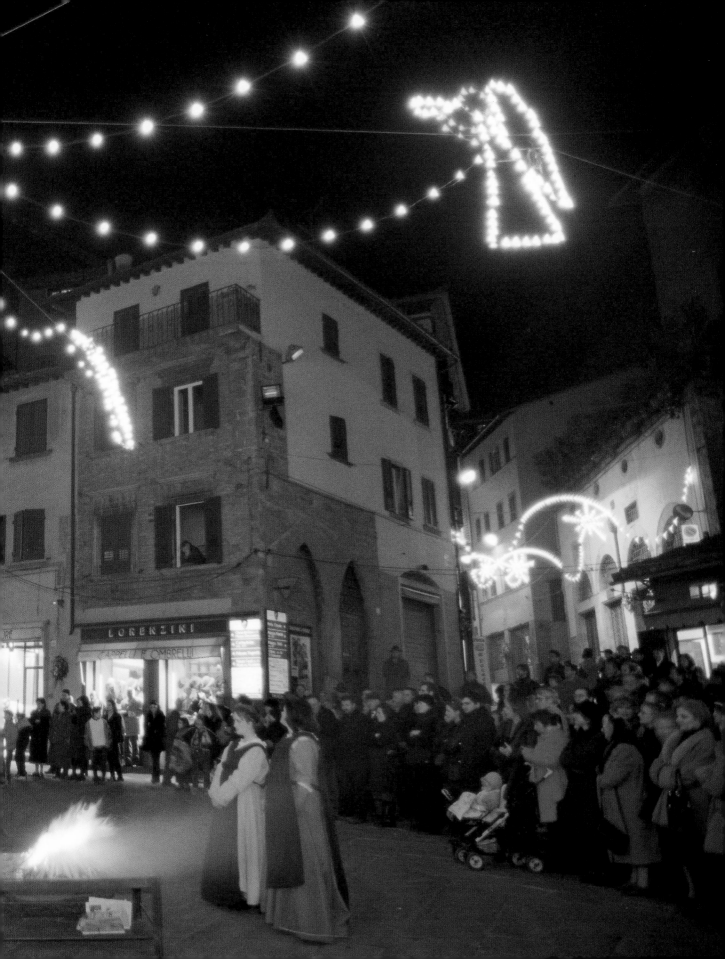

Ed's Crostini Neri
Chicken Liver on Little Crusts

Crostini neri, *black* crostini: *Chopped liver it ain't. This is the Tuscan recipe, the universal favorite, ubiquitous at every feast. I'm always astounded at how quickly the* crostini di fegatini *disappear, no matter how many platters are passed around. If you order mixed* crostini, *the* fegatini *will be accompanied by cheese, mushroom, fish, or vegetable* crostini, *but* fegatini *is the number one choice of Tuscans.*

These antipasti *are more than "little crusts"; they're the beginning of the ritual and fact of eating together. At any* trattoria, *they jump-start the meal, which then proceeds to* il primo, *the pasta, risotto, or soup course, then* il secondo, *the meat and vegetable course, then comes the sweet end to the elaborate sequence,* dolci.

We love the crostini caldi, *the warm ones, as well as the* crostini *topped with cheese, tomato, or a microscopic bit of black truffle. We pass these back and forth so many times that often we just want to ask for the check and leave, forgetting the big plateful of pasta to come, followed by roasted guinea hen or grilled sausage, with side dishes of whites beans and chard, then a round moon of panna cotta. We should just allow ourselves to say* basta, *enough, the word lingering in the air. Yet one's hand moves slowly to the plate that still holds a few* crostini neri.

Odori (see page 188)
2 tablespoons (30 milliliters) olive oil
2 to 3 anchovies, fresh or salt packed
1 pound (450 grams) chicken livers
Salt and pepper
½ cup (120 milliliters) red wine
2 tablespoons (30 milliliters) balsamic vinegar
1 tablespoon capers (15 milliliters), drained

Sauté the *odori* in the olive oil. After 5 minutes add the anchovies (if salted, wash under cold running water) and cook over low heat until they begin to dissolve. Meanwhile, wash and pat dry the chicken livers, season lightly, add them to the pan, browning them on all sides. Press with a wooden spoon from time to time so that they begin to fall apart. After 5 to 10 minutes add the wine and the vinegar. Continue cooking over low heat, uncovered, until most of the liquid has evaporated. In the last few minutes of cooking, add the capers. For a finer texture, chop the mixture briefly in the food processor, or chop by hand for a rougher texture. Serve either warm or at room temperature on small toasted rounds of bread. *Makes around 30.*

Silvia's Tagliatelle all'Anatra
Pasta with Duck Sauce

Riccardo and Silvia Baracchi are good friends who own the idyllic inn, Il Falconiere, outside Cortona. A falcon on a perch welcomes guests to this serene kingdom. My nephew married in the garden just outside the estate's eighteenth-century chapel, and the wedding dinner took place on the patio with arched bowers of red roses and a profile view of Cortona in the distance. Silvia and Riccardo respect Tuscan food traditions and the noble property, which once was owned by a poet and falconer. They have added their own refined and playful style. The romantic dining room at Il Falconiere centers on a tapestry of a woman with a falcon on her wrist, riding a horse. Metaphorically, Silvia is now the woman in the tapestry, leading the way through fantastic meals, with experimental flourishes solidly based on local ingredients. I'm flattered that they named their popular cooking school "Under the Tuscan Sun." In classes, they often prepare this recipe, more complicated than most Tuscan pasta preparations, but worth every moment. The taste is rich and concentrated.

One 3-pound (1½ kilograms) duck

Odori (see page 188)

4 tablespoons (60 milliliters) extra virgin olive oil

½ pound (230 grams) ground beef

2 Italian sausages

1½ cups (360 milliliters) dry white wine

1 tablespoon (15 milliliters) tomato paste

2 pounds (1 kilogram) fresh or canned tomatoes

A handful of parsley, chopped

2 pounds (900 grams) pasta (preferably *tagliatelle* or *pappardelle*)

½ cup (110 grams) grated *parmigiano*

Cut the duck into 4 to 6 pieces. Discard any fat and coarsely grind the breast meat in a food processor, or finely chop it.

In a large pan, sauté the *odori* gently in olive oil for 10 minutes. Add the remaining duck pieces, brown them on all sides, then add the duck breast, ground beef, and sausages. Raise the heat to medium-high and brown all the meat (this will take about 10 minutes).

Add the wine and cook rapidly until the liquid is reduced to a few tablespoons. Add the tomato paste. Chop the tomatoes (reserving the liquid, if canned) and add to the pan with the chopped parsley. Lower the heat to simmer and cook covered for 1 hour. Check occasionally to see if there's sufficient liquid in the pan; if not, add some of the reserved liquid from the canned tomatoes. (If you used fresh tomatoes, add some water or a splash of white wine.) After 1 hour, season the sauce to taste. Raise the heat and cook the sauce an additional 30 minutes to thicken it. When the sauce is ready, remove the duck pieces and set them aside.

While the sauce is cooling, remove the duck meat from the bones and discard them. Chop the meat coarsely and add it to the pan. Warm over medium heat.

When ready to serve, bring lightly salted water to a boil. Add the pasta and cook until it is *al dente*. Drain and turn the pasta into the simmering sauce, stirring to coat the pasta. Cook another 2 to 3 minutes. Turn into a warm serving bowl and serve immediately.

Pass the *parmigiano* in a bowl to be sprinkled over the pasta. *Serves 8–10.*

Silvia's Torta di Ricotta
Ricotta Tart

Silvia Baracchi

For the pastry:

4 ounces (110 grams) unsalted butter

¼ cup (60 milliliters) sugar

1 egg

1¾ cups (410 milliliters) unbleached flour

Pinch of salt

½ teaspoon (2.5 milliliters) ground cinnamon

For the filling:

2 cups (460 milliliters) whole milk

Zest of 1 lemon

4 eggs

⅔ cup (155 milliliters) sugar

Pinch of salt

1 tablespoon (15 milliliters) flour

1 pound (450 grams) ricotta, preferably from
 sheep or goat's milk, drained

1 teaspoon (5 milliliters) vanilla

To make the pastry, cream the butter and sugar in a bowl. Add the egg and beat until the mixture is light and fluffy. Add 1 cup of the flour, the salt, and cinnamon, stirring well to combine all the ingredients. Sift in the rest of the flour, kneading until the dough is easy to handle. Turn it on to a floured board and knead briefly. The dough will be very soft. Shape it into a round disk, cover with plastic wrap, and refrigerate for at least 1 hour or overnight.

Preheat the oven to 350°F (175°C). Roll out the dough to fit a 9- or 10-inch tart pan with sides about 2 inches high (a springform pan is ideal). Roll between two pieces of waxed paper—it's easier. Prick the bottom and sides of the dough with a fork and bake for 15 to 20 minutes.

Meanwhile, to make the filling, put the milk in a small pan with the lemon zest and heat just to the boiling point; do not let it boil. Set aside to cool slightly and steep while you beat the eggs. Combine 3 of the eggs with the sugar in a bowl and beat to a thick ribbon. Add a pinch of salt. Sprinkle the flour over and beat into the mixture. Slowly beat the hot milk into the egg mixture. When all the milk has been added, transfer the pastry cream to the upper half of a double boiler and cook over simmering water for 5 to 10 minutes, or until the cream is thicker than heavy cream but not so thick as sour cream. Remove from the heat and let cool to room temperature.

Push the ricotta through a *chinois* or food mill into the pastry cream and stir to mix well. Then stir in the remaining egg and the vanilla. Mix thoroughly. Pour the ricotta mixture into the prepared pastry shell and bake for 25 to 35 minutes, or until the cream is firmly set but not tough or rubbery.

You can add to this, if you wish: golden raisins, plumped in *grappa* or cognac; lightly toasted sliced almonds or pine nuts; a tablespoon of grated lemon or orange zest; some slivers of fine-quality citron.

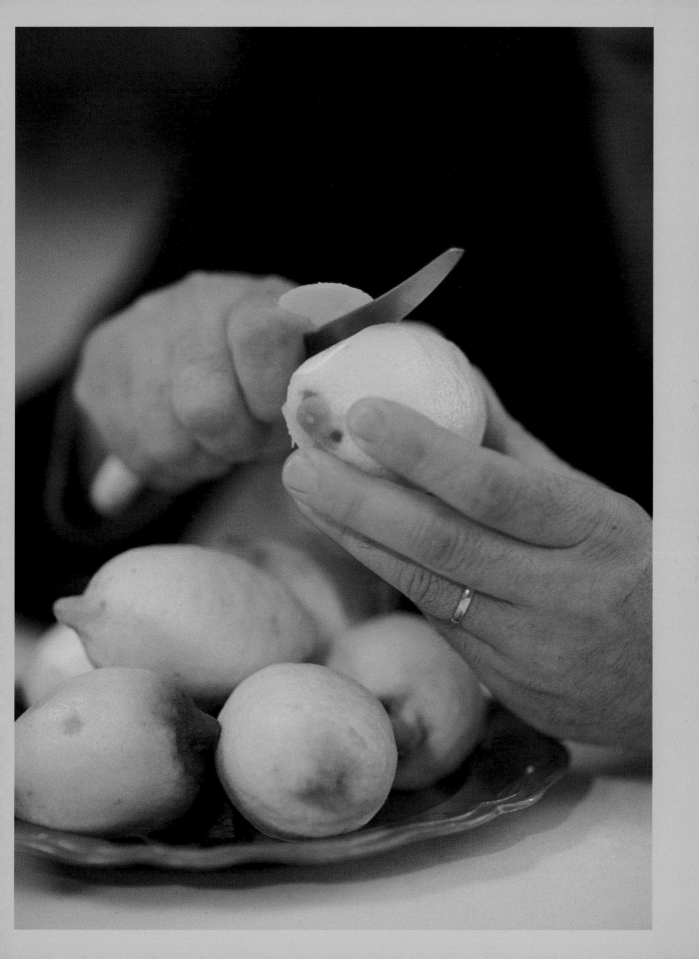

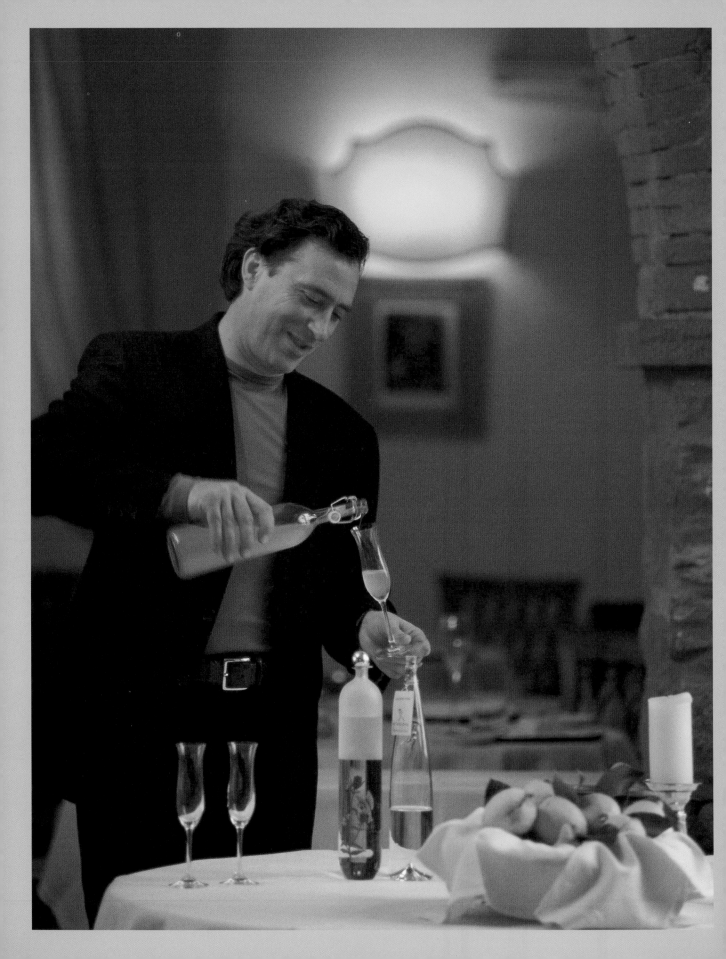

Riccardo's Limoncello

Lemon Liquer

Silvia and chef Michele Brogioni are the presiding geniuses of the kitchen but Riccardo has a few specialties of his own, especially during hunting season, when he invites friends for woodcock, quail, and pheasant. In hot weather, he often pours us a glass of his limoncello, which is like a glass of distilled early summer morning. Originally an import from the south of Italy, it's now at home all over the peninsula. In the realm of liqueurs, this is easy to make. When we made limoncello with Lucio, he added four lemon leaves to the alcohol and peel mixture, which deepens the color. Pour into pretty bottles and give to good friends.

8 organic lemons—Riccardo stresses that the lemons must be untreated

1 quart (950 milliliters) alcohol, 90%

14 ounces (410 milliliters) sugar

1 quart (950 milliliters) bottled still water

Peel the lemons, leaving a little white attached to the peel. Reserve the lemons for other uses. Put the peels in a large container together with the alcohol, close it well, and leave it in a cool place for at least 4 days, preferably a week. Gently shake a couple of times a day. The peels will lose their brilliant yellow color. On the fifth day or later, prepare a syrup of the sugar and hot water, making sure the water never quite boils. Stir and simmer 5 minutes, then after the sugar has dissolved, allow the syrup to cool. Strain the lemon-scented alcohol through gauze or a strainer, discard the lemon peels, and mix the alcohol into the syrup. Shake well before bottling. Let the *limoncello* sit for 2 or 3 days. Serve cold as an *aperitivo. Makes 2 quarts.*

Riccardo Baracchi pouring the first taste of his limoncello *(left); summer dinner at Il Falconiere with Cortona in background (following pages 130–131).*

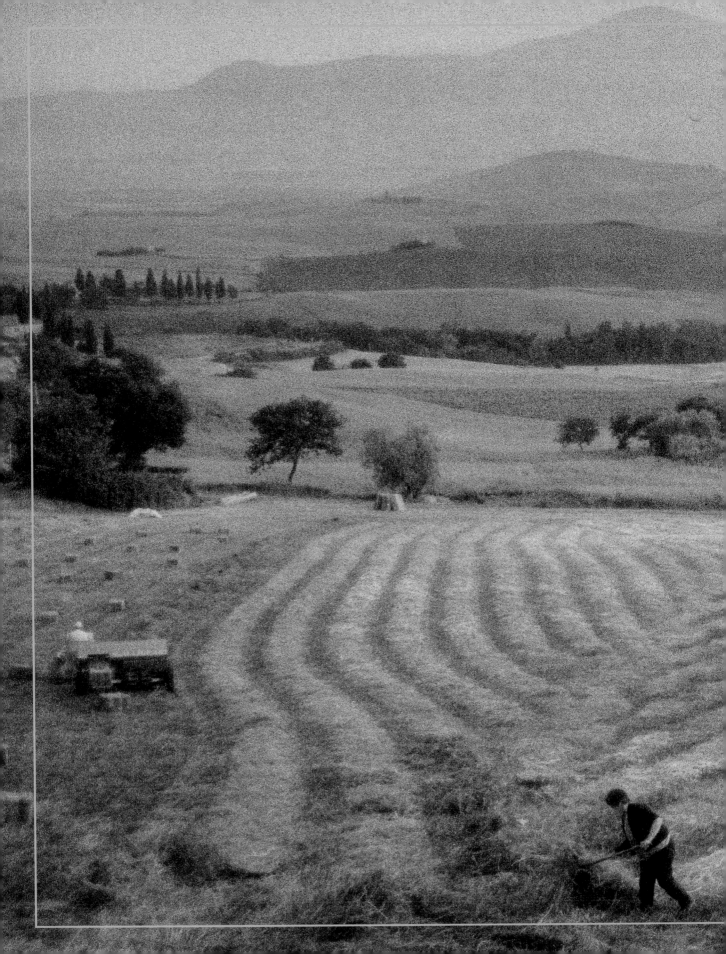

IL CAMPO

(Field)

. . . Tuscany is predominantly a man-made landscape.

Wild and mountainous patches survive, but most of the land

has been sculpted to the measure of humans.

Reading the landscape,

you find the story of how the people lived.

⁓❈⁓

IL CAMPO
(Field)

From Ed's field notebook:

When Giorgio picks me up at the Florence airport, he's surprised to see me exit the customs area alone.

"*Solo?*" he asks.

"Yes, Frances had to take care of some last-minute things in San Francisco, and I decided to come over early."

He raises his eyebrows but gives the nod of recognition when I say one simple word. "Olives." For Giorgio, that one word fully satisfies his quizzical look.

"Ah, *sì*," he says, walking to his car. "Yes, I was picking all morning with my father and mother. A very good year. Everyone is picking. A friend called City Hall to schedule an appointment with the mayor but was told to call back later, after dark. The mayor is also in his fields."

I notice his slightly green-tinted right hand, chapped and scraped, as he downshifts to pass a line of trucks on A-1, hurtling us toward Cortona. In a few days I'll adjust, but right now, with the needle scratching at 150 kilometers, I tighten my seat belt.

I drop my luggage in the hall, pull on winter work clothes, and go off to take on a small olive tree, adorning myself with a *cestello,* willow basket, strapped to my waist. I bend the pliable branches one by one.

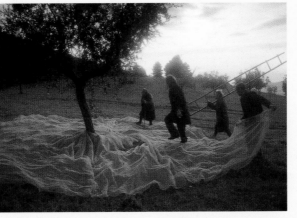

Waiting for light when Beppe, olive and grape *maestro,* will arrive to help me, I think of one fall after college when I picked apples in an orchard near Iowa City, where I was living. I arrived each day at dawn and picked until it was too dark to see the apples. I loved climbing up the ladder into a tree full of Jonathans, and in ten minutes I'd be down, tipping the canvas bag and gently letting the apples fall into a large crate. The owner of the orchard, who spoke English accented with his native Dutch, let his horses eat the fallen apples that were bruised. The round hard full cold feel of apples in early morning! Several times a day the owner's wife would bring out a tray of cookies and, what else, apple cider for the workers. Then we'd be back in the trees, canvas bags bulging.

After several weeks we had picked every tree clean. I brought in Robert Frost's poem "After Apple-Picking" and read it at the harvest party. I look back at that moment as a hidden clue; otherwise, I never would have expected to be in an olive tree in Tuscany.

It takes twenty-five times the effort to pick olives, I learned quickly. They're small. Some are nearly out of reach. What physical satisfaction in that dangerous stretch—reaching beyond one's grasp—to snap off that lone olive on the highest branch.

Harvesting hay outside Pienza (preceding pages 132–133); Ed and Beppe filling their baskets with olives (left); the ancient ritual of the olive harvest (above and following page).

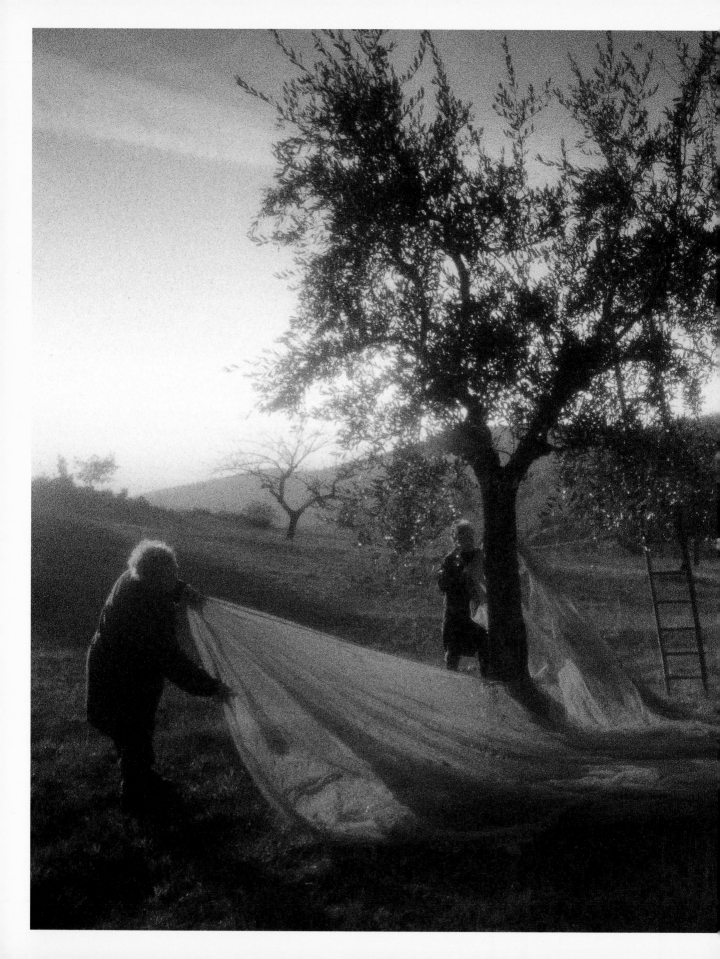

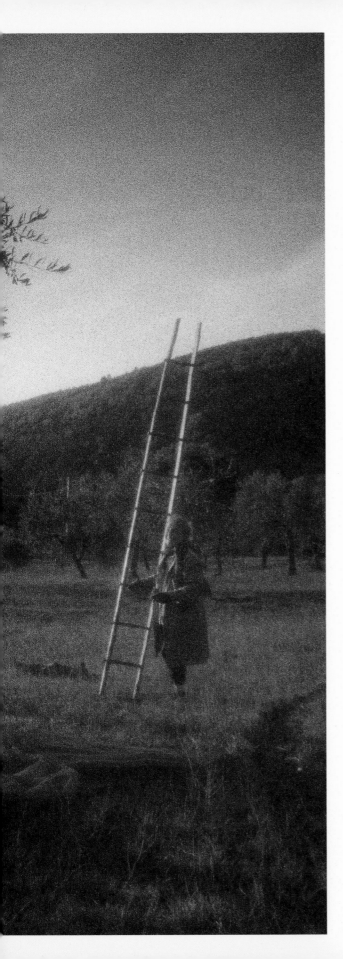

Beppe first wants to see my *fustini,* stainless steel canisters for oil. He peers in at the remainder of last year's oil. *"Morchia,"* he says as he looks inside. He's referring to the sludge in the bottom, a half inch of velvety, muddy-looking sludge. "Oh *professore,* you should have poured the oil off in spring after it settled," he tells me.

Always something new for the *professore* to learn, I think. "Is this stuff of any use?"

No waste for the farmers. They use everything. "You can put the *morchia* in a vat," Beppe tells me, "and soak hard *pecorino stagionato* [aged sheep's milk cheese] wrapped in walnut leaves to soften the cheese." Too bad I don't have any venerable *pecorino.*

We scrub out the *fustini* with vinegar, using a short broom expressly made for this purpose, then after a hot water rinse, we set it in the sun to dry.

For large trees, Beppe and I use ladders. If Frances were here, she would take the low branches. When she gets cold, she goes in and makes a pot of hot chocolate for us. While we pick we talk. Olives, like wine, lubricate speech.

"The weather is *bello*—this is the right moment," Beppe says.

He has a friend who makes the simplest ladders imaginable: a slender tree sawed in two lengthwise, with nine branches cut for rungs and drilled in. Long enough for most picking, it's light enough for carrying. Simply slip your arm between rung four and rung five and the ladder balances on your shoulder.

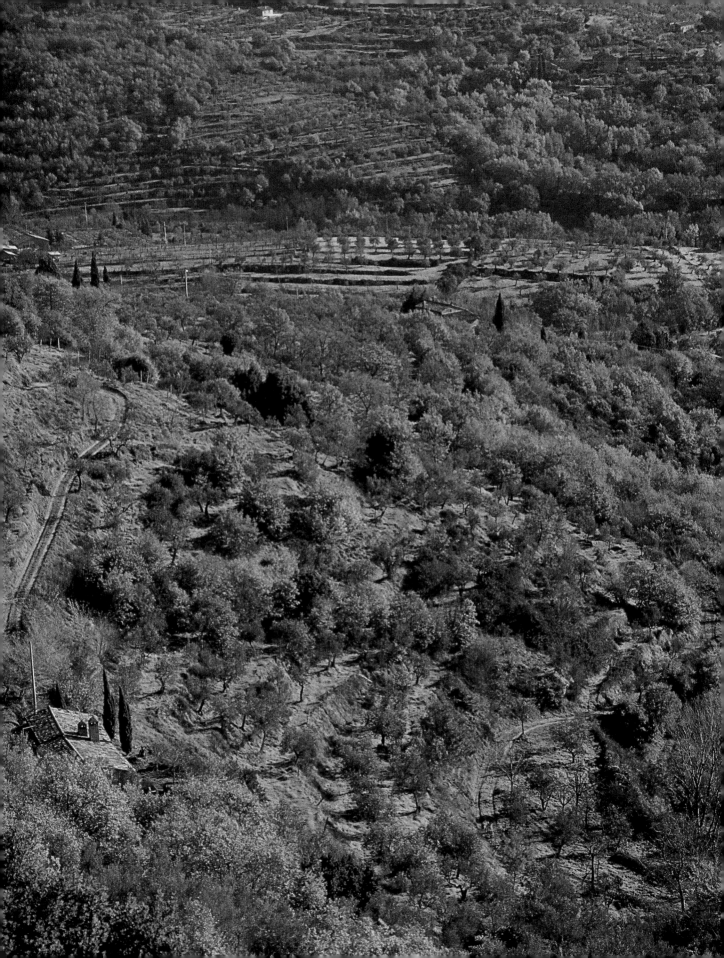

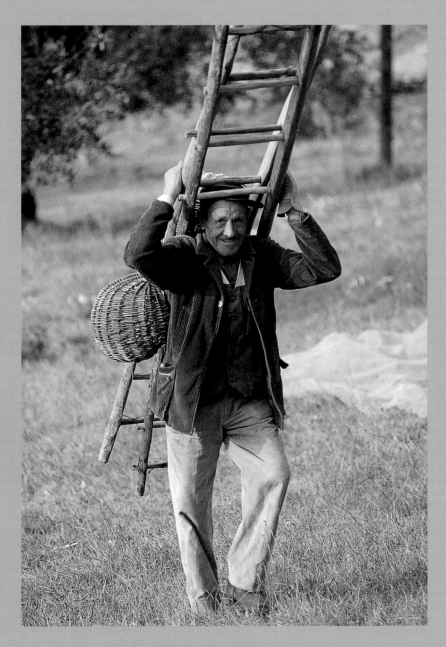

Olive terraces below Bramasole (left); Oreste carrying his handmade ladders and basket (above).

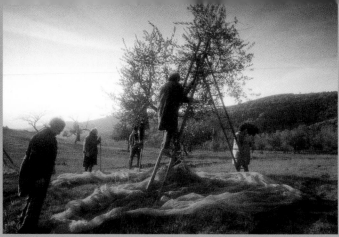

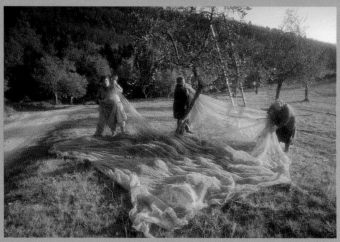
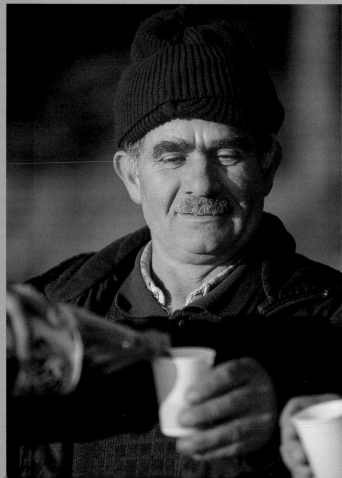
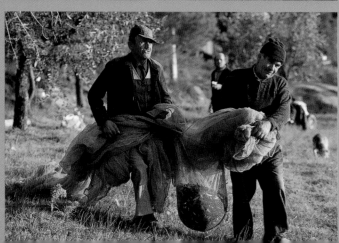

I thought that just *food* was governed by the seasons in Tuscany. Now I realize that *talk* is too. Each season has its own vocabulary. We talk "olive pruning" in March and September; "fear of olive trees freezing" from December through March; "organic fertilizer for olives" in February; "plowing the olive fields" at various times of the year. In California just mention a restaurant for a conversation icebreaker; here it's olives.

Now, in late fall, we get to the essentials: *oil*—the yield (how many *quintali,* 100 kilograms, of olives vs. how many liters of oil) and the virtues and vices of each *frantoio,* mill.

We use *la tela,* the net that's cut in such a way that it easily wraps around the base of an olive tree. From a distance, the wide net looks like water or a cloud. Now we're able to pull the olives off the trees with both hands and let them drop on the net. Beppe recalls Ugo, who two years ago fell off a ladder, hit his head on a stump, and died. We're careful; those are the hazards.

We fall into a working rhythm. I try to keep up but he picks faster. After we strip the tree we carefully gather up the net and drag it to the next tree. If the net starts getting too heavy, we scoop the olives into a woven sack, *un balo,* that breathes. With the two of us, work seems to go three or four times as fast; we can pick a hundred kilos a day. "We're like *pescatori,*" fishermen, he says, as we haul in the net.

I discovered at twenty-one a natural content from working in trees. There's a fatigue, but a good tiredness, thumbs and index fingers on both hands fill with new strength. "Strong hands to hold the fork well," Beppe points out.

And what pasta ever has tasted better after a full day among those olives that last year gave me the oil I now use for sautéing the *trito,* the mixture of onions, celery, parsley, and garlic, my solo sauce for pasta.

❧

I run into town to shop around five, as dark comes on. The tailor and I talk olives. He chalks off the hemline of my new black pants. "You have the great oil in your location," he says. "The higher the olives trees, the better the oil, and Bramasole is almost 2,000 feet above sea level." The maximum altitude for olives here is at 2,900—after that, chestnuts and pines.

"The olives in the valley are fatter and plumper—up at Bramasole ours suffer for beauty. They grow out of a mountainside, don't have the water supply that's in the valley. They have to witness frosts, stone walls falling."

Timeless moments of a olive harvest near Cortona (left);
terra-cotta olive oil jars at Avignonesi Vineyards (above).

"But," he says, "the oil has more life and it's easier to digest. You pick late, too, and that makes the oil richer."

I decide to eat in town. At the Osteria del Teatro, Ylenia gives me a small bottle of her father's oil from the nearby lower altitude of the Val di Chio. It's spicy and fruity—how can oil from a higher zone be any better? The next day Giorgio brings a bottle from the land he owns with his father, also on a lower slope. This oil, too, is full of body with plenty of bite. In restaurants and at friends' I hear over and over "*nuovo olio,*" new oil. It's all good.

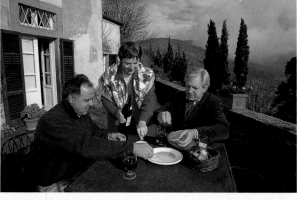

∽

When Frances arrives, we are almost through. We've saved one tree for her. As Beppe stretches for the top branches, one trunk of the tree slowly uproots, riding Beppe in slow motion to the ground. We replant, hoping it will take root again. We're through. We're late. We're off to the *frantoio.* We've picked the last olive in Cortona.

Our olives go to Landi, at Mezzavia, where pressing is done the old way: large round stones grind the olives and they use no heat in the process. In a corner of every mill, someone stokes a fireplace for *bruschetta,* grilled bread, the litmus test for the first taste of new oil. No one can wait until they drive home. They must know *right now* that theirs is the best oil in Tuscany.

We go to Landi because Beppe went to school with the proprietor. Beppe's friend, now retired, gently and wisely oversees his son who runs the family operation. During the season, a mill functions like a *piazza*—the men discuss yields, check out each other's health, catch up on family news. They fill the loading dock with wooden crates or red plastic baskets of olives. Olives in one door and oil out the other. There are few more satisfying moments than when bright green oil pours freely into my clean stainless steel cans. Beppe and I each walk out carrying a can, thirty heavy liters of oil sloshing its *extravergine*-self inside each one.

At dinner, Frances brings out a plate of *bruschette.* She's learned, like the local people, to douse the bread, not trickle it lightly. I have to consider that the state of being happy consists of something very simple: your hand parts silver leaves to reach a clump of shiny black olives, your thumb and index finger pull an olive and snap it off the branch, letting it fall just as fast as Galileo said it would. "Hitch your wagon to a star," Ralph Waldo Emerson advised. That star is an olive.

Sharing the first taste of Giorgio Zappini's olive oil at Bramasole (above); fruity new oil is green and murky (right); olive terraces near Trequanda (following pages 146–147); Ed's work shoes (following page 148).

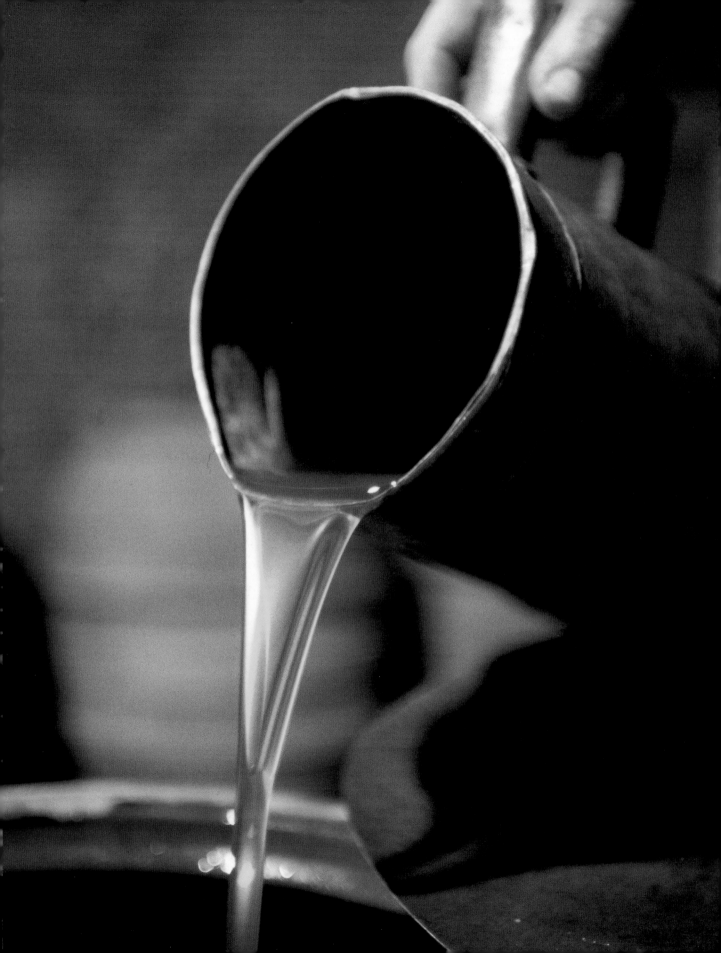

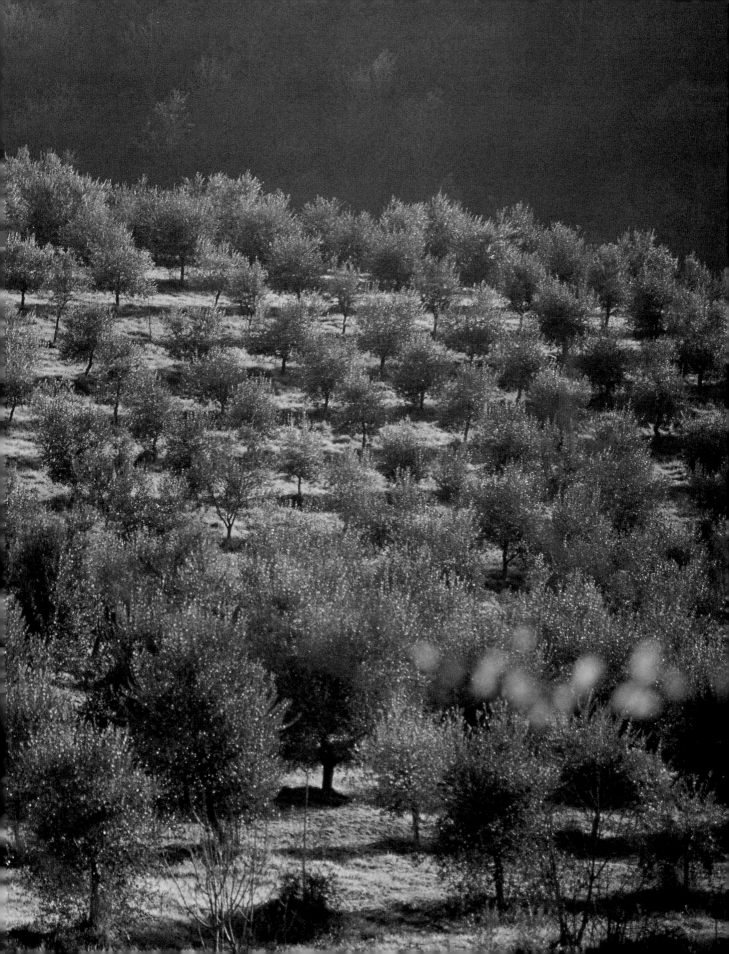

The Bramasole regime: wake at dawn, pull on boots, then while shaking off sleep, deadhead the roses, water pots, and survey the *orto,* the vegetable garden. Before launching into field work, I visit the asparagus patch, touch leaves for the thrilling scent of tomato plants on my fingers. The *finocchio,* fennel, that Frances planted in September is ready, two rows of one-hundred-watt lightbulbs heating the soil around them. The *pullezzi,* rape (greens from a variety of turnip), is bushy and strong, some of it sending small yellow flowers into the early morning air. A shame that the word *vegetable* has connotations of dull, inactive, passive, since its real meaning is "to enliven, to make lively." Even in early winter we're able to say, Well, what shall we pick tonight for dinner? I dig two kilos of potatoes for *gnocchi di patate,* clip some thyme, celery, parsley, cut off some of the lower leaves of the *cavolo nero,* black cabbage, for the *bruschetta—basta,* enough! In the pantry, braids of garlic and onions hang on a nail, also dried red-hot peppers and herbs.

Break the tour for an espresso—black, with a handful of cherries or a few figs. Next, with the machete cut down the dozen locust shoots on the *orto* terrace, bundle them, and carry to the brush pile. Walk the terrace Giorgio just plowed and pick up all stones larger than a pinecone (pick up pinecones, too). I feel a shiver of pleasure—and daydream that it's a genetic flash from one of my Polish ancestors who worked the fields near Gdansk. *Good boy,* he says.

Giorgio and I have been talking tractors, one with a powerful engine to pull the *fresa* (a rotary plow that levels furrowed fields) more easily. He's a skilled driver, maneuvering his small tractor around the bends and trees, edging too near for my comfort the soft edges of the terraces. We measured the broad low terrace and he calculates we could put in around 300 grapevines. This is a large vision I feel myself moving into.

I have decided to go in with him on the purchase of a new tractor. So, we've finally come down to buying a tractor! Immediately I wonder—will we kick the tires and talk about horsepower? Does it come with an instruction manual? I've seen Lamborghini tractors in fields and wondered if they made them in red, if you test-drive them on the *autostrada* and take on a Ferrari. Could they plow our olive fields in one tenth the time?

But Giorgio shakes his finger. He's always had Pasqualis—reliable service in Camucia. You don't need a pit stop crew on the hillside to change the oil. The plowshare slices through earth and curls of earth foam away, making furrows. I'm the rock hauler. Giorgio will turn up a boulder the size of Rhode Island and I'm left to drag it off to the side. Later we stack it in the growing pile for building and rebuilding walls.

Spuntino, snack. Bread with jam. Strawberries. A few slices of salami. Time to take out the *decespuliatore,* the handheld weed cutter, fill up the tank with *miscela,* a mixture of gas and oil. I try not to sprain my shoulder jerking the rope that makes it start. Beppe starts it with one pull and it's good he can't hear me curse. I clear the highest terraces, where only the snakes live. They'll be back. Two overgrown cherry trees need cleaning; ivy has begun to strangle them. I hate ivy, even those topiary balls Frances sometimes buys for our house in San Francisco. I let what I cut fall to the ground until tomorrow, when I'll pitchfork it, a big balloon of weeds hoisted over my head.

Pranzo. I can smell the *ragù* as I hand-pump water over my legs still stinging from nettles. After lunch, before the sun starts rolling its great wheel toward the west, there's rest. I read *Quattroruote,* Four Wheels, a few poems of Martial, then doze in a lounge chair on the upstairs terrace.

At three, I chainsaw the twenty bottom branches that Beppe and his brother-in-law, Armando, cut from the pine and spruce last week and stack the wood. More brush for the pile. I clip off suckers from the olive trees, a job like painting the Golden Gate Bridge. When you're finished, time to start again.

Beppe arrives with eight bottles of red wine, our first wine! Our vines were neglected for thirty years, but pruning and my speaking poems to them have coaxed them to produce. Before we left in September we saw the sexy bunches ripening. Beppe added our grapes to his and now has brought us our share, or probably more. He always leaves his wine in the barrel until the waning moon and a clear night sky allow him to fill his demijohns, as well as our line of water bottles. *"Buono,"* he pronounces it. Good. And it is. We're not going to be selling Vino Nobile futures, I suspect, but I'm spurred toward the idea of planting the lower terraces with vines.

Why not? Italy has over 1.1 million vineyards, most of which are on three or four acres. I'd like to get to at least 100,000 of them. Everyone with a little plot will plant a few rows, just enough wine for the family's *feste. Viti,* vines, but so close to *vita,* and yes, the growing and tending of a vineyard is as old as life on these hillsides.

This could be quitting time. There are letters of recommendation to write, course proposals to consider, research for a new course, all the ghostly reverberations from my other life seven thousand miles and quantum leaps from here. Here—where I live near the heart of my poetry, where I learned the art and act of turning.

From writing poetry, I knew *turn* as a concept. The etymology of *verse* is "to turn." The line turns at its end and I now know how an ox or a tractor plowing is the physical notion of writing, my hand being pulled by some spiritual ox, or my hand an ox, pulling the pen along the marked furrows of a page. The field is the best book I've ever read.

Over dinner, we scheme with Placido, who owns the land on the other side of ours. When his father worked the land as a vineyard, he produced excellent *vino da tavola* from the *sangiovese* grapes that now are the hit of the wine world. "Let's replant it," he says, tasting the wine Beppe made from our grapes. I inhale spring violets, their perfume and color at once. Maybe a whiff of the climbing rose called Eden. Never mind that 95 percent of the grapes came from Beppe's side of the hill, they travelled well, and we taste exciting possibility in the dark fruity wine.

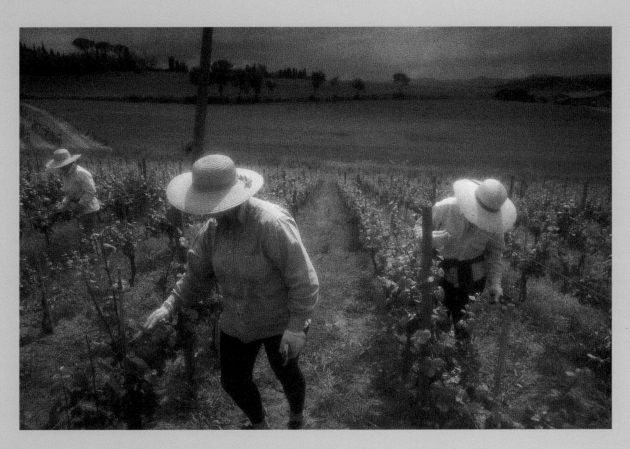

Good signs to look for in the countryside—direct sale of wine and oil (left); vineyard workers
at Trerose Vineyards, between Cortona and Montepulciano (above); Nello decants his sfuso *(loose wine)*
(following pages 152–153); late summer light near Cortona (following pages 154–155).

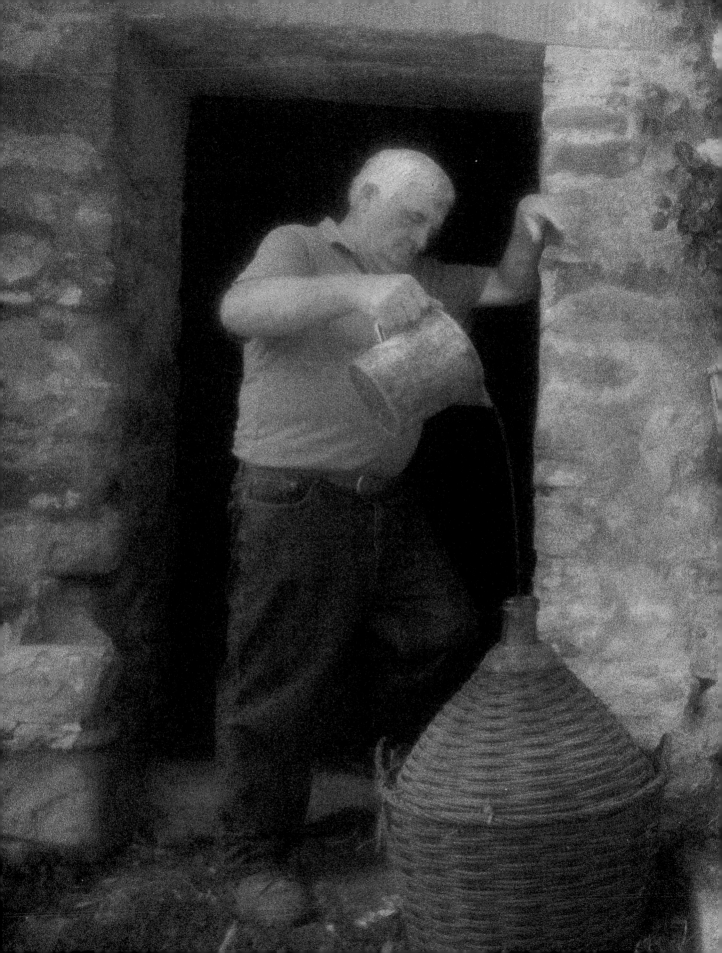

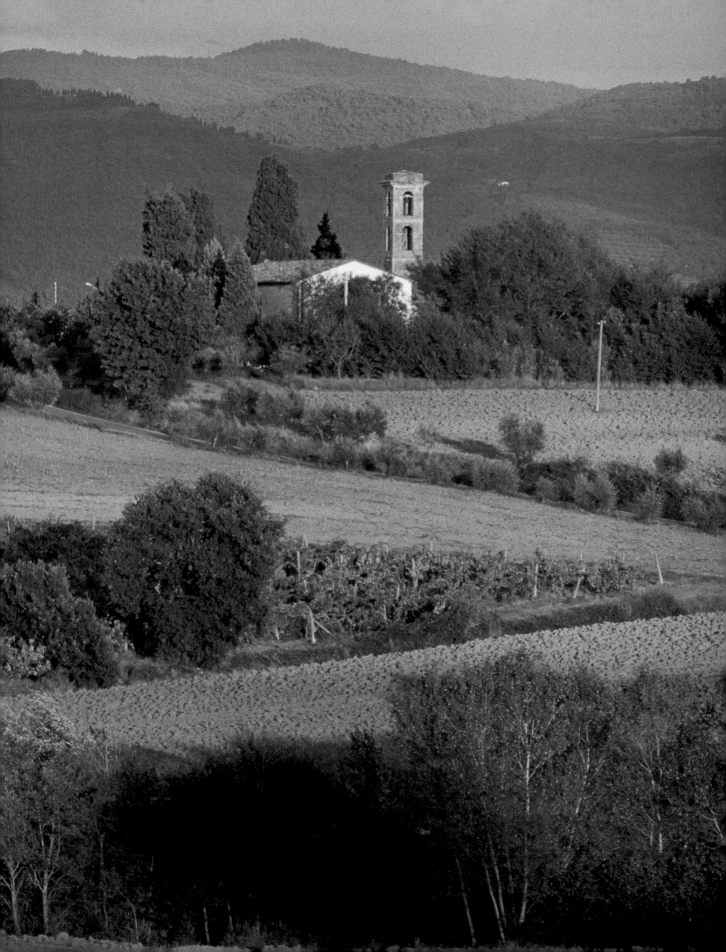

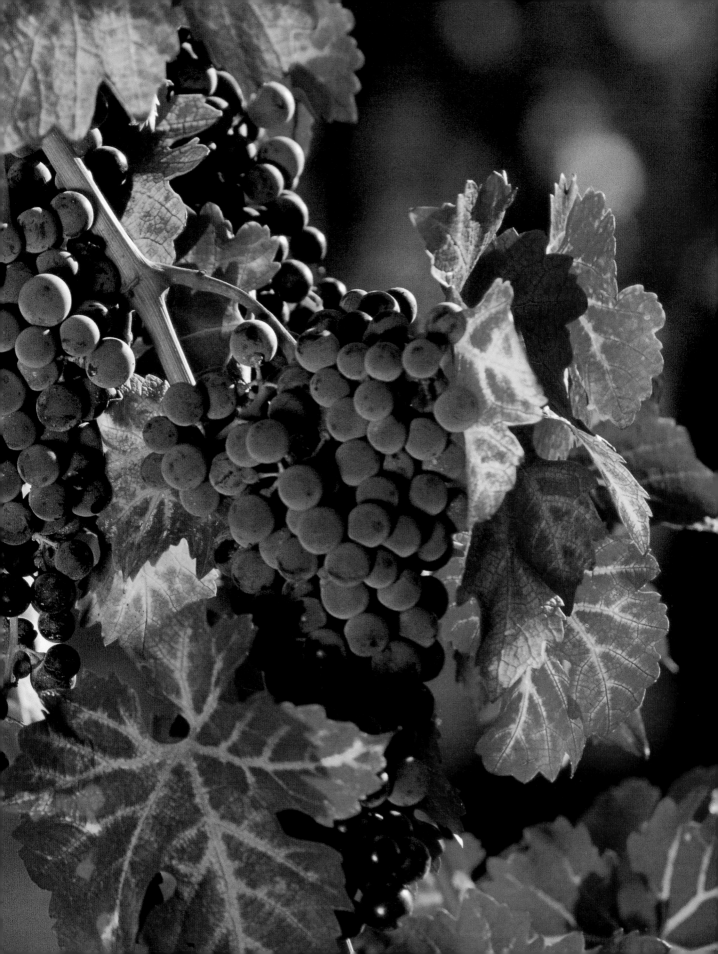

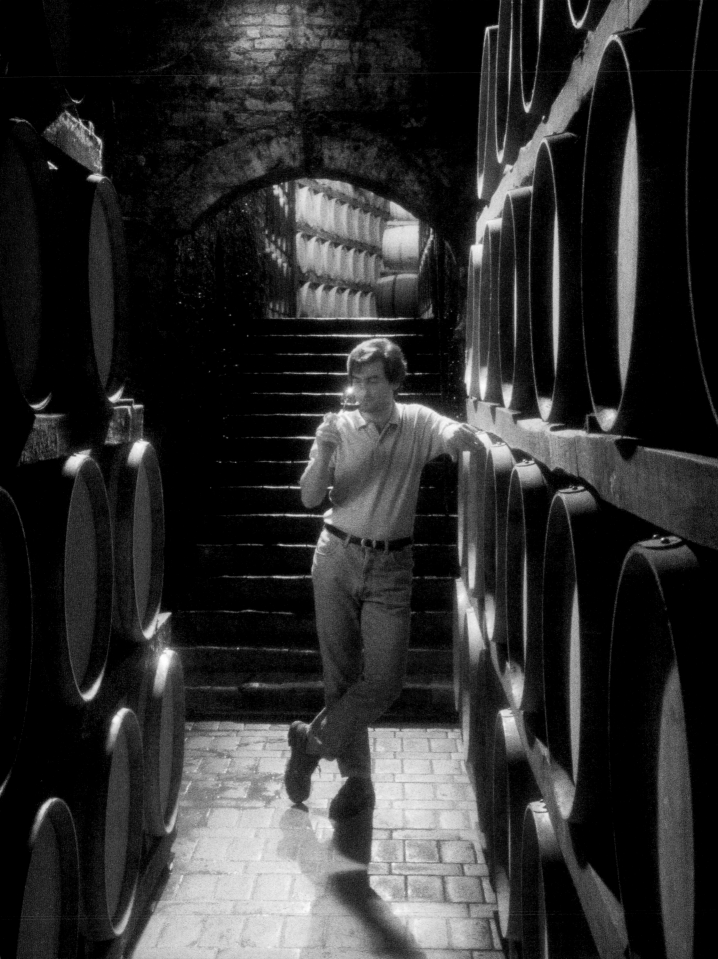

*Paolo Trappolini, winemaker at Avignonesi Vineyards (left); grapes drying
for* vin santo *at Avignonesi Vineyards (above).*

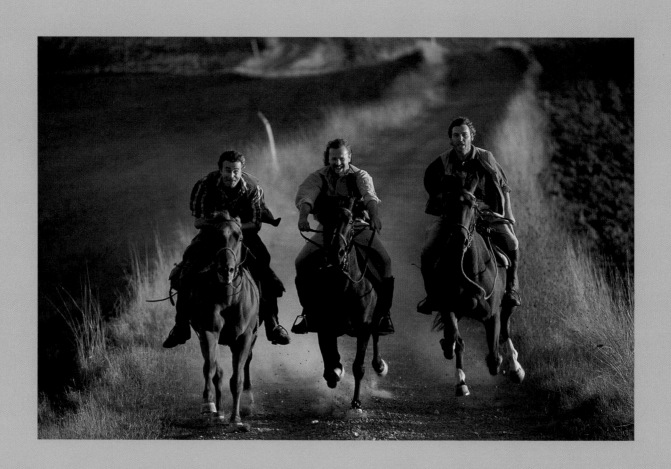

PORCINI
(Little Pigs)

After the languid and torrid dog days of summer, rains revive the scorched hills with new grasses. Ed and I usually spend our autumns in San Francisco, whose fall season *does* occur, but with subtle markers. Here, thrilling changes are unfolding every day. The *vendemmia,* the wine harvest, is coming and, later, the olive oil season—both primal rituals occasion many feasts. The evening light over the valley is turning from the delicate lemony tints of summer to a diffused, opulent gold.

On a walk, I see twelve men in head-to-toe camouflage, gathered at the crossroads, smoking, leaning on their cars, rubbing the barrels of guns. Anna, who owns the *bar caffè,* is hanging her wash. "Oh, that's the neighborhood *squadra* [literally, squadron—a hunting club]," she tells me. "They are mad for the wild boar. They will bring home perhaps forty this season. Plenty of *ragù,* this winter, *signora,* and also *salsicce di cinghiale.*" Boar sausages—just the thought makes my cholesterol level jump, but I love the *ragù* made from these tusked and wiry creatures. The depth of flavor definitely sends warmth to chilled bones.

At the market, Fabrizio unloads baskets of fresh chestnuts, some polished to a shine, some still in their spiny husks. Ed is a chestnut fiend. He even loves the blackened honey from bees who feed on chestnut flowers. It's ugsome to me, but he spreads it on bread and frowns as he tastes it. "Primitive," he says, closing his eyes. He's probably thinking of dark combs at the heart of the hive. After dinner, he slits the skin of a dozen chestnuts and roasts them in the fireplace, to enjoy with his late-night *digestivo,* a little glass of bitter, bitter Averna.

We're longing to go mushroom hunting and have bought a mycological guide with many skulls in the margins, signifying instant death. Innocent-looking *funghi* can land you in the hospital, even if they're not lethal. And some have a protein that, unless thoroughly cooked, makes you wish you'd not had that delicious slivered salad of mushrooms and *parmigiano* drizzled with fine oil. One, which looks evil and is named "trumpet of death," is much appreciated.

When we take tiny mushrooms we find on our land over to Placido for identification, he says they're "dry legs," safe, if not too exciting. He knows the land, knows every fruit, nut, vine, lettuce, creature, tree. He invites us to come with him after the next rain, to go in search of the famous *porcini.*

∽

On a paradigm fall day, we drive with Placido and Lucio far into the mountains. These two friends have hunted birds and mushrooms together since they were boys. They are prepared. Caps with flaps, woods-colored sweaters, bright scarves, wool pants tucked into high boots. Their capacious osier baskets have straps lined with sheep wool to ease the strain on the shoulder.

Hunters near Buonconvento.

We are in jeans and suddenly insubstantial-looking jackets. We carry baskets we usually use for passing bread at the table. We've brought water and a few of the parrot-green tangerines from Sicily to eat during the afternoon. They laugh and open their baskets. They have small curved knives for cutting low on the stalk of the mushroom. They have hearty sandwiches of mortadella, some pears, and winy russet apples.

We turn down white roads, lurch over rocks and streams, and pull up to a grand farmhouse and granary, now collapsing into ruin. Ed and I can't resist a quick tour of the deserted buildings, then the four of us set off downhill, crossing a stream by stepping on logs and rocks. We enter a thickly wooded area of steep hills. We're directed to look under chestnut trees and to keep moving to the north. Which way is north in this forest, I don't know. Ed and I stay close. Almost immediately, I find a perfect *porcino!* Soon we see mushrooms everywhere. We pick a few of each kind. We're tramping up and down, sliding and fording the stream over and over. When we encounter Placido or Lucio, they quietly show us their baskets heaped with *porcini;* they haven't bothered with anything else. Ed has collected five small ones. After my lucky first strike, I haven't seen any more. We come across the men taking a break; they look astonishingly at home in the woods. "How do you see what we don't see?" I ask. They just smile.

We hike to another part of the forest. How long, I wonder, will we hunt? In the fifth hour, I'm beginning to think of the uphill march to the car. My new boot hurts my right foot. When I pull it off, I see a broken blister. I press four leaves into it as a shield against the rubbing leather. Fortunately, the forest floor, thick with the leaf mold of an entire millennium, feels springy. Then I find two medium-sized *porcini* at once and am spurred to continue. We cross a meadow and discover the remains of a mill beside the stream. In the aurous afternoon light, we sit down and Placido and Lucio look through our treasure trove, tossing out the bad and the deadly, replacing them with prime *porcini* from their own baskets. They dip tin cups into the stream, which looks like bourbon, and drink; we (the cautious Americans) take out our bottled water.

On the way home, Placido invites us to a *porcini* feast at his house the next night. A few friends—we know that means about fifteen—for *crostini,* rounds of bread with sautéed mushrooms, grilled *porcini, risotto* with *porcini,* pounded veal also with this sacred mushroom, and a pasta, too. We will bring wine, a huge pear and mascarpone tart. As we weave along the curvy road, I'm already tasting everything, the tumblers of wine, course after course served on huge platters, the lively faces around the table, the feel of the fire at my back, the rise of laughter, autumn, fall of the year, the turn of slow days in an ancient place.

Fiorella's Ragù di Funghi Porcini

Porcini Mushroom Sauce

Placido comes home with baskets of porcini and several other kinds of mushrooms all fall. Feasts ensue but still there are plenty of mushrooms to spread on flat baskets and dry in the autumn sun. For the ragù, Fiorella naturally would use her own preserved tomatoes; I suggest fresh, canned San Marzano, or boxed Italian tomatoes as a substitute.

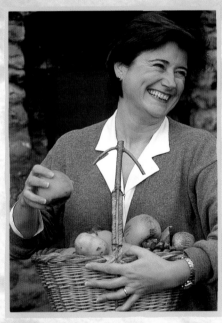

Fiorella Cardinali

Odori (see page 188)

2 tablespoons (30 milliliters) olive oil

2 Italian sausages

¾ pound (340 grams) ground veal

2 chicken livers, cut in pieces

Salt

Pinch of red pepper

2 cloves garlic, minced

1 cup (240 milliliters) red wine

1 ounce (30 grams) dried mushrooms

1 tablespoon (15 milliliters) tomato paste

6 to 7 fresh chopped tomatoes, or one 28-ounce (800-gram) can of tomatoes

Sauté the *odori* in the oil and add the sausage, veal, liver, salt, red pepper, and garlic. Sauté until brown, stirring often. When the mixture begins to stick to the pan, add the red wine and stir until it evaporates. Meanwhile, put the dried mushrooms in hot water for 10 minutes. Remove them from the water and add them to the meat, stirring well. Add the tomato paste and the tomatoes. When the sauce has come to a boil, add the water from the dried mushrooms, well filtered. Simmer slowly for about 40 minutes. Serve with *tagliatelle* or *fettuccine*. Serves 4–6.

Fiorella's Sugo di Porcini Freschi in Bianco

Mushroom White Sauce

1 clove garlic, minced

3 tablespoons (45 milliliters) olive oil

4 fresh *porcini* mushrooms, cut in pieces

1 sprig of mint or some parsley

Salt

1 cup (240 milliliters) milk or cream

Tagliolini or other egg pasta

Sauté the garlic in the oil in a pan. Add the mushroom stems, cook them for 3 to 4 minutes, then add the caps. After some minutes add the mint or parsley and some salt, then the milk. Simmer for 5 minutes to form a liquid sauce.

Drain the *tagliolini* a moment before it's *al dente* and add it to the sauce with mint leaves. Quickly heat and serve. *Serves 4–5.*

A Fall Salad

Porcini are esculent when raw but I prefer a brief sauté. Sliver *porcini* (or portobello) mushrooms and *very* briefly sauté them. Arrange over field lettuces, including arugula. Add slivers of *parmigiano* and toasted pine nuts. Dress with a hint of vinegar and your best olive oil, salt, and pepper.

Baked Fennel, Onions, and Celery

A simple vegetable stew can be made in minutes. Cut 3 fennel bulbs, 3 yellow onions, and 4 stalks celery in similar-size pieces, toss liberally with olive oil, and season with salt, pepper, and dried fennel seeds or flowers. Pour a spoon or so of oil on the bottom of a roasting pan, cover, and bake for 40 minutes at 325°F (165°C). *Serves 6.*

Fennel and Orange Salad

Slice 2 or 3 fennel bulbs and put them in a bowl with three peeled, seeded, and sectioned oranges. Thinly slice a sweet onion, separate the rings, and add them to the bowl. Add a handful of thyme leaves stripped from the stems. Make a vinaigrette of 5 tablespoons (75 milliliters) olive oil and 1 to 2 tablespoons (15 to 30 milliliters) balsamic vinegar, season with salt and pepper, and toss with the fennel and orange mixture. *Serves 4–6.*

Chiara's Marmellata di More

Blackberry Jam

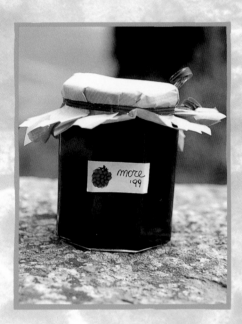

Chiara is a university student in Perugia, studying literature and writing a thesis on Cortonese surnames. She's a sunny Tuscan beauty with a deep feeling for the land and the culture. We first met her while she was gathering wild asparagus. As Fiorella and Placido's daughter, she has been a natural gourmet all her life. We picked blackberries one afternoon—she was twice as fast—and later she brought over a jar of her jam.

With this jam, Chiara also makes a crostata, which especially delights Ed because he likes it for breakfast. The simple crostata summarizes the Tuscan approach to desserts. Make any short crust, spread a layer of good jam, and, if you like, a layer of fresh berries. Bake it until it's crumbly but not dry. Chiara's parents entertain constantly, so she often makes two or three crostate: mirtillo (blueberries), blackberry, strawberry, or apricot, each laced with her homemade preserves. The filling depends totally on the quality of the fresh-picked fruit and the jam.

2 pounds (900 grams) fresh blackberries
1 pound (450 grams) sugar

After washing the blackberries, put them in a pot and boil them slowly until they become soft. A little at a time, put them through a food mill with a fine blade so that the seeds can't pass through and you obtain a smooth cream. Put them back on the stove, add the sugar, and simmer slowly for at least 45 minutes. Put the marmalade in 6 pint-size sterilized jars. Seal with melted paraffin and screw on the lids. Eat within 6 months. Or close the lids and place the jars in a pan of barely boiling water for 15 minutes. Like this the marmalade will last 2 years.

Vittoria's Cinghiale in Umido
Wild Boar Stew

Giorgio's squadra, *hunting club, brings down thirty to forty boar a season, one per person. We come home to find a sack of boar meat hanging on the kitchen doorknob. This is how Giorgio's wife, Vittoria, prepares it. Easily available through the Internet, boar in the U.S. often is not strictly wild, but is raised free-range and the meat tastes milder. Real wild boar is available in some states.*

For the marinade:

Odori (page 188), including 3 gloves garlic

Pinch of coarse salt

2 sprigs of rosemary

3 bay leaves

1 cup (240 milliliters) white wine vinegar*

Water to cover

2 to 3 pounds (900 grams to 1.35 kilograms) wild boar

Olive oil, as needed

Salt and pepper, to taste

1 cup (240 milliliters) white wine

2 tablespoons (30 milliliters) tomato paste

One 28-ounce (800-gram) can puréed tomatoes

Red pepper (*peperoncino*)

Beef or vegetable broth, as needed

Cut the boar into 3 x 3-inch pieces, put in a bowl, and cover with the marinade. Let the meat rest in the fridge for at least 12 hours and up to 3 days, then drain it in a colander for about an hour. In a frying pan, sauté the garlic from the marinade in olive oil and add the boar, stirring so that any water remaining in the boar evaporated. In another pan, heat olive oil, add the *odori*, and sauté. Add the boar to this pan. Add salt and pepper. After browning for a few minutes, add the wine and let it evaporate. Add the tomato paste, tomato purée, and a pinch of red pepper. In the meantime, prepare a little broth and add it to the boar. Cook the boar covered on a low flame or in the oven at 300°F (150°C) for two hours. *Serves 4–6.*

*If the boar is not wild, I'd use red or white wine instead of vinegar in the marinade.

Placido's hunting gear.

LA CUCINA

(Kitchen)

The word "focus" comes from the Latin for fireplace.

In Italian, it's "focolare"—

the center of the home where we cook and eat and talk,

all of which gives focus, a clarity to life.

Without our food we fall apart.

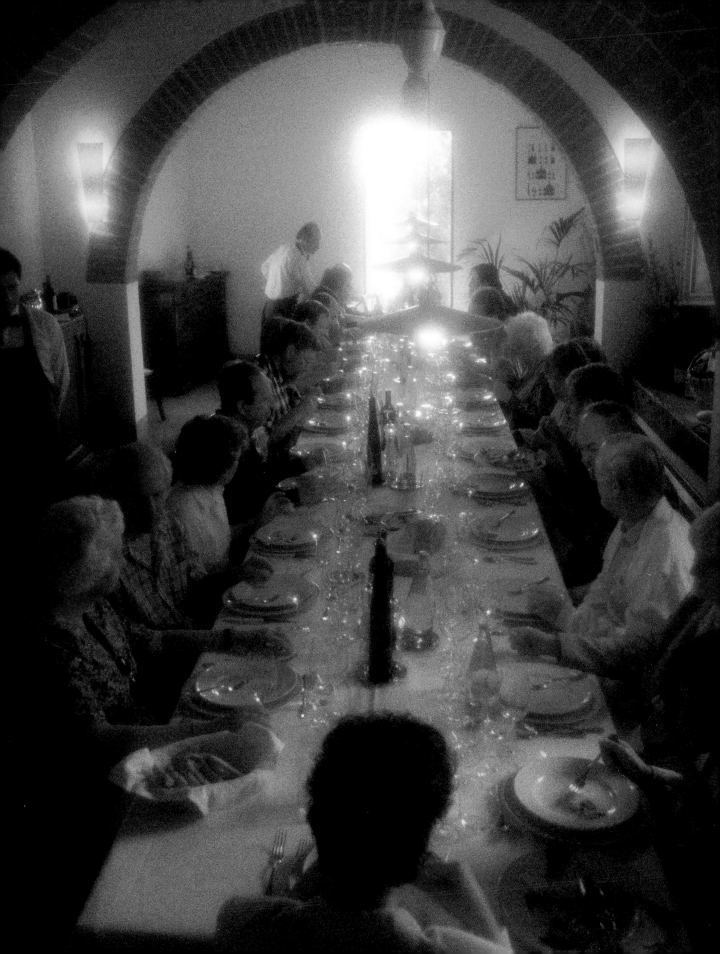

LA CUCINA
(Kitchen)

⟨⟩

Tuscans celebrate the moment. When I first travelled to Italy in my twenties, I remember thinking, *These Italians are having more fun than we are.* Ten years ago, when we set up camp at Bramasole, I learned that my early perception was accurate.

People obviously and thoroughly enjoy each other, especially gathering, preparing, and sharing food. "It's unhealthy to eat alone," Fiorella says. She welcomes guests to the table with an innate sense of hospitality. Another plate or three or four, what's the bother? At a summer dinner, Marco looks down the row of plates and says, "It's good to have at least twenty at dinner," and he's right. Naturally, children and elders come to the table, too, and no one minds if the dog looks longingly at the bones. The host is grilling at the fireplace, guests arrive with bottles of wine, melons, and baskets of whatever gardens are yielding at the moment. Friends help bring out large platters of *antipasti* to the laden table overlooking the valley. The ambience of the Tuscan table never feels like a dinner party but as if, somehow, *you've come home.*

Besides the Tuscan generosity and abundance at the table, what I love most about these feasts is the pace. The meal is a microcosm of the whole attitude toward time.

No one rushes from the table, although a few will surely step away briefly if they're shouting too loudly into their cell phones. Some feasts last six to eight hours. Although the workday looms, even at a Wednesday night dinner, we push back chairs around midnight. Why is the coming together of friends and family around the table such a joyous occasion?

On a flight from California to Rome, Ed sat next to an Italian who immediately began to chat rather than fold into himself for the duration. After two or three preliminary sentences, he asked, "What was your most memorable meal?" And then he whipped out a photo of himself eating at a restaurant at San Fruttuosa. He carried it with him when he travelled, and in strange cities he'd prop it against the lamp in his hotel room. He had other snapshots of friends toasting, and one of a fish on a plate. A fish!

"Your word *focus,*" he told Ed, "comes from the Latin for fireplace. In Italian, it's *focolare*—the center of the home where we cook and eat and talk, all of which gives *focus,* a clarity to life. Without our food we fall apart."

All this before the plane lifted off. "Food is the sun: family, work, friends, the day-to-day, the extraordinary— all in orbit like planets. There's order in the universe

Ducks and pigeons roasting in the Cardinali's fireplace (preceding pages 172–173); dinner at Avignonesi Vineyards—it's good to have twenty at the table (left); lunch on a terrace overlooking Cortona (above).

when someone says, 'Let's eat.'" He looked with disdain at the package of pretzels tossed down by the flight attendant. "Look at the story of Jesus, how one of his last acts before he was crucified was dinner with friends. One identifies, naturally. One thinks, what will I be having for my last dinner, who will be there? Perhaps we Italians always have this image in the back of our minds. Make every dinner count—something unbelievable may happen to you the next day."

He was from Genoa but would feel at home in Tuscany, where feasts are not just for special occasions such as birthdays, holidays, and anniversaries but are often for the foods themselves. Each season's particular foods are celebrated intensely. In spring, Tuscans appreciate the young *fave* beans, green almonds, fresh *pecorino,* and wild asparagus. Not only are these foods celebrated at *feste* and dinners at home, they influence daily activities. Anyone with a garden will plant those *fave* in winter, knowing they'll be carrying a willow basket overflowing with the tender beans in April. A hike in the woods results in a pocketful of crunchy almonds to eat, fuzzy green skin and all. Most everyone knows a farmer way in the hills who milks his twenty-five sheep then makes his own *pecorino* to enjoy creamy and young, or to age to a *parmigiano*-like hardness. On Sunday walks along the road, a leap over a ditch and a scramble up a hill enable you to find the thread-thin wands of the

coveted wild asparagus or fennel flowers or a handful of *rughetta,* the rowdy cousin of arugula. Each loved food is relished for its particular time. And almost everyone takes the time to pursue seasonal delights.

In early summer, Placido and Chiara are out with flashlights at midnight. gathering snails from damp stone walls. In a pot the circumference of a car tire, the snails are braised with *pancetta* for hours. Lorenzo, age ten, asks for seconds.

Cherries ripen in June. Although the birds often get to our five trees exactly one day before the fruit is ripe enough to pick, we have more than our share from the *frutta e verdura.* Later, the green beans of Sant'Anna make their brief, revered appearance. In early fall, the brilliant green tangerines from Sicily are snatched up at the market, then the most riotous culinary event of the year arrives—the *funghi porcini.* Mushroom madness descends on Tuscany. Special baskets, secret assignations, calculations of the number of days since rain fell—we're all combing the woods, then celebrating with *porcini* dinners, all *porcini,* except for dessert, which on fall evenings is likely to be a pear poached in sugared red wine or a fig and walnut tart.

Cardoons, chestnuts, rape, and fennel come into their own at their appointed times, then vanish for the rest of the year. They're welcomed, savored, feted, then the next thing comes into its prime, a pleasure cycle.

Summer lunch at Bramasole (above);
a friend brings a gift of figs (right).

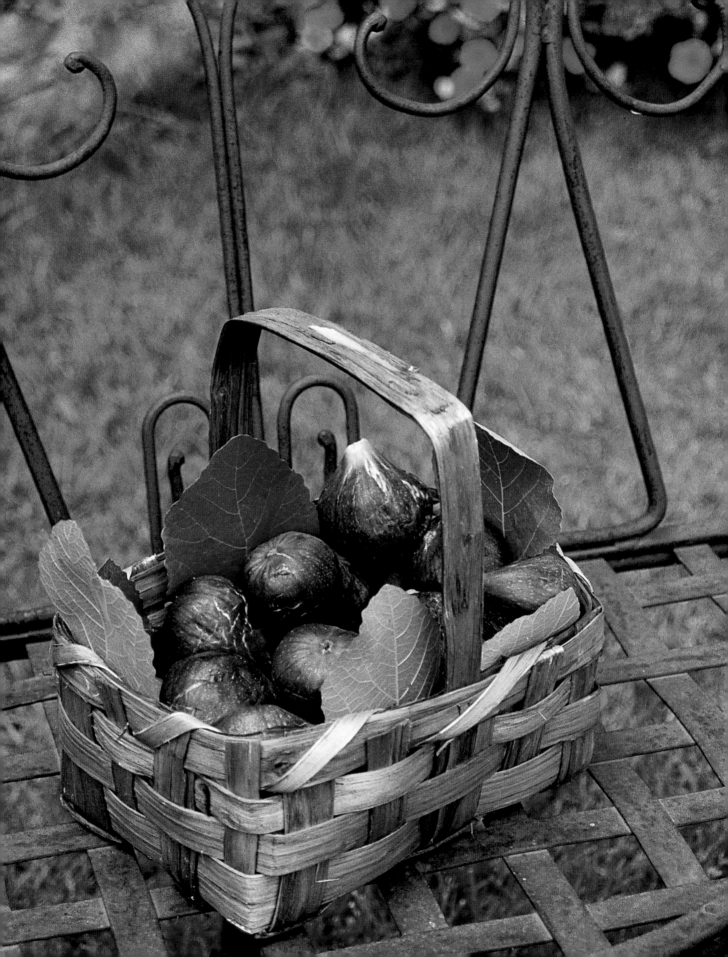

I'm constantly reminded of the great groaning-board dinners at my mother's, my aunt's, and my grandmother's tables in the South—the abundant, made-from-scratch, just-picked, just-ripe foods that both express the place and derive directly from it. I wish I could magically gather the three of them at just one Tuscan feast.

❧

"Genuino" (genuine—but also natural), Beppe says, as he presents me with a rabbit from his hutch. "This rabbit has eaten only bread and grasses." We know, because we've seen Beppe hack a bundle of greens, tie them with a string, and take them home.

"Genuino," the Tuscan touchstone word, applies to meat, game, vegetables, oil, and wine. Similar to the French concept of *terroir, genuino* resonates with a sense of place and also a confidence in appropriate care and cultivation. Cooking Tuscan food is simple, but ingredients must be of optimum quality. Recipes are fast and the ingredients work toward the intensification of intrinsic flavors. I used to cook eight-hour elaborate meals from French cookbooks or from my family's southern repertoire. I still occasionally fall into binges of preparing Moroccan or Indian meals with extensive preparations of complex ingredients, but now I usually turn to the simplicity of Tuscan food, which I've come to love from eating at *trattorie* and tables of friends.

"May I have the recipe?" I ask those at whose tables

I have loved to eat. Most have to stop and think because there is not really a recipe, just a process handed down from the family—a way, a taste, a smell. The recipes I include here range from the traditional to the idiosyncratic; most are not ordinarily found in cookbooks, though they're straight from the heart of Tuscan cooking. That they are gifts from special people is clear in their faces—each *piena di vita,* full of life. My private album bulges with menus, recipes scrawled on envelopes, and snapshots of friends at the table. Also included are a few easy recipes I've imported into my Tuscan kitchen.

❧

A family-run *trattoria* menu reveals the hallowed essentials of the Tuscan kitchen. These favorites are so fundamental to the culture, you can begin to think some official cranks out a state-mandated menu: Bruschette, Crostini di Fegatini, Ribollita, Acquacotta, Carciofi Fritti, Fiori Ripieni, Tortellini in Brodo, Spaghetti al Ragù, Arista di Maiale, Bistecca alla Griglia. Most locals don't even glance at the menu because they already know it by heart. Instead, they ask if anything special is cooking today, perhaps a pheasant or woodcock. If not, they know the thick strands of pasta called *pici* will be excellent with a sauce of duck or wild boar. The rabbit with fennel will be as good as they know it will be. Blindfold a Tuscan in the Philippines or Antarctica, give her a bite of Pinzimonio, Panzanella, Pasta ai Funghi Porcini, or Salame Toscano, and she will say, "Home." Or perhaps, *"Genuino."*

The oldest story of the Tuscan table is fire and the second oldest is bread. When we first looked at stoves for the house, we saw that wood stoves for cooking are still sold. Bright red, blue, and green enamels, they look like much more fun than plain old white and chrome. Ed wanted one but I didn't see myself stoking a fire every morning, especially in July. We've since found that many kitchens have both types. A cultural preference for food cooked on wood remains strong. In summer, the outdoor ovens and grills are fired nightly. For winter cooking, fireplaces are equipped with grills of various sizes and rotating spits, either electric or spring-loaded. We see loads of wood heading into towns for the pizza ovens. Charcoal is rarely used, and certainly not lighter fuels. One man in the mountains still makes charcoal the way it was made in Neanderthal times, in a dirt-covered cone, with the wood burned inside very slowly for several days. His charcoal, of course, is prized. The blackened grain of the wood still shows and the pieces tinkle like glass when they strike each other. One match starts the fire.

From a crude bread made with chestnut flour and water and cooked in ashes, to the farmhouse outdoor bread ovens, to the town *forno*, bread shop, the local cuisine evolves from and revolves around *pane*. I hear women asking for their bread *ben cotto*, well cooked. Bruno squeezes the middle for the satisfying *crunch* sound and the bread is approved. They ask for a taller loaf, a flatter loaf, a kilo, a half kilo, stone-ground, bread with grains, they're singing a hymn to this daily bread. I simply listen, lifted by the warm aromas of the bread. Although salted is available, the Tuscan bread is unsalted, an inheritance of a time when salt was heavily taxed, and now simply a preference. Salt, of course, draws moisture, which causes mold, so this salt-free bread retains its usefulness even when stale. At first, we bought the unsalted because we wanted to eat only the way the local people ate; now we have come to love this bread, which works with the rather salty cooking.

If you hang your basket or bag on the gate, the bread truck stops, leaving your bread, still-warm. Even if you're only standing outside, you get a whiff of bread in the wake of the passing truck. Bread in kilo or half-kilo loaves appears at every meal, but even in households with plenty of *ragù* to polish off with a bit of crust, leftovers accumulate in the bread basket. They do not go to waste. *La dolce vita* holds sway in Italy but, even so, there's a punishing proverb about having to pick up breadcrumbs with your eyelashes in hell if you waste bread. In earlier times, a housewife baked once a week, covering the loaves with jute and storing them in a *madia,* whose top lifts open to a coffinlike chest. Restaurants often use *madie* now for displaying the evening's bread or for bottles of wine.

We go to the *forno* not only for loaves, but for the flat, salted bread called *schiacciata, skah shah' tah,* a mouthful of ah's. Even though this bread is flat, it can be

Buying straight-from-the-garden produce (left);
Tuscan bread is firm and crusty (above).

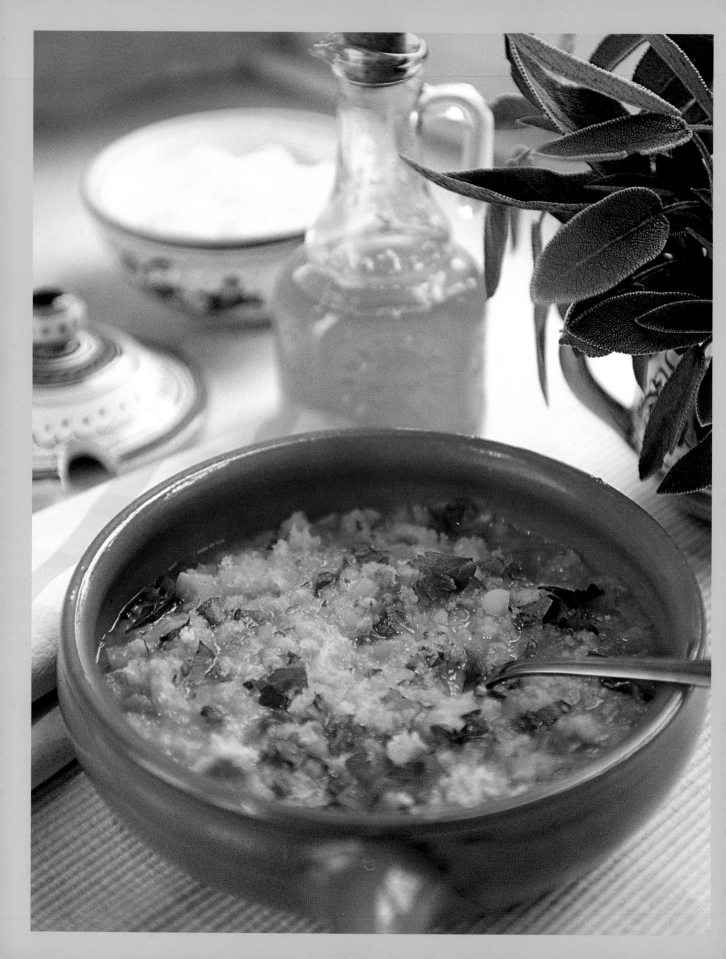

split for the best sandwiches. On most days in summer, for lunch we eat a big square of *schiacciata* with two layers of dripping, luscious tomatoes inside.

The *forno* in Cortona bakes not only the simple oil-and-salt *schiacciata* but also others flecked with sage leaves or topped with tomatoes, olives, or melted onions. Sliced into fingers, they're great for an *antipasto* platter. For breakfast, there's always raisin *schiacciata* to toast, and as the season turns to fall, the *schiacciata all' autunno* appears—a ripe-grape-studded tribute to autumn, with garnet juices staining the bread.

We watch for the hand-written sign announcing that Ciaccia con Ciccia— which sounds like a Latin dance—is available today. *Ciaccia* is dialect for *schiacciata* and *ciccia* refers to small squares of pork or *pancetta* baked into a cakelike savory bread.

I admire the thriftiness of the Tuscan kitchen; ingenious uses of leftovers, especially bread, define the cuisine. I have heard of a farm recipe called *la frittata di pane,* a frittata made with five slices of bread—a panful— brushed with oil, then covered with four eggs beaten with a cup of milk and some salt. This is cooked until just set, and sometimes sprinkled with grated cheese. A plain meal, for sure, but one almost always available.

Historically, this habit of using stale bread was a necessity; today it continues because the recipes are tasty. *La cucina povera,* the poor kitchen, revealed many flashes of genius with leftover bread, especially *pappa al pomodoro,* a bread soup, and *panzanella,* bread salad, both of which use the August boon of ripe tomatoes.

Other classics, too, such as the soup *ribollita* have been prompted by bone-hard stale bread. Beyond these, the chickens can sharpen their beaks on the stony loaves. *Ribollita* is an inspired work of art. The bowl comes to the table—or to your chair by the fire—so thick with the crumbled hunks that you can stand up a spoon in it.

I met Graziella at Bar Tacconi, where she and her whole family cook stick-to-your-backbone midday meals on a wood-burning stove. When Graziella came to visit at my house, she shyly held out a gift, wrapped with a mile of curled ribbons, along with an armful of yellow lilies.

As a small child, she lived at Bramasole with her parents. One day her father found a pipe on a high terrace. He brought it inside to the kitchen where it exploded in his face, a mine left over from Partisan-German conflicts in these hills. He died there. Soon after, Graziella and her mother moved into town and never returned.

I show her around the house and she compliments me on the kitchen, where their ox used to live, and on keeping the cooked-brick floor. In the living room (which used to be the kitchen), she scans the room quickly, her glance resting on the floor near the fireplace only briefly. She is silent.

A bowl of ribollita in winter at Bramasole (left);
breads from Cortona's forno *(above).*

I begin to open the gift. Inside I find a tureen, perfect for *ribollita*, in the yellow and green Cortona pattern. Digging in the garden, I've found dozens of shards, handles, and plate-rims in the same pattern. If I could put back together some of the yellow and green puzzle pieces of ceramic I've unearthed, perhaps I could make something whole that Graziella's family once used.

As we live here longer, a cache of rich memories begins to gather around each of these essential Tuscan recipes. None more so than *ribollita*. I can arrange many memorable servings in my mind; one remains especially vivid.

After leaving the *notaio*'s office, where I signed away my life savings for the pursuit of happiness at Bramasole, we got in the car and drove in no particular direction. We raised dust on winding white roads, sped through tunnels of shoulder-high corn, glimpsing Cortona out a side window. Twice we stopped because we were laughing too hard to drive. And then we found ourselves staring up at the battered *trattoria* sign, Enzo's.

"You've come too early for dinner, my friends," he yelled. "Too early for dinner and too late for *pranzo*."

"We just bought a house, Enzo, and we're starving. Please, anything."

"*Allora.* For a house, you'll need some *ribollita*. It will make you forget this heat, and maybe forget all the reasons why you should not have bought!"

He set down the *parmigiano* and threaded a little of his father's oil onto the soup. "This soup is like my life,"

he confided, but we were too dazed to ask him what he meant. I was having hallucinations of throwing open the shutters on a summer morning. Ed stared at his spoon, his head bent as if in prayer.

❧

To the Tuscan kitchen, bread is more basic than pasta, polenta, or risotto. All the farms had a bread oven, often attached to the house. The *massaia*, woman in charge of the *cucina* and farmyard, oversaw the baking of thirty to forty kilos of bread every week. Many people use these ovens, not only for bread and pizza but for roasting meats. Even when not used, they are left in place as a reminder of times when the household counted on the loaves rising in the *madia*, the olive cuttings burning in the domed oven, and the emergence of the crusty bread. Bread is ritual, just as the tortilla is in Mexico. The minute you sit down in a restaurant, a bread basket appears, assurance that first things are first.

An evolutionary Tuscan cousin of wheat, *farro* (spelt is a close approximation) has become a staple in my kitchen. When Elio came on his *ruspa*, a small earth-shifting machine, he tossed me a book as he tore across the new grass of the front garden. Friend of a friend, he'd come over to redefine a terrace that slowly was reverting to hillside in an area where I wanted to build a grape and rose pergola. *Knowledge and Taste of Farro*, I read, and Elio was the author.

The rising Italian interest in preserving artisan cheeses, bringing back almost-lost varieties of grape

Fragments found in the garden at Bramasole (above); At Bramasole: Yellow tureen is the traditional local pottery pattern; espresso cups in other traditional majolica designs (right).

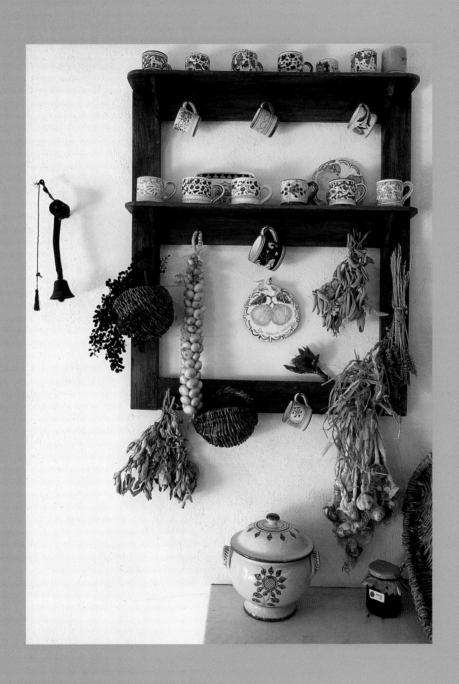

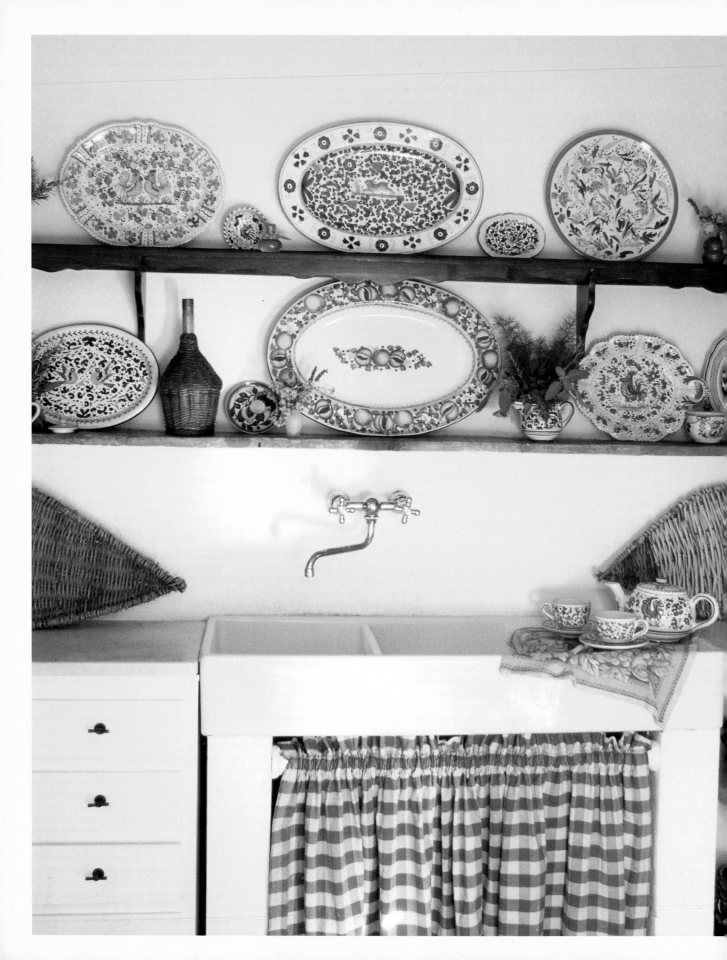

stock, and cultivating regional specialties includes also the revival of *farro*. Elio became fascinated with it long before this renewed interest because his family always has grown three varieties of *farro* (small, medium, and large) in the countryside near his house. His neighborhood celebrates a *festa* centered on the harvest and preparation of *farro*. He read about a handful of grain found in an Etruscan tomb in Volterra in 1980. Incredibly, someone was able to germinate this millennia-old grain and put it in cultivation, resulting in a harvest of thirty *quintali* (3,000 kilograms) in 1989. The grain completely resembled the smaller variety of *farro* still grown in Tuscany. Elio found documents in a Romanesque church describing payment made in 1258 in the form of *la spelta*. He researched archives in Florence and talked to many Cortona cooks as well. As I read his collection of recipes, I could sense the ties between *farro* and the culture, for here were all the staples of Tuscan cuisine paired with this grain—many *farro* soups with fava beans, or sausage, or with *funghi porcini; farro* and red beans, *farro* and lentils.

Such hearty, sustaining combinations raised images of the women who tended the fireplaces in farmhouses far in the country, the men stamping in at midday, redolent of the fields and barns. They raised images, too, of new ventures to launch in my own kitchen with this earthy grain. Croquettes of *farro* and herbs, *farro* with black cabbage, and the soup of the three F's: *fagioli, finocchi, farro* (beans, fennel, and *farro*). *Grazie mille,* Elio.

A corner of the kitchen at Bramasole,
with serving platters.

Odori

Basic to several recipes is odori, *that gift at*
the frutta e verdura *tucked into your shopping bag*
as you leave. With the odori, *you make a* trito,
a mince of the vegetables, which are then sautéed
in olive oil until softened.

Finely chop 2 carrots, 2 stalks celery, 1 onion, 2 cloves
garlic, and a handful of parsley. Sauté in 2 tablespoons
(30 milliliters) olive oil until golden.

"Less is more" applies directly to this and other
Tuscan recipes, which tend to have few individual ingre-
dients. Vegetables and meats, especially, are served with
total assurance that they speak very well for themselves.

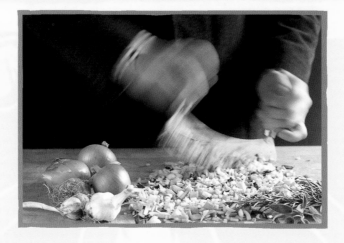

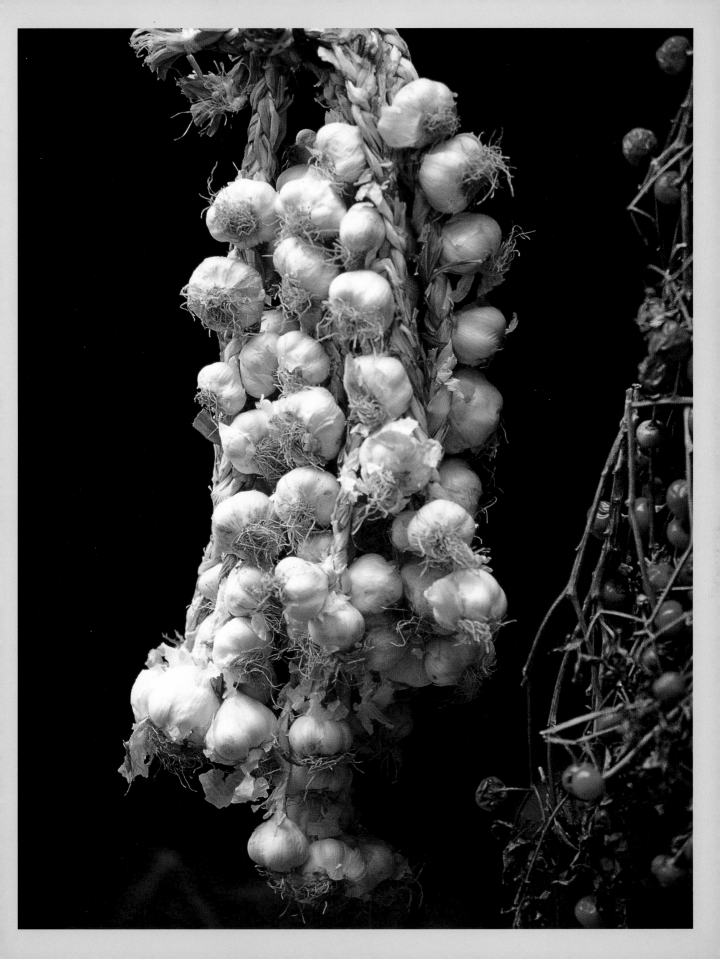

Panzanella

Bread Salad

Nothing as good as panzanella *ever sounded less appetizing—a lumpen mound of squeezed wet bread? Some desperately hungry person with an empty cupboard must have invented* panzanella, *which is one of the mainstays of late-summer lunches under the trees. The quality of the bread and oil mean everything. I once used stale whole-grain bread that simply dissolved. Those leftover Tuscan loaves, however, could double as baseball bats. Nothing destroys them. Genuine bread, fruity oil, and the bountiful tomatoes of August— what an inspiration from the poor kitchen. A mystery is how well* panzanella *keeps. When I've made far too much, we're still pulling it out of the fridge days later for a two* A.M. *snack. Some people add tuna or anchovies to* panzanella. *This is a sin. It obscures the balance of summery flavors.*

12 slices of firm, stale bread, including crusts
A handful each of chopped basil and Italian parsley
3 to 4 ripe tomatoes, seeded and chopped
1 onion, 1 carrot, 1 celery stalk, all diced
6 to 8 tablespoons (90 milliliters) olive oil
2 to 3 tablespoons (30 milliliters) red wine vinegar
Salt and pepper, to taste

Soak the bread in water—really drench it—then squeeze out the water. Place it in a bowl and break apart with two forks. Add the other ingredients then toss with the oil and vinegar. Season with salt and pepper, and let the bowl rest for at least an hour. Before serving, toss well again and sprinkle with more basil and parsley. I sometimes add a little mint, too. *Serves 8–10.*

An attractive option: Slice the top off a loaf of bread and hollow it out. Pack the *panzanella* inside and replace the top. Wrap the loaf in foil and chill for 2 to 3 hours. Slice thick pieces and serve as an *antipasto* or as an hors d'oeuvre. I thought this was a California twist but later came upon a similar recipe in a historical study of *contadini* cooking in the Arezzo area.

Pappa al Pomodoro
Tomato Soup

Another treat of high summer, pappa al pomodoro, *bread with tomatoes, is the simplest of all simple soups. In a restaurant, I have ordered a second bowl and skipped the rest of the meal.*

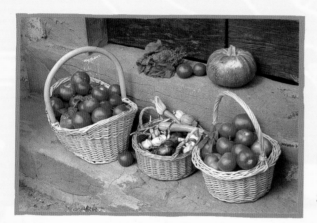

2 onions, finely chopped

1 celery stalk and a few leaves, finely chopped

1 carrot, finely chopped

2 to 3 tablespoons (30 to 45 milliliters) olive oil

8 slices bread

2 to 3 cups (460 to 700 milliliters) water or
 vegetable broth

8 tomatoes, chopped and seeded

15 to 20 basil leaves

Salt and pepper, to taste

Sauté the onions, celery, and carrot in the oil in a pot with sides. When just done, place the bread on top. Add water to cover the bottom of the pot and bring to a boil, breaking the bread apart. Simmer over low heat. As the bread absorbs the water, add 2 cups more of water or broth, and the tomatoes. Season with basil, salt, and pepper, and simmer for 15 minutes. *Serves 8.*

Second place in the Tuscan kitchen, after wheat in all its uses, has to go to pasta, particularly to *pasta al ragù*. Of all the thousands of pastas, it's the most loved. Ed always wants to have a contest at our house, invite all the Italian cooks we know to bring their own *ragù*. Donatella says that Francesca makes the best. When I relate the compliment to Francesca, she appears the next day at the door, holding out a quart jar of her *ragù*. It's unbelievably *delizioso.* I'm eating it with a spoon at the stove while it heats. Giusi's beef and pork *ragù* stops us from speaking while we eat, especially when her mother has made her special pasta, *cavatelli.* Then we try Giusi's *ragù* made from wild boar. Altogether different. Boar is dense, with—what?— a nutty hint, perhaps of the chestnuts boars love. We hear these crazy characters in our garden at night sometimes, thundering through the beans, snorting. Boars may not look appetizing, with their wiry hair and gross snouts, but long-simmered boar becomes irresistibly tasty.

What's the secret of *ragù*? we ask them. "Simmer three hours," Giusi says. "Equal amounts of veal and beef," says Francesca, "with half as much pork." "Have the butcher grind the meat in front of you," another neighbor adds. Everyone has a different way, but all over Tuscany I've found that the concentrated *ragù* casts an unflattering light on my own prized spaghetti sauce, and that my family and friends would not be so enamored with mine if Giusi or Francesca materialized in the doorway with a platter of *tagliatelle* bathed in luscious sauce.

Ragù is the crucial food of the soul, the true mark of *casalinga,* home cooking. Some cooking I prefer to do alone, but I love working with someone while making pasta and *ragù* in the morning, wrapping the coils of pasta in a dish cloth and letting it rest in the fridge while the *ragù* aromas begin to spread through the downstairs.

Although eggs appear infrequently on menus, they are quietly fundamental to the Tuscan kitchen. When there was almost nothing on the farm, there might be an egg or two, a bunch of wild herbs, and hence a soup, *acquacotta,* cooked water, which now has many refinements. At the Saturday market, vendors bring eggs from their farms for those who live in town. In the country always, there are chickens, running through the olive groves, pecking at the edges of the vegetable garden, coexisting peacefully with the cat under the tractor. We're happy when we hear roosters crowing from a nearby farm. I don't like chickens; they're the creepiest creatures, so Beppe brings us eggs, six at a time, often leaving them outside on the table.

"What's the matter with the eggs?" my guest asks as we start to cook one night.

"Nothing. What do you mean?"

"The yolk is so…so *yellow.*"

"Oh, they're fresh. And the chickens run around loose."

I like the Tuscan proverb: Eggs of an hour, bread of a day, wine of a year, and a friend of thirty years.

These eggs! In no time, the whipped whites billow out of the bowl. Cake batter with four yolks turns golden. When Ed makes his special Julia Child soufflé, it just about hits the top of the oven.

Tuscans eat almost no breakfast, so eggs don't often appear in boiled, scrambled, or coddled forms. Their best guise is the humble *frittata,* a supper dish that provides an occasion to use whatever in the kitchen needs to be used—even leftover pasta. In fall the *frittata* achieves status with wild mushrooms while the ultimate form is reached with slivered truffles and *parmigiano.* In spring we make a *frittata* with artichoke hearts, spring onions, parsley, and *parmigiano.*

Everyone places beans high in the hierarchy of ancestral food. Writers always mention that Tuscans are called "bean eaters," but by whom they never say. In my experience, this reputation doesn't seem accurate any longer. True, the plain white *cannellini* beans are ubiquitous. Doused with oil, they're just *there,* often overcooked and bland. The glory of the local bean scene is fresh *cannellini* in summer. Those might make a bean eater of anyone—they're taut and toothsome, especially enhanced with chopped fresh tomato and sage.

Tuscans, above all, are meat eaters. The portions are small, by American standards, but intensely savory. Meat is not the main course: a Tuscan meal features no main course but instead has a dynamic rhythm. Each course balances with the next so that one is not more important than another. This is radically different from American expectations, where everything leads toward a *pièce de résistance.*

One bite of lamb fed on wild herbs, or roasted free-range chicken, or grilled Chianina steak reveals that in America we have sacrificed a lot of flavor for industrial production of meat. No meat is tastier than pork. This is big pig country. Tuscan *prosciutto* and *finocchiona,* sausage spiked with fennel seeds, are renowned. At artisan butcher shops, such as Antica Macelleria Falorni in Greve, traditional *contadini* preparations indicate just how thoroughly a pig was employed on the farms. They make *guanciale* and *capocolla,* cuts from the cheek and neck, as well as *salame di cinghiale,* wild boar, and *rigatino,* an aged *pancetta.*

Colonnata, near the marble quarries of Carrara, is the source of *lardo,* a treat with a cult following. The dorsal fat of a pig is aged for six months, pressed inside marble casks in caves or pits. The result: Lardo di Colonnata, slivered white fat, delicate as butter. I was shocked when first served this delicacy. Imagine eating pure fat, soft as a cloud, fat infused with hints of vanilla, cloves, coriander, garlic, rosemary, and pepper. I looked around me at the table, all slim people diving into platefuls. My neighbor drives all the way to Colonnata to find the finest *lardo.* He serves it on *crostini,* or just plain on an antipasto platter. Someone should write an ode to *lardo.* In San Casciano, Val di Pesa, you can stay on a Cinta Senese farm, where compact pigs with white belts are raised, and taste many handmade *salumi* of these Cinta Senese, including an aged *pancetta.*

Roast guinea hen is a savory fall favorite, as are the sausages grilling in the fireplace at Bramasole (left and above).

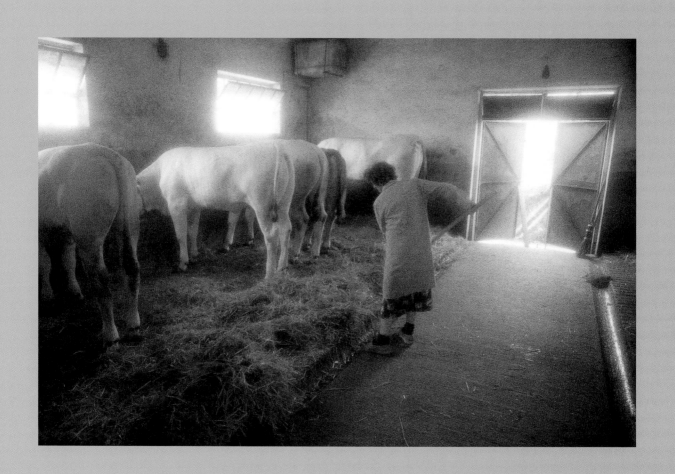

Cooks prize the pork liver. Ground pork goes into *ragù,* and *pancetta* goes into everything else. Tuscans use every part of the pig, with *arista,* the loin, being the choice cut, the Sunday cut. Roasted in a covered pan, chunks of *pancetta* keep it moist.

The other premier pig pleasure is *porchetta,* which is sold at stands on market day and from trucks pulled off to the side of the road on other appointed days. On Wednesday afternoons in Cortona, one of the *porchetta* mavens opens the flap of his truck outside a city gate, revealing his whole pig, which he has slow-roasted in a wood oven. In the pig's mouth he's stuffed a *porcino* mushroom, a hard roll, or an apple. Some people are grabbing a snack: a split roll stuffed with slabs of juicy pork. That's it. No mayonnaise, no pickle, no mustard, just plain bread and the pork that needs no embellishment. We buy a pound of lean and Ed always asks for some *sale,* which is not only salt but some of the stuffing and herbs.

Tuscan chicken is not always as tender as the American birds. Scrounging outside rather than living in megacoops where they never touch their feet to the ground must result in a more muscular chicken. What's missed in texture is recooped in taste. They actually taste. Chicken is cooked fast, sometimes weighed down on the grill with a brick *(al mattone),* so that all parts come in direct contact with the fire, as in spicy Pollo alla Diavola. The chicken is split and flattened, seasoned with hot pepper, and grilled on each side with a brick on top. Then it's simply cut in four pieces, each served with half a lemon.

When I studied Italian in Siena, I'd leave the second four-hour class of the day in a whirl of subjunctive and past remote verbs and head up the street to a *rosticceria,* where a well-flattened Pollo alla Diavola was the speciality. I'd take this splayed chicken home, feeling somewhat akin to it after eight hours of study.

A couple of years ago, Ed and I had a hunger for this *diavola* and went out to our stack of leftover household parts, where we chose a heavy, handmade brick from the stack. When we scrubbed it, we found the print of a cat paw. Now that brick is part of our kitchen utensils.

In our area, steak is king. The Val di Chiana below Cortona, in early times a marshy swamp, now is a rich plain famous for its fruits and vegetables and also for the cattle named for it, the Chianina. I rarely see them outside their barns, where they're carefully tended and petted. What immense beasts—tall, spooky, white steers with horns and dolorous big eyes. Sometimes they have red ribbons tied around their necks to protect them from the evil eye. Though they're taken to market before they reach one ton, they would grow to maturity at around two tons. A lot of beef.

Butchers pride themselves on these Chianina steaks. Posted on their walls are many photos of the butcher at auctions, his name on a gigantic white rump. Often in the *macelleria,* butcher's shop, the whole cow hangs from a hook just inside the door, a shocking entrance if you drop in for a few sausages. Michael, one of the town dogs, stares up from the doorway, where he awaits a treat from the butcher.

The prize cut, the *costata,* is a big thick T-bone. Tuscan friends cut this enormous steak into two or three portions after grilling and always serve it *al sangue,* very, very rare, unless you request otherwise. Richly flavorful, this steak is juicy, juicy, juicy.

Because the home of the Chianina is right below Cortona, the town celebrates a Sagra della Bistecca every August 14 and 15. The whole town turns out in the park for a communal feast. Ten or twelve men tend the enormous grill, constructed for the occasion, and the women serve beans, salad, bread, wine, and fruit to everyone. At the end everyone buys a bag of *brigidini,* anise-flavored chips.

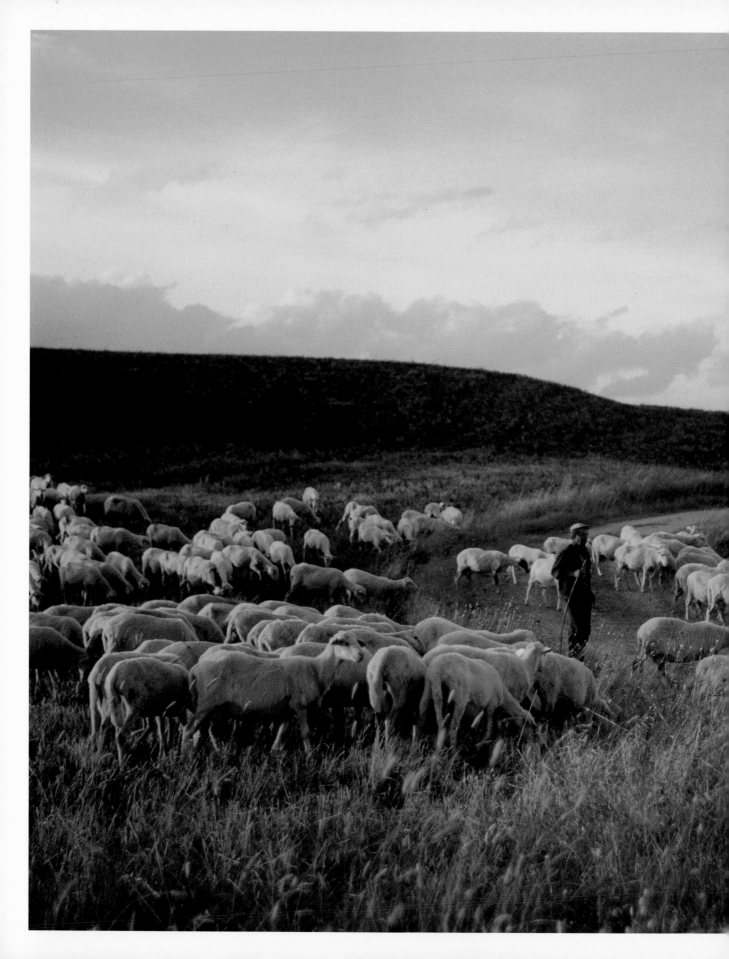

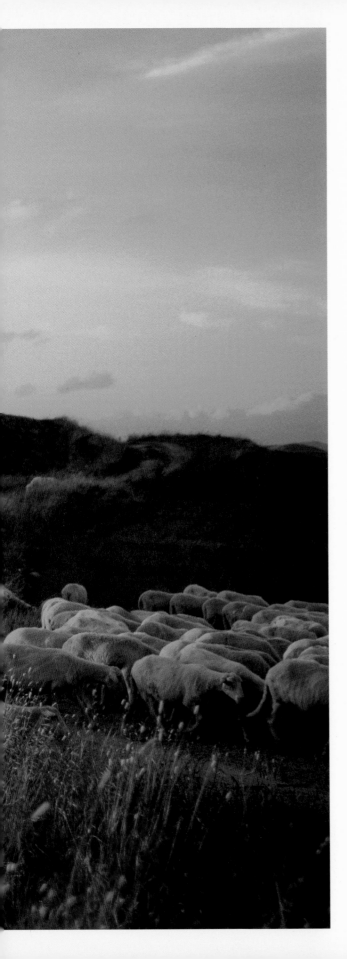

Many times at the homes of Tuscan friends, I've felt incredulous that something familiar, something known and ordinary can taste so delicious. It's as if the pigeon or the rabbit were appearing in ideal form. Twice I've had roast lamb at Dario and Giusi's house, where the family raises almost everything they eat. I see Ed take a bite, frown in concentration, then look at me in wonder from across the table. No one else seems electrified, as we are; they take such superb food totally for granted. Rupert, Giusi's English brother-in-law, often catches our astonishment at these family dinners. "You see, don't you," waving his fork as he leans over the table to say, "that Donatella and I never could live in England."

The lamb comes around the table several times, sliced, bathed in its own essences. Giusi's sister-in-law, Anita, notes that the family doesn't like to eat milk-fed lamb because they don't like the taste that milk imparts to the flesh. "*Puzzo,*" she explains—stink. They wait until the lamb is weaned. Giovanni, patriarch of the clan, has been denied a third glass of wine because of his heart. He holds up his glass of water to the light. "*Brutto colore,*" ugly color! he shouts.

What makes this lamb so incredible! we want to shout.

Tending young Val di Chiana cows (preceding pages 194–195); bucolic morning near Radi (left).

Giusi's Pasta al Ragù
Meat Sauce for Pasta

Giusi is a natural cook. Her home in the mountains supplies her with choice ingredients.

Giuseppina De Palma

Odori (see page 188)
1 pound (450 grams) ground beef
1 pound (450 grams) ground pork
4 Italian sausages
Salt, pepper, and thyme, to taste
1 to 2 cups (240 to 480 milliliters) white wine
2 tablespoons (30 milliliters) tomato paste
2 quarts (2 liters) tomato purée

Prepare the *odori* (Giusi omits the garlic for *ragù*) in a 4-quart heavy pot with a lid, then add the ground beef, ground pork, and sausages and sauté until browned. Add salt, pepper, thyme, and a cup or two of white wine. After the wine has evaporated, add the tomato paste and tomato purée. Cover and simmer over a very low flame for 3 hours, stirring now and then. If necessary, add a glass of water. *Ragù* and striated *penne*, which holds on to the sauce, marry well. *Serves 12 or more.*

Giusi's Faraone alla Cacciatora
Guinea Hen Hunter Style

1 whole guinea hen (or chicken), cut into pieces
¼ cup olive oil (60 milliliters)
Salt and pepper, to taste
Odori (see page 188)
1 cup white wine (240 milliliters)
2 cups of tomato sauce,
 preferably homemade (480 milliliters)

Prepare the *odori* and set aside. In a large skillet, sauté the chicken in the oil for ten minutes. Add salt and pepper and lower the flame. Add the *odori* and sauté until golden. Add the white wine and simmer until all the liquid has evaporated. Add the tomato sauce and cook over a low flame for 15 minutes. As with many tomato recipes, this is best the next day. *Serves 4.*

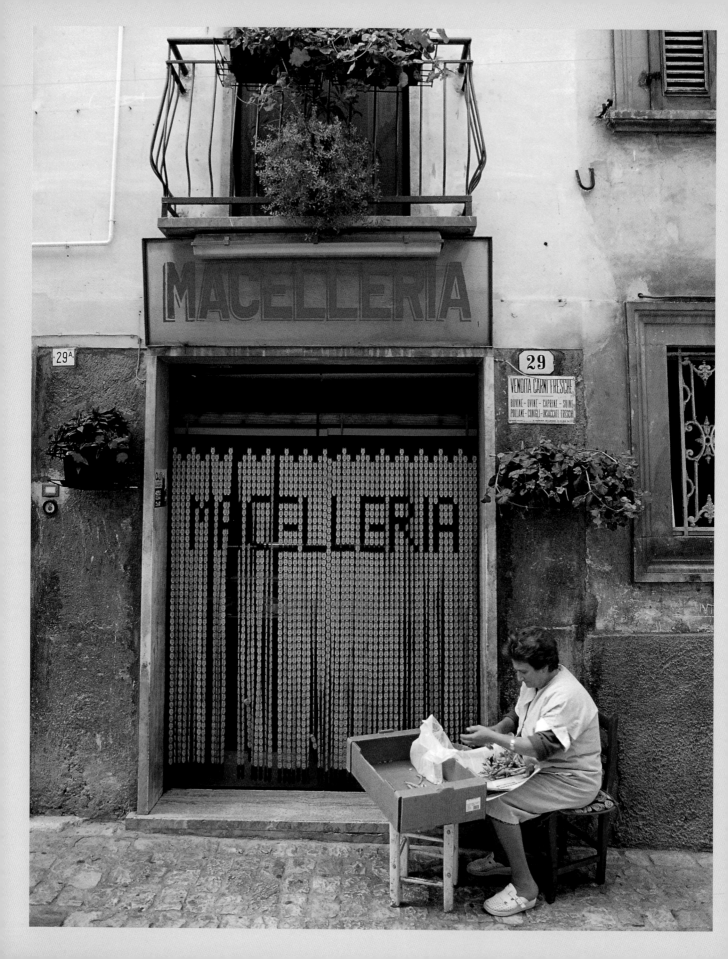

Bean-Eater Beans

Fagioli al Fiasco, *white beans cooked in a wine bottle, is one of the oldest Tuscan recipes. I'll never try it. When we bought our house it had been abandoned for thirty years. We spent two weeks clearing out the scorpions, dust, spiders, and junk. We also cleared out hundreds and hundreds of wine bottles, without suspecting that the inhabitants had needed the bottles because the land had once been a vineyard. We just thought they over-indulged in a good thing. As we uncovered the land beneath brambles and ivy, we found the gnarly vines and finally understood.*

We filled many recycling containers, but we did keep the handblown bottles that used to be covered with straw. I love their globular shape and the bubbled surface of the green glass. With a stash of these on hand, I suppose I could try this classic Tuscan bean recipe. I'm drawn to the romance of nestling the fiasco in coals and ashes overnight, unstopping the bottle, and pouring out roasted beans.

But how do you keep the ashes hot for hours, and if you can do that, how do you know the bottle won't explode in the night, sending beans all over the living room? How do you get the expanded beans out of the quarter-size opening? And doesn't cleaning the bottle sound fun?

I'll chalk this one up to the wisdom of those who cooked in fireplaces, and happily simmer mine in a terra-cotta pot in a plain old oven.

4 cups fresh *cannellini* beans or 3 cups
 (700 milliliters) dried white beans

Garlic cloves, to taste

A few sage leaves

4 or 5 slices *pancetta* or lean bacon

1 onion, chopped

3 tomatoes, chopped

Salt and pepper, to taste

Fresh *cannellini* beans, just shelled, are best. Any small white bean will work. If you use dried beans, soak them in plenty of water for 5 hours. Drain and rinse the beans then simmer them in salted water with garlic cloves and a few sage leaves until not quite done—still "to the tooth." Drain and put in a terra-cotta pot, or other covered baking dish. Sauté *pancetta* or bacon, along with the onion, and add to the beans. Cover and bake in the oven at 300°F (150°C) for 30 minutes, or until beans are just cooked. Keep tasting, because the beans are best with a firm texture. Remove the meat and allow the beans to cool. Stir in the chopped tomatoes, some cut sage leaves, and salt and pepper. *Serves 8.*

Catching the sun while shelling beans in Siena.

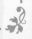

I love vegetables. Eating in Italian *trattorie,* I've thought that cooks slight their preparation. Often, French fries are from frozen potatoes. Glum rounds of spinach are like eating bocce balls. The beans usually are unadorned, even by a few sage leaves. *Sformata di verdura,* a kind of quiche without the crust, can be good but can sink quite low onto the soggy side. But sometimes fried zucchini flowers or artichokes, or a *pinzimonio* will appear. I love the word *pinzimonio*—so crisp, like the freshest vegetables that are doused in this seasoned, fragrant olive oil. Forget the crudité platters of yore, with the bowl of sour cream dip designed to mask the flavor of everything. Any carrot will benefit from its quick bath in *pinzimonio.* Fennel, too, is required on the platter; its anise flavor awakens suddenly when dipped.

Unappreciated in America, fennel has become a staple of my kitchen in Tuscany. I plant two dozen seedlings at the end of summer, droopy, feathery plumes that immediately start to stand up, wave, and grow. I should have known that cultivated fennel would take to the land, because wild fennel grows everywhere, even popping out between cracks in the steps. In late summer, I take a basket and walk the terraced land, gathering the individual yellow flower heads. Spread on a tray in the sun, they dry out in a couple of days, then, as Francesco taught me, I rub them between my hands and tediously pick out the stems, leaning down frequently for the prickly anise scent. I have enough gold flecks to give away several jars and plenty to season oven-roasted potatoes, rabbit, and baked fish.

In private homes I've seen the kind of preparation of vegetables these superb specimens grown here deserve. At outdoor summer dinners, cooks love to serve fresh zucchini flowers stuffed with a tad of mozzarella, then deep fried. This is what the angels dine on when they float over Tuscany. The gold *fiori,* flowers, seem to have caught sunlight in their petals. Finding a cluster of these loud trumpets opening among the sprawling leaves is one of the joys of the vegetable plot.

Even a few zucchini plants yield plenty of flowers. Straight from garden to kitchen is best; the flowers wilt quickly. Not to worry though. If they're rain-beaten or a bit bedraggled, sliver them into *risotto,* along with chopped zucchini. Because the area around Cortona is blessed with endless sunflower fields, I always use sunflower oil for frying *fiori.* My thinking is that the two brilliant yellow flowers naturally go together.

Whatever Tuscan vegetable or meat can be stuffed, will be. *Fiori,* made with a light hand, defy that ugly word "stuffed," *ripieni,* by their delicacy. Because of the cooks' instinctive talent for balancing flavors, their *ripieni* recipes do not turn leaden in the oven. Zucchini routinely appear with their middles mounded with peas and béchamel sauce. Red peppers baked with seasoned ricotta and herbs is the best fate a pepper can imagine. Meats are flattened and rolled with vegetables, other meats, or herbs, making a colorful wheel when sliced.

I admire the perfection of herb and vegetable plots I see pictured in garden books, the neat boxwood borders and the shaped plants all in proportion to each other. No wild boar has mangled all the lettuces, no wind has landed a plum branch on new thyme, no Jack-and-the-Beanstalk weeds have choked fledgling basil, and the strawberries edging the terrace have not bolted overnight—all of which happens in my garden. Not to mention porcupines. Not to mention the flocks of birds who send signals throughout Tuscany: *tomatoes ripening at Bramasole, attack new peach tree while you're at it, pears almost ready to dive-bomb.*

Pulling up winter fennel.

I have planted my herb garden on a broad terrace partly shaded by a pear and an olive tree. On the terrace above, we've planted the more extensive vegetable garden. Basil likes the light shade and rewards with spreading plants that perfume me with their scent as my leg brushes the leaves. In the sun, my *dragoncello,* tarragon, has edged out the savory. The peppermint I like for iced tea fights it for space. I planted rue because I like the English name, though not its Italian one, *ruta.* Italians have an old taste for bitters. Imperial Romans liked rue, which they used in sauces with fruit wines and honey. Since I do not plan to flavor *grappa* with this herb, or to use it for medicinal purposes, there's really no use, other than for a bank of silvery foliage in front of the double hollyhocks. Twice a year, I cut the tarragon wands low, but it bounds back. Since the pungency has faded over four years, soon I must ruthlessly hack it out, replace it with a new plant.

Cooking here, I have learned to use herbs abundantly, the way they grow. If I don't prune, it's fun to see the marjoram spread into a grand, perfect circle, of which Giotto would approve, to see the sages' soft color punctuate the hillside as the bushes flourish, to see how tenacious parsley can be, reappearing year after year (*come prezzemolo,* he's like parsley, the proverb goes— he turns up everywhere). My creeping thyme, which I expected to form a fragrant path, refused to creep but stood right up and produced yellow flowers.

Beyond the plot, wild herbs abound in the fields. Most abundant is a *nepitella.* I pick this wild mint almost daily, so important for lentils and zucchini, for roast lamb and salads. Lemon balm could be regarded as an invasive pest if I didn't like it so much for a soothing sorbet. A hot bath, drawn with a handful of leaves, is a full-body tisane of woody, citrus steam. Wise women who roam the hills and roadsides know dozens of greens and herbs and roots. I'm learning. When I transplant some prize of the field to my garden, it dies immediately. Some things are best left wild.

On the walk out to our view of Lake Trasimeno, we've planted several dozen artichokes on a narrow terrace. Opposite, the civilized line of lavender and cypress proceeds along with this touch of the wild. Artichoke plants look primitive and robust. Their green sawtoothed leaves and the spikes topped with artichokes, armor-coated like an armadillo, then the purple thistles, show us a constantly changing plant.

Until coming to Italy, I'd never eaten the artichoke stalk. I thought artichokes were sold at the markets with foot-long stalks to show they were fresh. The peeled stalks taste like a slightly tougher version of the heart. In spring, tiny purple-tinged artichokes are enjoyed totally raw—just trim the outer leaves and dress with seasoned olive oil. In homes, artichokes may be served with a simple stuffing and baked upright *(ritti).*

Who can resist the fried ones? When I find fried *porcini,* zucchini flowers, zucchini, or artichokes on the menu, I'm transported to my family's Georgia kitchen, where hush puppies, sweet potatoes, and okra sizzled in a black cast-iron pan. We used lard or peanut oil. Here, because artichokes are members of the sunflower family, it's only natural to use this oil.

Il Falconiere Chef Michele Brogioni gathering herbs.

Lemon Zucchini

Many of the old houses in Tuscany have a limonaia, a glass-fronted room for wintering-over potted lemon trees. We have a special flat cart for the huge pots so that we can wheel them inside where they rest in pale sunlight, requiring nothing. In spring they're wheeled out again and positioned exactly as they were. Beppe marks each pot so the orientation to the sun will be the same. I wonder why, with so many lemons grown this way, they are not a common ingredient in the Tuscan repertoire. Beautiful they are, but did no Tuscan ever shout Eureka, crab and lemon, or even lemonade?

Lemon pesto hits bland zucchini like a stun gun. The zucchini should be small and firm, organic if possible. The lemon pesto can be used on pasta or shrimp or with other vegetables, especially summer squash.

8 to 10 zucchini, grated
3 to 4 spring onions, minced

For the Lemon Pesto:
Juice and zest of 2 lemons, organic, if possible
A big handful of basil leaves
5 to 6 cloves garlic
3 tablespoons (45 milliliters) toasted pine nuts
¼ cup (60 milliliters) olive oil
Salt and pepper, to taste
3 tablespoons (45 milliliters) grated *parmigiano*

Steam the grated zucchini and onions until they are just done. Squeeze out some of the liquid from the zucchini.

In a mortar or food processor, combine all the ingredients for the pesto and blend well, working in the cheese at the end. Combine with the vegetables in a saucepan and heat through. *Serves 6–8.*

Frankye's Tarragon Beans

Dragoncello, *tarragon, spreads like a brushfire*
in my herb garden. Although it is not used much in
Tuscan cooking, it always has been a favorite of
mine. Adjacent to the herb garden, we have a summer
plot of green beans and the two hit it off splendidly.
I rediscovered a childhood favorite, my mother's
way with green beans, and tweaked it a bit because
at that time we didn't use olive oil.

2 pounds (1 kilogram) tender green beans,
 topped and tailed

2 onions, chopped

1 yellow and 1 green pepper, cut in slivers
 the size of the beans

2 tablespoons (30 milliliters) olive oil

4 to 5 slices bacon

For the Marinade:

¾ cup (180 milliliters) olive oil

½ teaspoon (2 milliliters) salt

1 teaspoon (5 milliliters) sugar

A few shakes of red pepper and black pepper

¼ cup (60 milliliters) tarragon leaves, finely chopped

4 tablespoons (60 milliliters) lemon juice

A pinch or so of thyme and oregano

Steam the beans just until done. Mix the marinade well
in a jar or bowl. Sauté the onions and peppers in oil
and mix with the beans. Pour into a shallow baking
dish and add the marinade. Let the beans marinate for
6 hours or longer, turning over them several times.

Serve at room temperature. In the old southern
way, four or five slices of crisp bacon can be crumbled
on top. *Serves 6–8.*

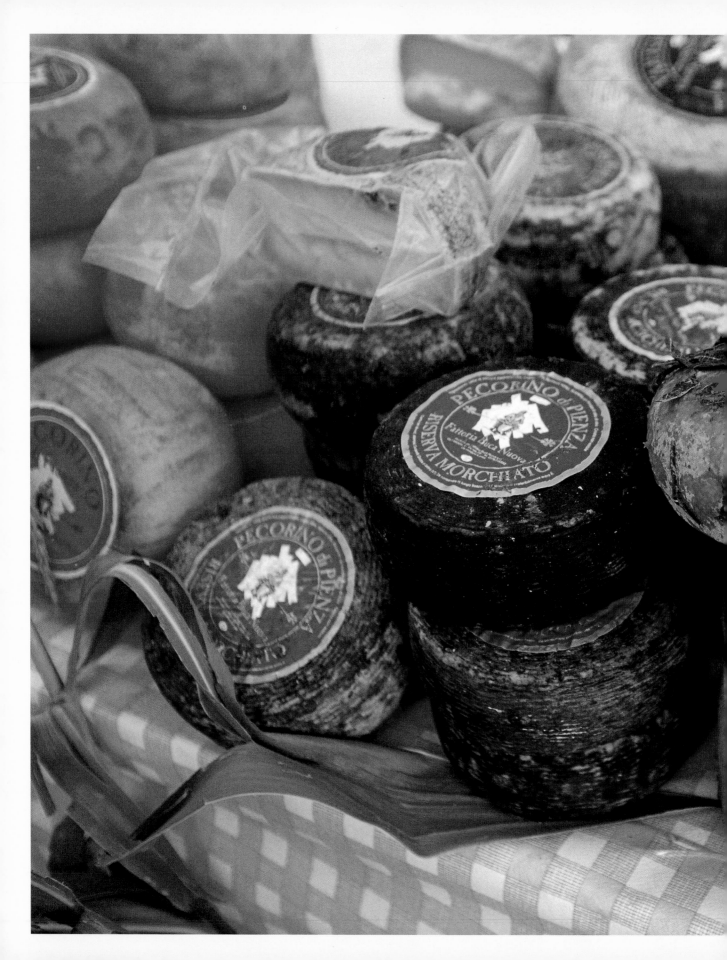

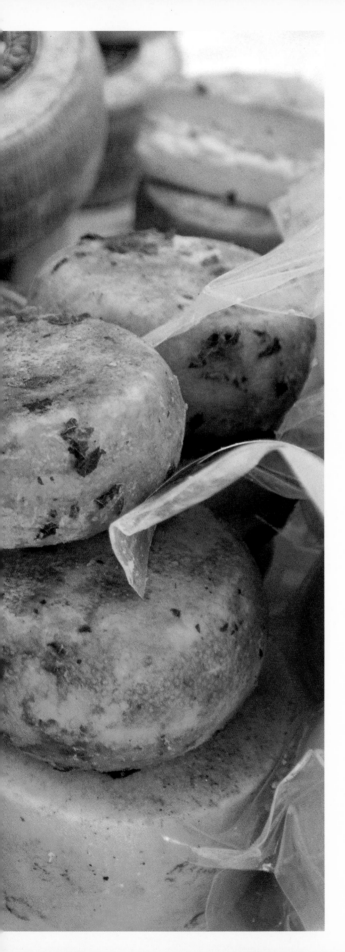

Parmigiano, surely, is a Tuscan essential, though this cow's milk cheese comes from Emilia-Romagna. The true Tuscan prefers *pecorino* in all its guises: fresh, semi-aged, or aged. In the pause before dessert, *pecorino* makes its way to the plate. *Pecorino* is the lawful wedded wife of fresh fava beans in spring. In fall and winter, we bring to the table a wedge of *semi-stagionato*, partially aged, with clementines, dried figs, and nuts; no dessert needed.

All around the countryside near Pienza, folds of sheep on the hillsides signal that *pecorino* and *ricotta* are in the works. Yellow *vendita diretta*, direct sale, signs point us to farms where fresh *ricotta* is available, along with either plain *pecorino*, or rounds covered in ashes or leaves. The two are products of ewe milk, the *ricotta* being the recooked (*ricotta*) whey. When we're lucky enough to find a few handfuls of wild strawberries, we mix them with a little sugar and white wine and stir them into *ricotta*, a revelatory experience. The shops on Pienza's main street lure you with their honeys, baskets, and *salumi*, but above all with the cheeses. Taste and see. You can go home with a few in your luggage if they're shrink-wrapped. My sister tucked a couple, wrapped twice in plastic, in her bag and, back in Atlanta, found her clothes perfumed with gamey barnyard scents.

The rounds of pecorino *are often wrapped in leaves or rolled in ashes for subtle flavoring and preservation.*

Not least in my little tour through the essentials of Tuscan food—creatures of the sea. A pasta I hear ordered all over Tuscany is spaghetti with various mussels and clams, Pasta allo Scoglio (*scoglio* means reef or rock, where various shellfish attach themselves).

Nowhere in Tuscany are you ever farther than two hours from the Tyrrhenian or the Adriatic. When we're hungry for seafood, we drive to Castelnuovo Berardenga, in the Chianti country, to dine at Da Antonio, a fish-only restaurant on a quiet *piazza.* Antonio, who travels the two hours every day to the Tyrrhenian for his fish, is a legend. You sit down at his tables and course after pristine course appears. Such simplicity becomes possible only with the purest fish. Nothing about his preparations interferes with the exhilarating taste of the sea—the tenderest, flakiest fish with a salty sting. How amazing to watch the waiter lift out the entire feathery bone. Across the *piazza* in a lighted room, I see an aquarium, with tiny fish circling in a blue-green glow, reflecting oddly on the vitality of Antonio's kitchen. Perhaps it is his house.

When Edo and Maria invite us to dinner at their country home, Chiara says to clear the calendar and go, no matter what we have planned. Edo works near Perugia and knows the best buyers who travel daily to fishermen on the Adriatic. Edo's clams and lobsters, according to Chiara, still drip seawater they're so fresh—and Edo

breaks every speed limit to zip the bounty forty minutes back to Cortona.

The dinner is memorable: No mermaid has ever enjoyed fresher morsels—or more vibrant colors, shapes, textures. Three baskets of crisp vegetables for *pinzimonio,* which awakened our taste buds, then the *primo* course arrives, risotto with *vongole, scampi,* and *cozze* (clams, langoustines, and mussels). Then begins a procession of banquet-sized platters; first, oysters on a bed of seaweed, then baby clams called *tartufi di mare* (truffles of the sea), more salt-braced mussels, these called *cozze di Margherita.* Maria brings bowls for the shells, then more bowls for shells.

During a pause, a few guests smoke, and Edo passes out his collection of vintage sunglasses. We all don a pair, then another grand platter emerges. "*Le cicale,*" Edo holds out the platter with pomp, as though it displays the head of John the Baptist. Instead, cicada-shaped (hence the name *cicala*) creatures that look like enlarged crayfish. Are they sweet? Are they delectable?

Any reasonable dinner would have long since wound to a brief dessert and good night but I know that is not the Tuscan way. We're in the land of the abundant table. After devouring the *cicale,* we meet large langoustines on a bed of ice, and then the finale, a round platter crowned with shiny *astice* (clawed lobsters), surrounded by small crayfish. For all we know, deep in the Cortona night, the sea could be booming just out the window.

Platter at Edo's seafood feast (above);
Who could pass up these melons (right) in Pienza?

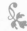

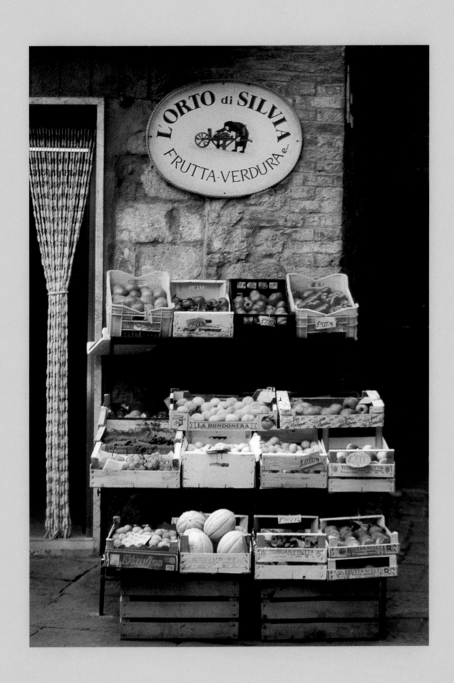

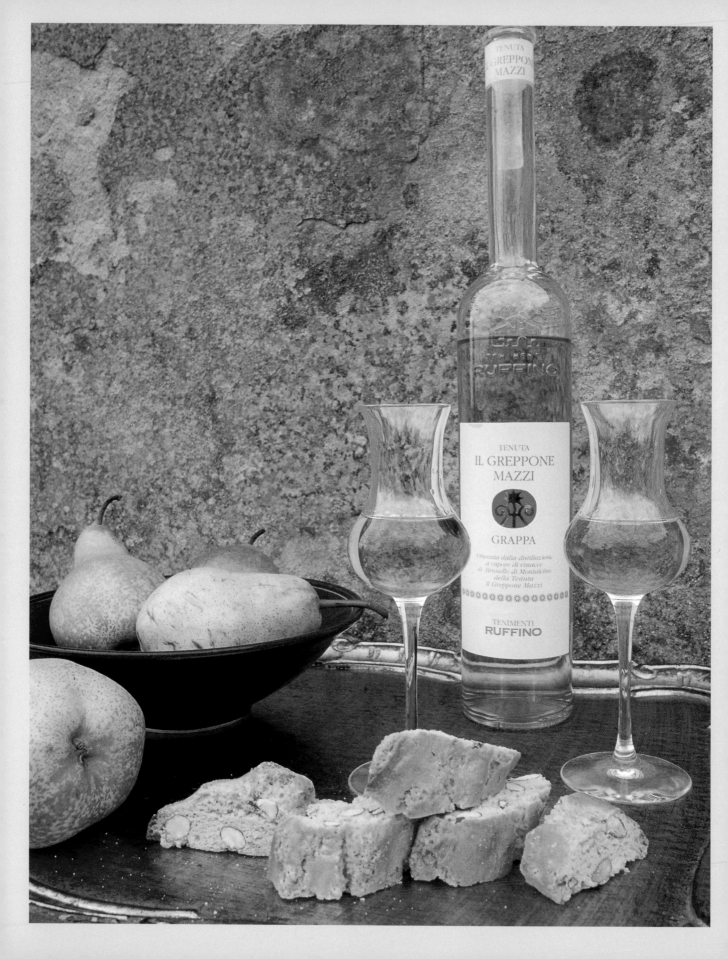

Dolce, the sweet moment of the meal. My inheritance from a food-mad southern family is a fondness for splendid desserts. I've always been disappointed when served a bowl of raspberries. How does that compare to a pecan pie made with cane syrup, or my mother's silken Black Bottom Pie? But after many summers in a place where I can pick my own fruit, I've slowly become a convert. When we have dessert now, we're in the habit of slicing that perfect pear, squeezing a little lemon juice on strawberries, or broiling a cut fig with a bit of honey.

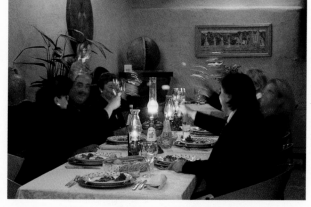

In winter, old longings come back. What else to do with all the almonds and hazelnuts I've gathered? Visions of lemon chess tarts and caramel cakes rise. And in the dark evenings by the fire, a *real* dessert feels called for by the *grappa,* the *vin santo.*

Winter days in Florence, too, pull me toward the great regional cakes such as *zuccotto,* custard-filled pastries, serpentine almond tarts. In December, when Florence becomes Firenze again, café windows steam, the aroma of roasting chestnuts fills the air, Florentines parade in their furs and tweeds and scarves. We often pause in our *fresco* quests, or shopping quests, for a slice of something creamy, something with drizzled chocolate, something laced with rum. The glass case is gleaming with pistachio, lemon cream, walnut tarts. Not a perfect peach in sight.

After a Sunday *pranzo* in Cortona, the ritual dessert comes from Banchelli's pastry shop. A small crush of people jams the shop on Sunday mornings to pick up their snowball-sized meringues filled with puffs of sweet cream. A guest might bring a dozen, and even though a dessert already waits on the kitchen counter, the meringues will be devoured as well. They're festive and surprisingly light. I imagine they figure in the dreams of Cortonese who are far from home. They must dream, too, of the way afternoon extends after that Sunday lunch, when the *vin santo* is pulled out of the corner cabinet and the stories begin.

It can't be just the exercise that comes with hunting and gathering food that keeps Italians fit—in cities they can't stalk the land for their dinner salads. In the *Corriere della Sera* I read the results of a fifty-one-nation study of Europe: Italy has the lowest percentage of overweight citizens, also it is last in suicide. Besides the obvious qualities of the Mediterranean diet that we've read about in every magazine, I think there are a few other factors at work. When food is really good, day after day, you don't have the urge to eat a lot; you're satisfied. When food is unbalanced or badly prepared, you keep eating; the body keeps wanting. Because of the rhythm of the meal, portions of meat are small. No one seems to want sugar or salt snacks between meals, though no one worries about

Pears, biscotti, *and* grappa *served after dinner at*
Bramasole (left); a toast at Le Antiche Sere, Sogna (above).

the occasional dessert or *gelato*. The least-used major ingredient in the kitchen is sugar. These preferences add up to a lifestyle. All kinds of fruit are enjoyed constantly. Frequently I've seen children reach for a tangerine and refuse the chocolate dessert.

We live in the heart of *vin santo* country and Avignonesi vineyards makes one of the best in Italy. In early autumn, visiting their room for drying grapes qualifies as a spiritual experience. Intense blue and green grapes, Trebbiano, Grechetto, and Malvasia, line racks in a long room with a little light angling in to illuminate the recently harvested grapes. The fragrance is indescribable. Musty as they dry, yes, but alive and fruity and warm and joyous. Sacred wine, *vin santo,* once was used for communion, as the story goes, but now *vin santo* is the quintessential Tuscan after-dinner wine. We have a collection of bottles of *vin santo* made by friends, usually in a capped *acqua minerale* bottle. We pour Anselmo's on major occasions only. He was a first friend here and, after his death, it seems strange still to be sipping his *vin santo,* slicing into a pear.

Often *vin santo* is described as nutty, like sherry, but when I take a sip, I think I can taste the flavor of mass in the cold churches, the nails pounded into the farmhouse beams where the grapes were dried, the special glass bottle on the sideboard where the *contadini* kept their own *vin santo*.

In Tuscan homes, tiny glasses of *vin santo* will be offered to unexpected visitors at any time, even in the morning, along with a plate of *biscotti* for dipping. Personally, if the *vin santo* is special, I never would dip a *biscotto* into it. I like it best with cheese and fruit.

Our two-year-old apricot tree yielded five perfect fruits this year. Five tender apricots in a blue bowl, a brief and exact promise of things to come. Of all fruits, for me peaches and apricots are the best, except for cherries, which bless the early summer. And except for melons. Blackberries grow with abandon. We take baskets up to the mountain roads with Chiara, eating and picking at once. Ours are transformed into blackberry tarts, hers into jam, from which she painstakingly removes the seeds.

Ed is enamored of figs and I'm mad for the dark blue plums rimed with silver. Who can choose? Tuscany has such an abundance of fruit. How many summer days does Lucio park his Fiat in our driveway, throw open the tailgate and unload three watermelons, a couple of cantaloupes, and a bag of rosy plums known locally as nun's thighs? In the evening Fiorella comes by with a watermelon, saying Lucio gave her too many and can we take one more? We leave and receive baskets of fruit. Ed whirls around the kitchen with a watermelon in each arm. A revel, a juicy excess. Abundance is the best way to dance.

Ancient stones for training grapes line the terraces at Bramasole (above); vin santo *room at Avignonesi Vineyards (right); Vino Nobile in the making at Trerose Vineyard (following pages 218–219).*

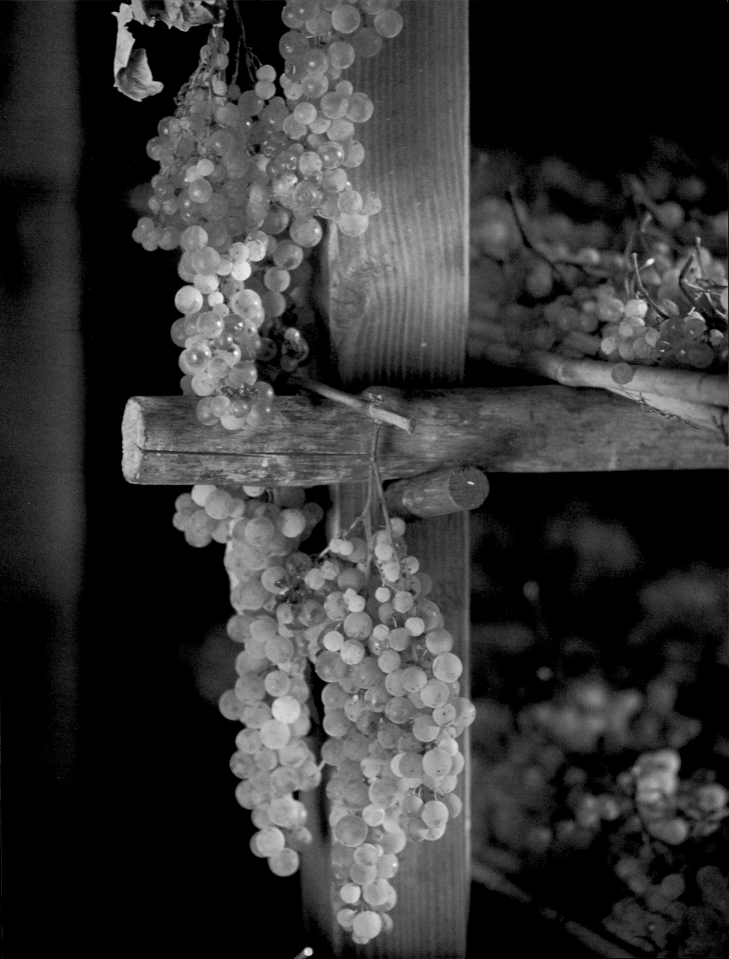

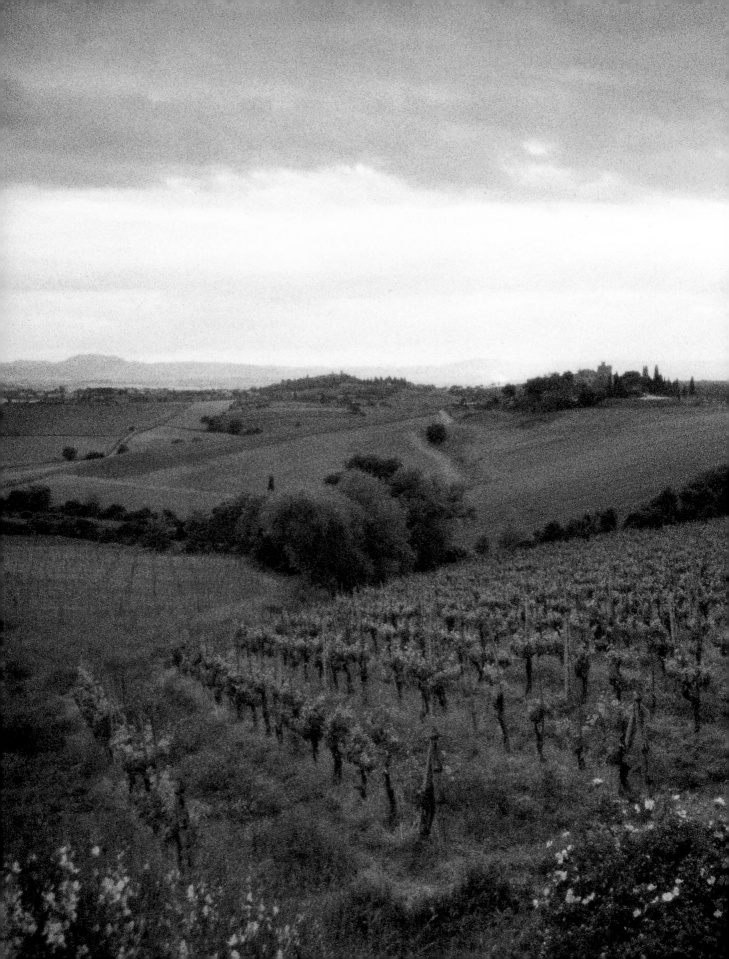

Sorbetto di Clementina

Clementine Sorbet

In the winter, when the small clementines roll in from Sicily, I like to serve this easy sorbet.
Chocolate cookies, wafer-thin, rhyme with it perfectly.

2 cups (480 milliliters) clementine or tangerine juice

Zest of 3 organic clementines

1 tablespoon (15 milliliters) *vin santo*

1¼ cups (290 milliliters) cold water

2 tablespoons (30 milliliters) lemon juice

1½ cups (360 milliliters) water

1 cup (240 milliliters) sugar

Mix the first 5 ingredients and chill. Make a sugar syrup by bringing the remaining ingredients to a boil. Quickly lower the heat so that a simmer is maintained and stir for 5 minutes. Chill *very* well, mix with the cold juices, and process in an ice cream maker according to the manufacturer's directions. *Serves 8.*

Valentina's "Gelato" al Parmigiano

Parmigiano "Ice Cream"

Valentina and Gioia Olivastri are the daughters of a painter and a teacher. Valentina studies in
England and Gioia designs clothes and jewelry in Cortona. Valentina has led us to great undiscovered country walks.
Gioia shares our passion for Cortona's history and has shown us Etruscan tunnels and streets beneath a palazzo.
Both young women bring openness and originality to everything they do, including this unusual dessert.

7 ounces (200 grams) *parmigiano*, grated

1¾ cups (415 milliliters) heavy cream

Pinch of pepper

2 pears

Red or champagne grapes

A dozen or so croutons

Balsamic vinegar (at least 8 years old)

Mix the grated cheese with the cream, adding cream a little at a time. Heat gently in a *bain marie* and stir, until a completely smooth cream forms. Add a pinch of pepper. Pass the mixture through a *chinois* or the fine blade of a food mill. Pour into a shallow dish such as a small pie plate. Refrigerate for 12 hours.

Peel the pears, halve and core them, leaving the stem if possible. Slice so that the halves fan out on the plate. Add a few grapes and croutons, then scoop a ball of the gelato on top. Trickle a teaspoon of balsamic vinegar over the top. *Serves 4.*

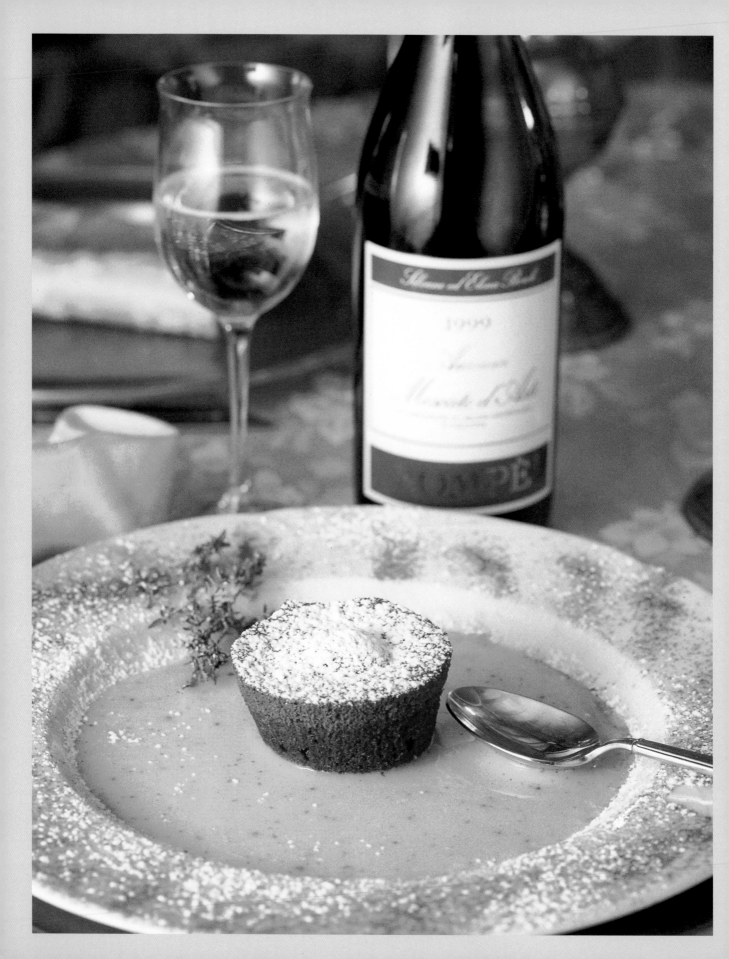

Loretta's Chocolate Dessert

Loretta and Vincenzo preside over Le Antiche Sere at Sogna, a hidden medieval borgo *completely restored by Fulvio di Rosa. If you go, you must reserve a table because the restaurant is small. Small and very special.*

13 ounces (365 grams) semisweet chocolate

11 ounces (310 grams) unsalted butter

8 eggs, separated

10 ounces (285 grams) almonds, toasted and ground to a powder

¾ cup (180 milliliters) sifted powdered sugar

6 ounces (170 grams) white chocolate

2 tablespoons (30 milliliters) cognac

Melt the semisweet chocolate and butter together in a double boiler. Cool for 5 minutes. Beat the yolks and add them to the mixture, stirring on very low heat. Then add the ground almonds and powdered sugar. Remove from heat and allow to cool. Whip the egg whites until stiff and gently fold into the mixture. Divide the mixture among 10 buttered ramekins or other small forms and bake for 25 to 30 minutes at 350°F (175°C). Unmold and serve on a pool of warm white chocolate melted with a dash of cognac. *Serves 10.*

Pears in Vino Nobile

*Poached pears are pretty to serve. In winter, their taste is heightened
when they're served along with some Gorgonzola, toasted bread, and walnuts roasted with butter and salt.
In summer, serve with sweetened mascarpone and curls of lemon peel.*

6 pears, firm, with stems
Juice of 1 lemon
1 cup (240 milliliters) red wine
¼ cup (60 milliliters) sugar
¼ cup (60 milliliters) currants
1 vanilla bean, split
3 or 4 whole cloves

Using a vegetable peeler, peel the pears, leaving the stems. With a paring knife, cut a small slice off the bottoms of the pears and stand them upright in a saucepan. Squeeze lemon juice over them, then pour on the wine and sprinkle with sugar. Add the currants, vanilla bean, and cloves to the wine.

Cover and simmer for 20 minutes (or longer, depending on the size and ripeness of the pears); don't allow them to become soft. Midway, turn the pears on their sides and baste several times with the wine. Transfer to serving dishes. Pour some wine syrup over each, and garnish. *Serves 6.*

*Two Bramasole tables awaiting guests
(right and following pages 226–227).*

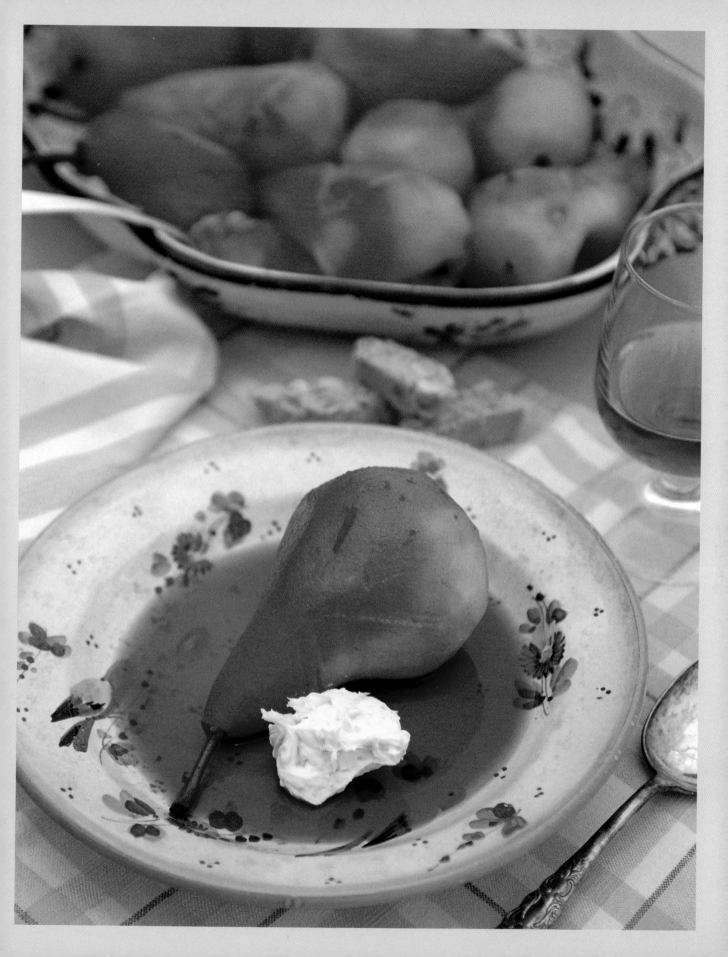

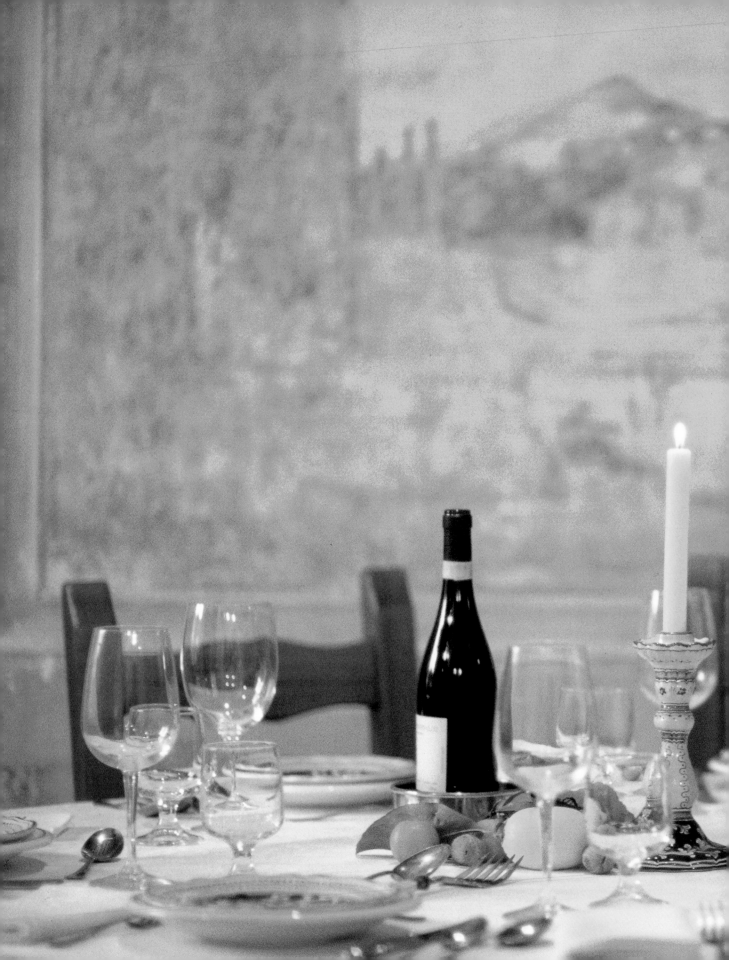

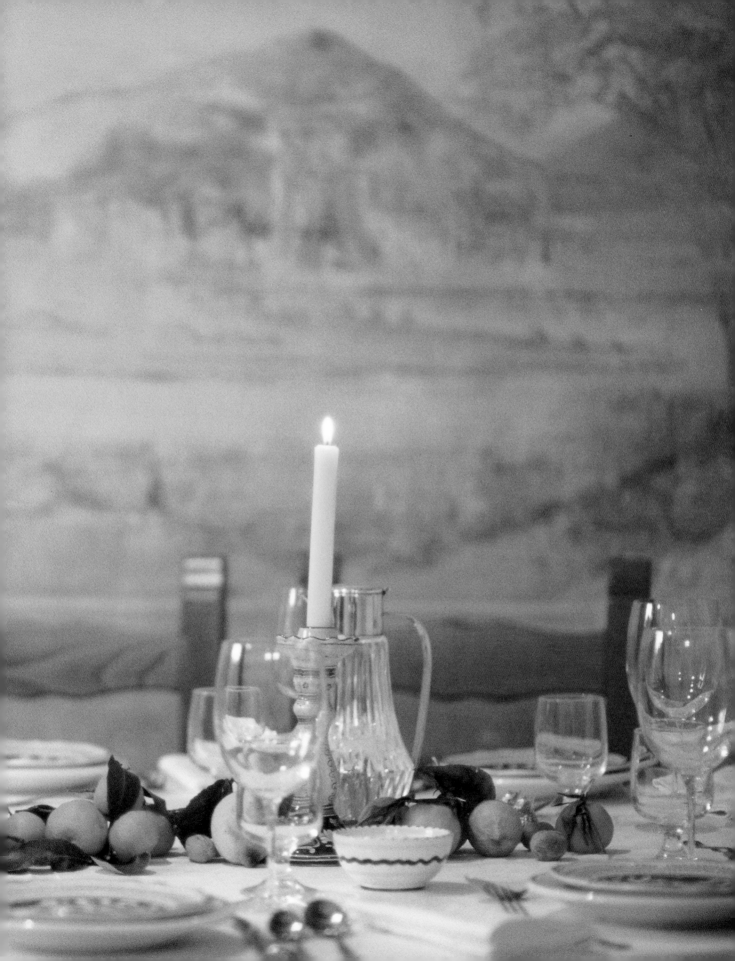

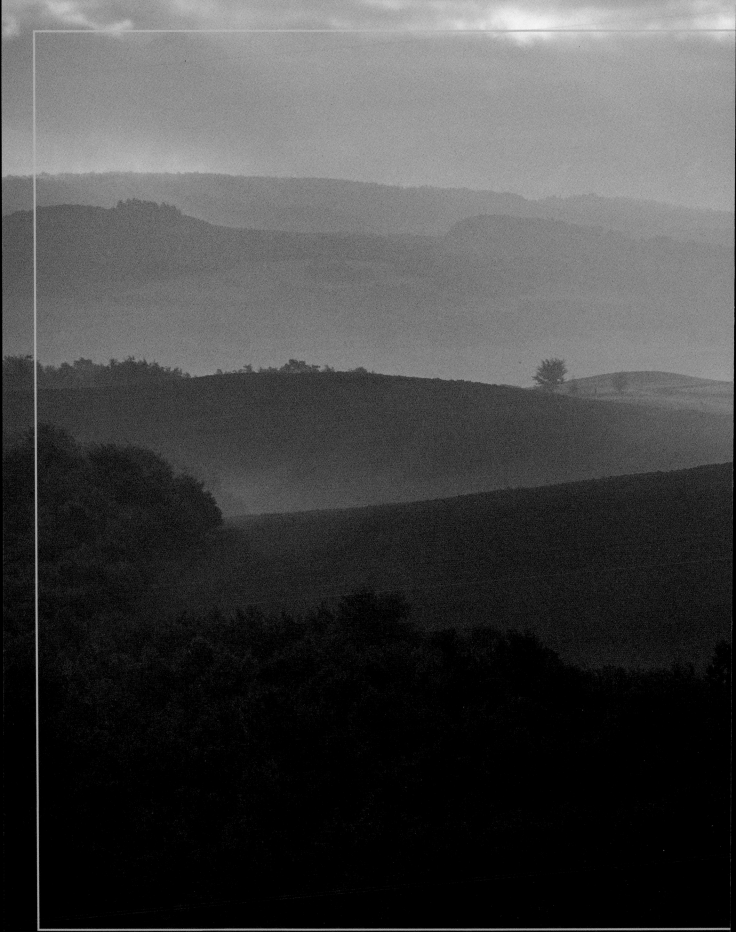

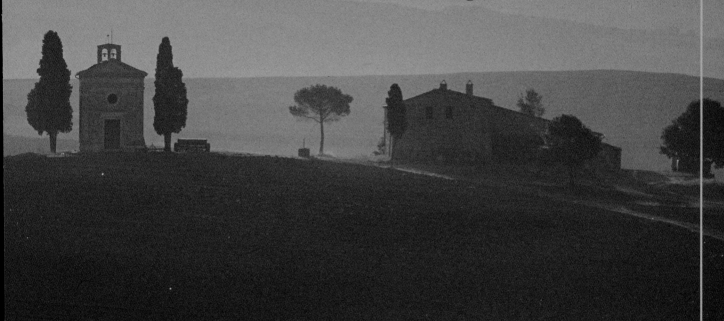

LA BELLEZZA
(Beauty)

Come see the light . . .

the hills have a thousand ways of holding light in their hollows.

Peace seems to reside in the landscape. . . .

I feel more than think that the beauty surrounding people

in rural Italy contributes enormously

to contentment with life.

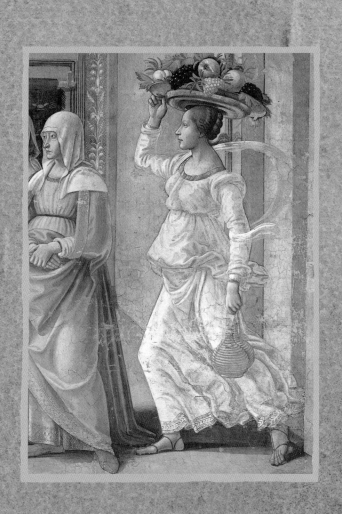

LA BELLEZZA
(Beauty)

❧

Light. I asked Maria when her boy was born and she said, *"Il venticinque di gennaio—Lorenzo è dato alla luce,"* literally, Lorenzo was given to the light on January 25. I'd seen the expression in the newspaper, recognizing with a thrill that it meant birth. What a precise and welcoming metaphor, *giving* the newborn to the relief and wonder of light.

The expression appeals to me, too, because it catches something of the way I feel—the privilege of living in Italian light, being shown to the light of each hour, day, and season. "Come see the light," Ed has called a thousand times. At all hours, I open my third-floor study window because the hills have a thousand ways of holding light in their hollows. Peace seems to reside in the landscape. Is light one of the keys to the Italian sense of pleasure in life? I feel more than think that the beauty surrounding people in rural Italy contributes enormously to contentment with life.

"Pull over! Have you *ever* seen the valley like this?" I jump out while Ed maneuvers the car close to the mountain so our mirror won't get clipped. The aqua and coral dome of Santa Maria Nuova lies below me, suspended in a pale mauve light, which spreads across the valley. The long rays of the setting sun pick out the farmhouses, glossing the roof tiles with gold. Ed's face, I see, catches the radiance. He looks like a luminous being. What you see sees you, too.

On an early December morning, the sky is scrubbed and burnished by yesterday's rough wind, which whipped bare the fruit trees, brought down chunks of plaster from the front of the house, knocked limbs from the wild black locust, and sent pinecones sailing like Frisbees. Huddled inside, we built a fire and planned to read away the afternoon, but, instead, the wind pushed smoke back into the chimney and we had to open windows and doors to air straight from the Alps.

The kickback this morning is a dome as blue as my mother's eyes, as blue as the big hunk of sapphire I coveted in the jeweler's window. Cold is coming but not yet. Now the air has an icy lining. Maybe the wind brought in more oxygen because I want to breathe in great gulps just for the freshness. Pine needles shine but the cypresses just stand there as always, defining the space around them, taking no notice of any change of weather.

For each season, a light. In spring, when I look out my window, I see hills and trees lit with a green I used to puzzle over as a child. In the big Crayola box, an unnatural green was labeled "veridian," and when I colored trees with it I thought it was a fake green. It's the olive in the neon martini sign, brazen green, blue-green with a dollop of sun dropped in, a bikini I once wore in Nicaragua. But here it turns innocent at evening, swathes every new grassy hillside, each budding almond or plum. The light is glassy, gossamer, silvery—it seems to slide over the crests of the low Apennines in the distance. In spring, almonds, the earliest flowers, start the sequence of plum, apple, pear, and cherry, all famous for their brief love affairs with light.

A private chapel dedicated to the Madonna in
the Val d'Orcia (preceding pages 228–229); an altar
in San Pietro a Cegliolo, near Cortona (left).

By summer the greens deepen and the coves between the hills darken to blue lagoons. We go on wildflower walks, book in hand to identify wild orchids and a flock of yellow volunteers. On our own land, we pick orange lilies, Queen Anne's lace, dog roses, naturalized daffodils and irises, and the wild cousins of carnations, bachelor's buttons, asters, and many we can't call by name. I never can identify trees, birds, shells, minerals, and flowers from those handy books I always buy. "That's it," I say, then turn the page and there *it* is again, under another name. No one needs to identify the million glorious poppies springing from cracks in walls, running along ditches, thriving in groves of olives and fields of wheat. An irritation to farmers, they're pure joy to my eye. We take drives in spring and early summer solely to feast our eyes on the lupin-lined roads and the poppy fields spilling downhill, especially near Montecchiello.

Skies change moment-to-moment but the clear blue noons look like the inside of a morning glory. The soldering-iron sun burns layer after layer of the afternoon. As the poet Ungaretti says, we feel "the roar of the naked sun." Air turns golden, as if the wheat and sunflower fields send up their light into the sky. In town, the sun funnels down the street illuminating the faces I meet, outlining them in distinct halos. Sitting in the bar with a cappuccino, I have had some of the best experiences of my life, simply watching people I know being transformed by the molten light. Except for a few thunderstorms that send us running to unplug everything, rain goes elsewhere for the summer. After the wheat harvest, hills and fields slowly parch, turning bleached blonde, which makes the accent marks of the cypress trees more pronounced. On a bare hill, the majestic green-black cypress has the presence of a sentient being. It *knows,* and we know that it knows.

In autumn, rains return and with them silky verdant grasses, nothing like the color of spring, but a lush, rampant green that makes you understand the urge horses must have to graze. When the trees begin to splatter yellow, russet, bronze, and scarlet over the slopes, the air sharpens to a noon clarity that outlines every leaf. I wish I could limn the autumn sunsets. Words sound too exaggerated because a literal shower of gold seems to fall over the valley, as if in a myth, forming a veil between me, with my feet on the solid ground, and the glob of live lava sinking in the western distance. The sky goes wild with colors—opal, saffron, dusty blue, copper, ash, blood. Impossible to see this daily feat and not think that perhaps, after all, the universe is not a random sequence of survival-motivated evolutionary events but a divine revelation, if we had the eyes to see it. I hesitate to go on about sunset, that hackneyed oil painting. If only the townspeople would gather at the Porta Colonia parking lot looking out over the valley and give a standing ovation.

Near Monticchiello (above); view coming down from the hilltown of Monticchiello (right); poppies astonish the fields around Montepulciano in spring (following pages 236–237).

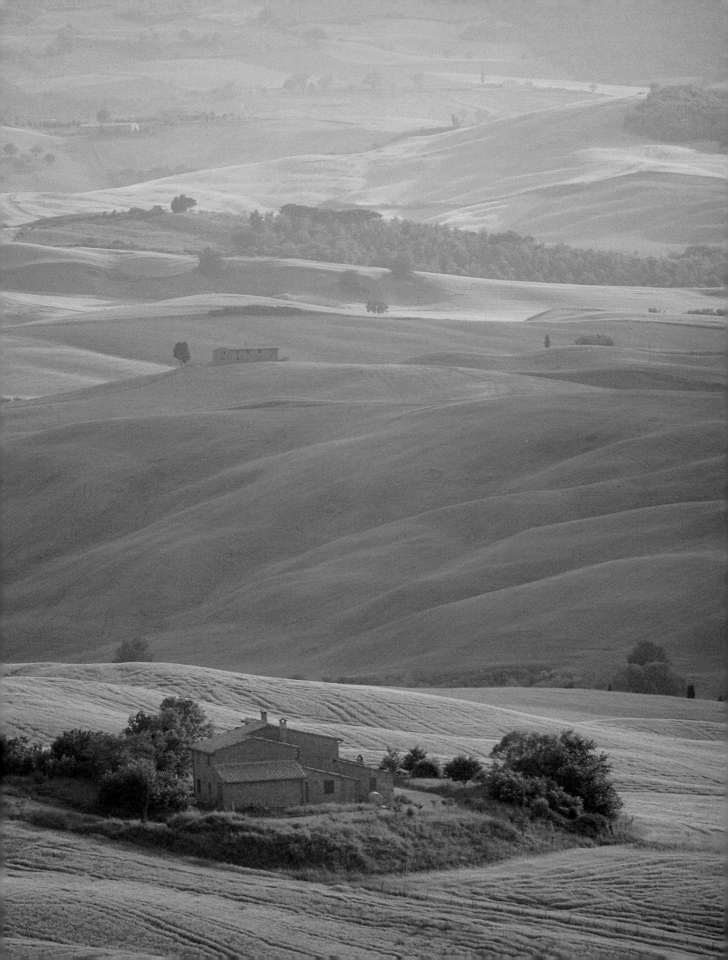

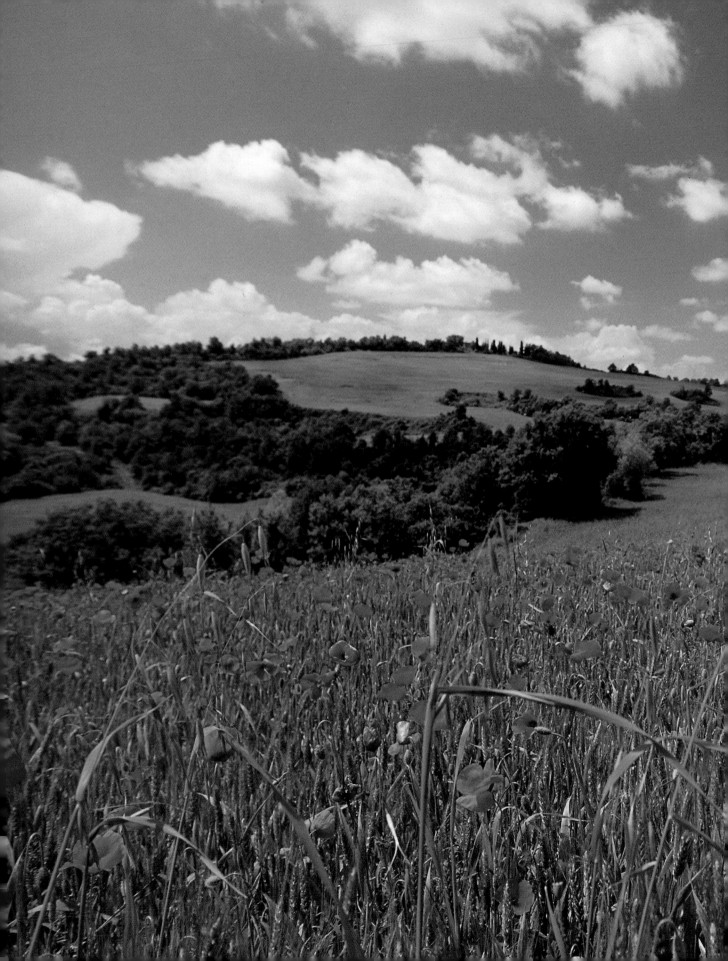

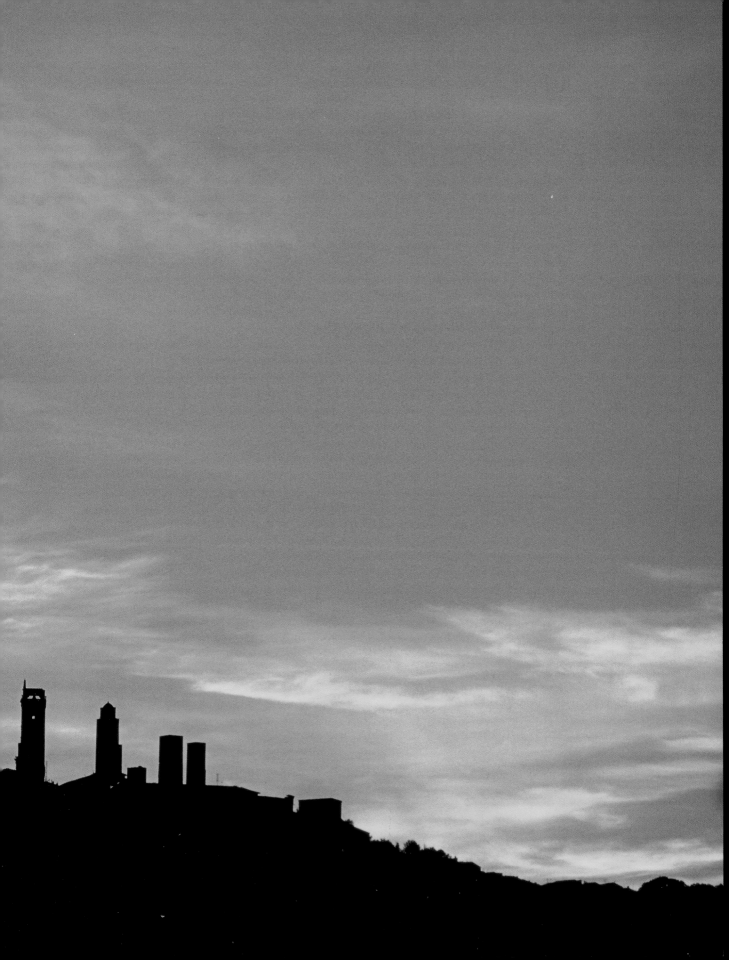

The stony town gets stonier in the pale light of winter. I think the chink of my boot heels might spark on the cold streets. The immense Val di Chiana fills with fog. In the white, white mornings, everyone looks out below at this billowing *nebbia* and says the same word, *mare,* sea. A dome or tower protruding above the fog looks as if it shot up from another era. Cortona becomes an island, as if the hilltop location were not isolated enough. Our house is higher than Cortona. All day we watch the fog burning off, spuming and dissolving. Sometimes when clouds press down from above, we're in a sun-infused layer of light between fog and cloud. On those days, I love the winter light; on other days the moody sky turns the color of *morchia,* olive oil dregs, and I long for spring's lissome days.

All year, the stars are large and close; in winter they are almost scary, the starlight so sharp it cuts rather than shines through the glass window. The immense sky displays all at once everything it has for us on earth. I have the primitive urge to speak to the stars but then I think, no, I must be a little looney under *la luna.* In the middle of the night when I wake up, I try to describe the brilliancy of the crescent moon to Ed. Words won't do. "It looks like the Turkish flag," I say.

"What are you doing up? Come to bed. Close the shutters, it's cold!"

Dawns are sweet—iridescent streaks of ivory and peach, so quiet I stand at the window and think I can hear my fennel and black cabbage growing. Who could describe the ancient surprise of the rising sun? Well, Gerard Manley Hopkins had the nerve to let it rip about dawn. Since I was sixteen, I've loved his poem "God's Grandeur," where he writes about how we allow ourselves to be cut off from grandeur because we are ". . . seared with trade," and "smeared with toil." He ends the poem:

> *And for all this, nature is never spent;*
> *There lives the dearest freshness deep down*
> * things;*
> *And though the last lights off the black West*
> * went*
> *Oh, morning, at the brown brink eastward,*
> * springs—*
> *Because the Holy Ghost over the bent*
> *World broods with warm breast and with ah!*
> * bright wings.*

Grandeur—not a word I hear very much, but there it sits every morning, right out the window.

Where is the real world? Right here. The newborn emerges into a bath of light.

The Val d'Orcia in early summer and late summer (preceding pages 238–239); the medieval towers of San Gimignano (pages 240–241); a vicolo (tiny street) in Siena (right); the sun glazing statues in a cloister in Pienza (following pages 244–245); the volumes of San Biagio swathed in fog (following pages 246–247).

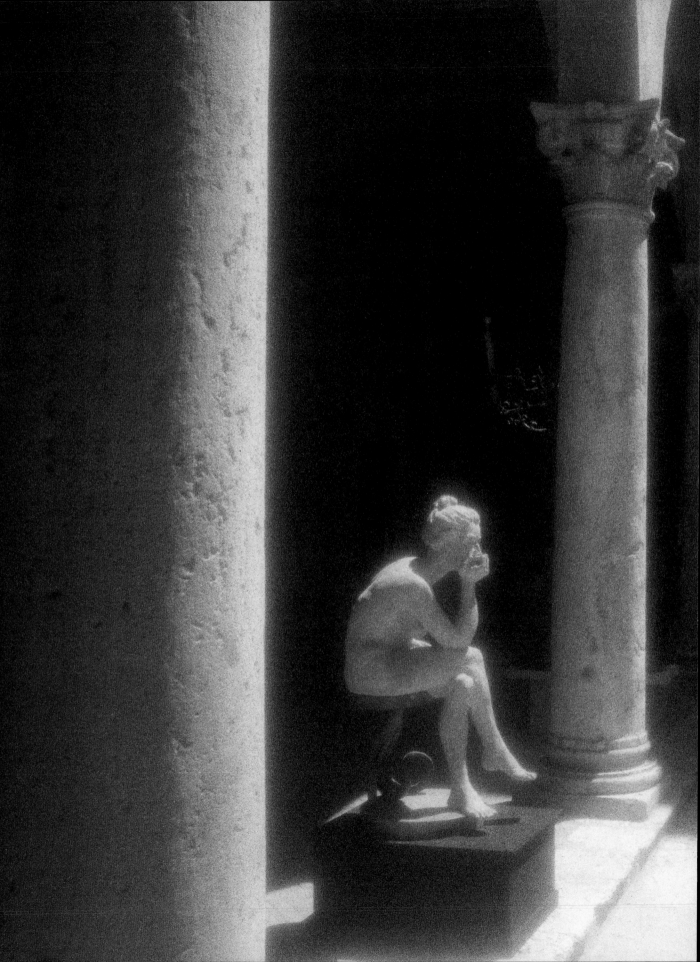

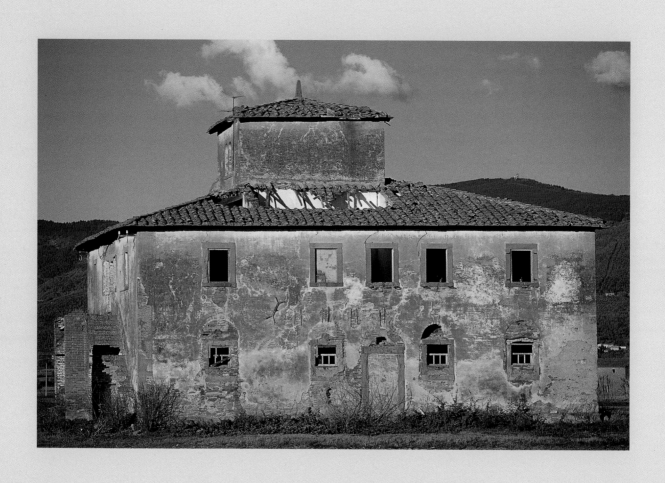

Stone. Tawny travertine, pocked-white alabaster, shades of dressed gray stone from slate to nickel, rough golden tufa, citrine, or rosy limestone. And marble—I have on my desk a ruler made from twelve colors of marble: zebra black-and-white, tombstone, cinnabar, milk, striated sand and coral, chocolate and cream, cobalt. Tuscany is built from what's found in its own ground, and stone is the basic element of the land's beauty. I never expected to be so well acquainted with the way stone piles need to be moved constantly from A to B then over to C and on through the alphabet. How handy, too. Need a wall around a gas tank? Head for the fields and haul for a few hours. Build a barbeque? Ditto. Every country house has a stone supply. Ours is separated into piles of huge, medium, and small.

Because houses were made from stones from the building site or nearby, they feel completely organic, perfectly situated, at home. As you travel, you notice the shifting colors of farms built from the nearest quarry. Volterra, Montepulciano, Cortona all have their palettes. When my book *Under the Tuscan Sun* was published with an abandoned house on the cover, Cortona people asked me immediately, why did your publishers choose a house in Siena?

After so many centuries of farming and carving terraces out of steep hills, rural Tuscany is predominately a man-made landscape. Wild and mountainous patches survive but most of the land has been sculpted to the measure of humans. Reading the landscape, you find the story of how the people lived. Traditionally, the family's wheat field was surrounded by olives, with grapes planted between the trees. There it was all together—the bread, the oil, and the wine, the sacraments of living. Each house dominates all the land a family could work. What a sure instinct for placement those canny builders had. They oriented the house when possible to fully face the sun on the summer solstice. I felt this instinctively in my own house: Someone looked long at the sun before laying a cornerstone. If there's a view, they took it, another practice I appreciate every day.

Leopoldo II, Grand Duke of Tuscany from 1765–1790, built essentially a housing project for farmers in the Val di Chiana. The square-block houses called *leopoldini,* little Leopoldos, survive in the sunflower and wheat fields. Each is topped by a *colombaia,* pigeon house. One is now a handsome *agriturismo,* country inn, but most of them have gone to ruin. One became a hay barn, another has *pericoloso,* dangerous, scrawled on the side. Dangerous or no, I often stop the car and walk around the upright walls, imagining the lives once lived inside. Venerable *case coloniche,* stone farmhouses, define the Tuscan landscape as much as terraced hillsides and cypress trees.

Many of Tuscany's mortarless walls in the country are falling down. Who will start a society to save them as an important heritage? We've had two walls collapse on our land. Roots, freezes, little landslides undermine

Abandoned leopoldino *in the Val di Chiana (left);*
dry stone wall on the herb terrace at Bramasole (above).

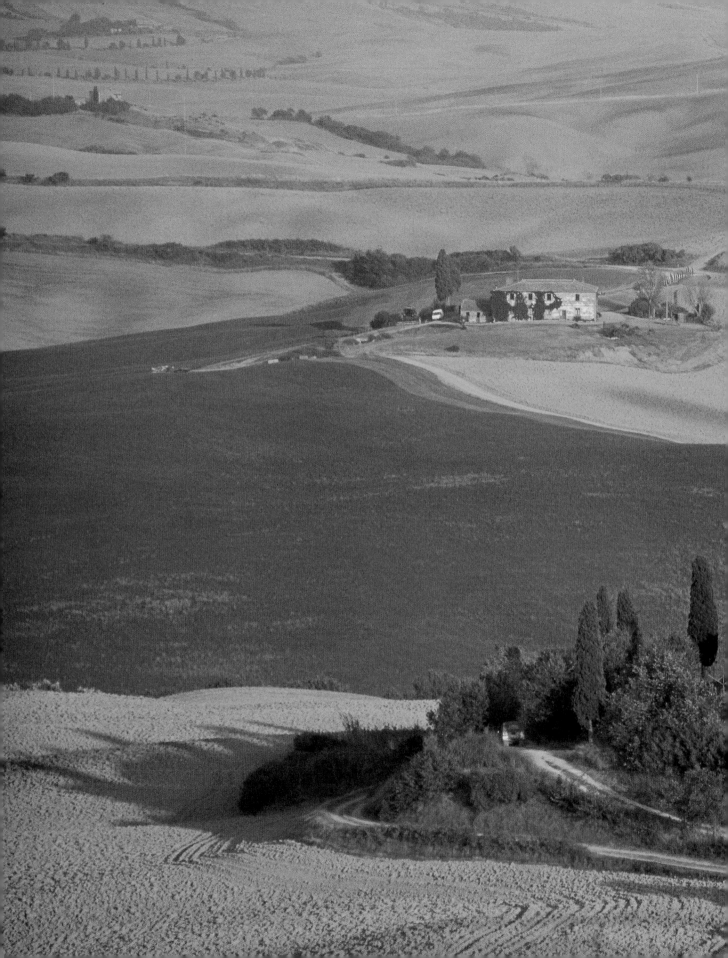

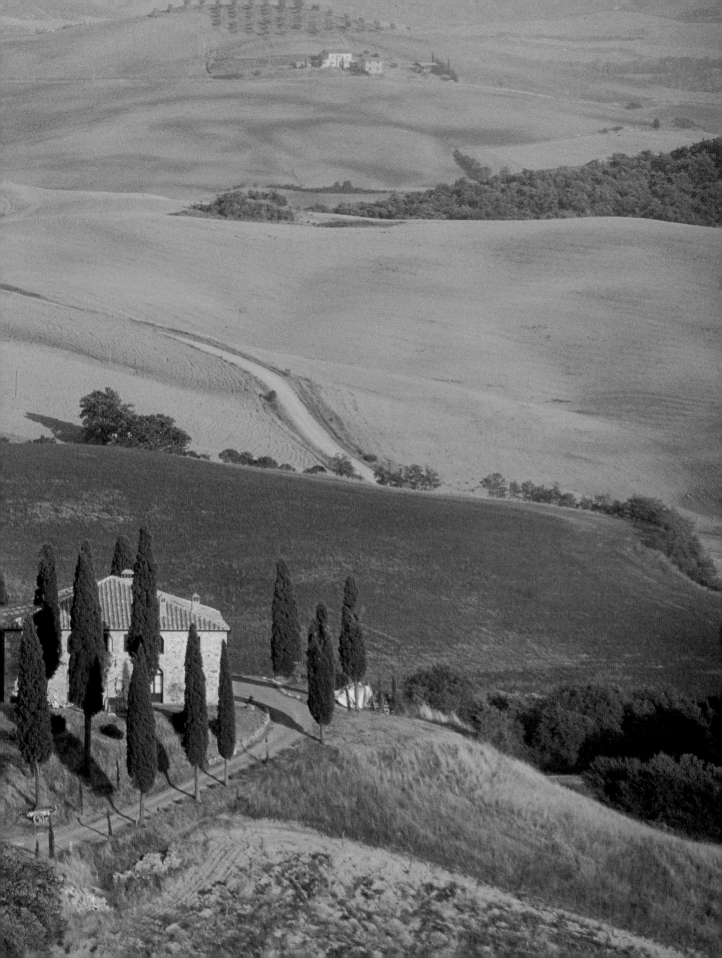

them over time. We had both of them rebuilt and one promptly fell again during a spring when deep, soaking rains must have put out the fires of hell. Nothing in these hills gives me more pleasure than stone; I have become a contemplator of these walls. The master stonemason's touch is easy to recognize. The even stacking, the backward slope, the arranging for strength, and the openings for drainage. You can intuit the selection of *this* stone for *this* place. Others are not so pristine. Bits of brick and even pieces of crockery are stuffed in gaps. On walks I run my hand over the lichen's fantastic white and green filigree and the spongy mosses. The walls are alive, figuratively and literally. Cortona's town walls are full of caper plants. Ours sprout violets, poppies, dandelions, ferns, and mâche. Occasionally, we find a half of a snake hanging out, his cool head hidden. In the earliest legends, stones were known to be the bones of Mother Earth. I'm sure this is true.

When Fulvio di Rosa, an architect from nearby Lucignano, restored the *borgo* of Sogna, he started with a respect for stone. The tiny village, completely abandoned after World War II, remained untouched for almost fifty years. *Sogno* is dream in Italian and when I first saw the place on a summer evening, I thought it seemed like a dream that had fallen through a crack in time. Fulvio laughed when I said that and told me *Sogna*, ending with an *a*, actually means "pig fat."

He has restored the buildings with integrity, letting each structure speak for itself rather than speaking for it. I first noticed that his paths show no cement between the stones. No ugly wires crisscross the air. Swimming pools usually blight a landscape; his natural stone one looks almost like a pool in the woods. Inside the buildings, in the first-floor rooms where the animals lived, he retained the mangers, which are now handy for storage, and even left the terra-cotta drainage channels in the stone floors. Because Fulvio loves purity of design in any medium, he has placed some contemporary sculptures on the grounds and has partially furnished rooms with straight-from-Milano chairs and tables. The contrast is startling, one time reflects on and gains strength from the other. We usually go to Sogna in summer twilight, arriving in time for a walk before dinner at Vincenzo and Loretta's tiny and extraordinary restaurant, Le Antiche Sere, Ancient Evenings, where we dine in a close family atmosphere. But what a family. With their two daughters, Simona and Barbara, Vincenzo and Loretta bring a deep pleasure in the Italian table to their guests. The menu changes daily—just sit back while the good times roll and the fine wines pour: a terrine of aromatic herbs, chickpeas with thyme and lobster, roast suckling pig with cloves and oranges, venison with cherries, lamb with juniper berries and balsamic sauce. Desserts, sometimes a lost item on the Tuscan menu, truly soar. Vincenzo might have had a true *cassata* flown in from Sicily, or perhaps Loretta has spun her great *tortino* of chocolate air. So—Sogna, with its origins in pig fat, is still a dream down a dirt road in a lost landscape.

Characteristic cypresses around a farm house near San Quírico (preceding pages 250–251); Minerva and other ancient carvings on a wall in Montepulciano (right); The road to Oz? No, a strada bianca *near Pienza (following pages 254–255).*

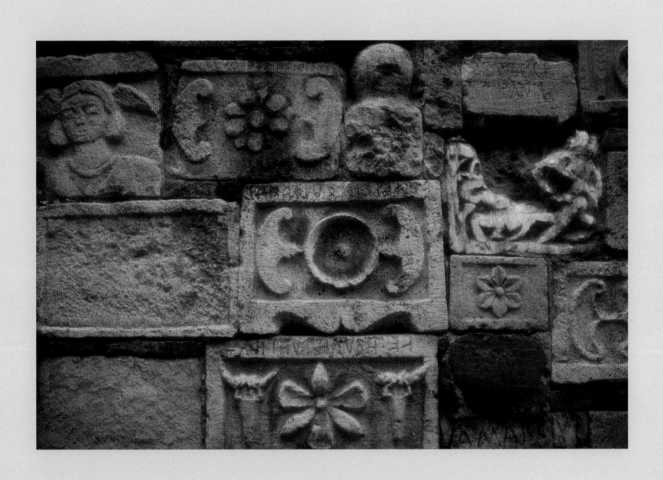

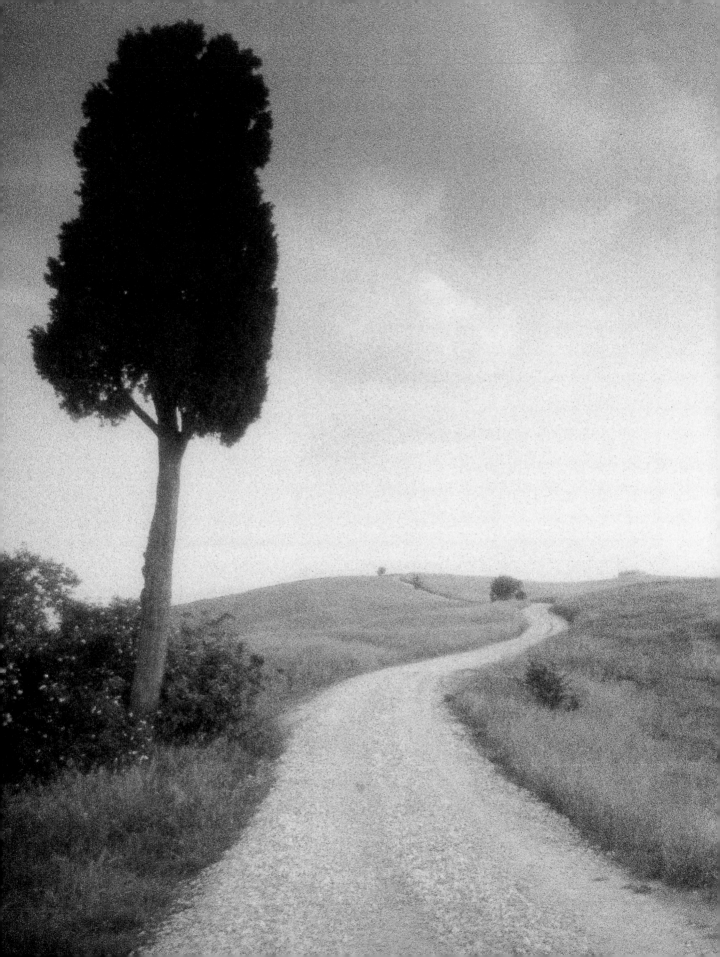

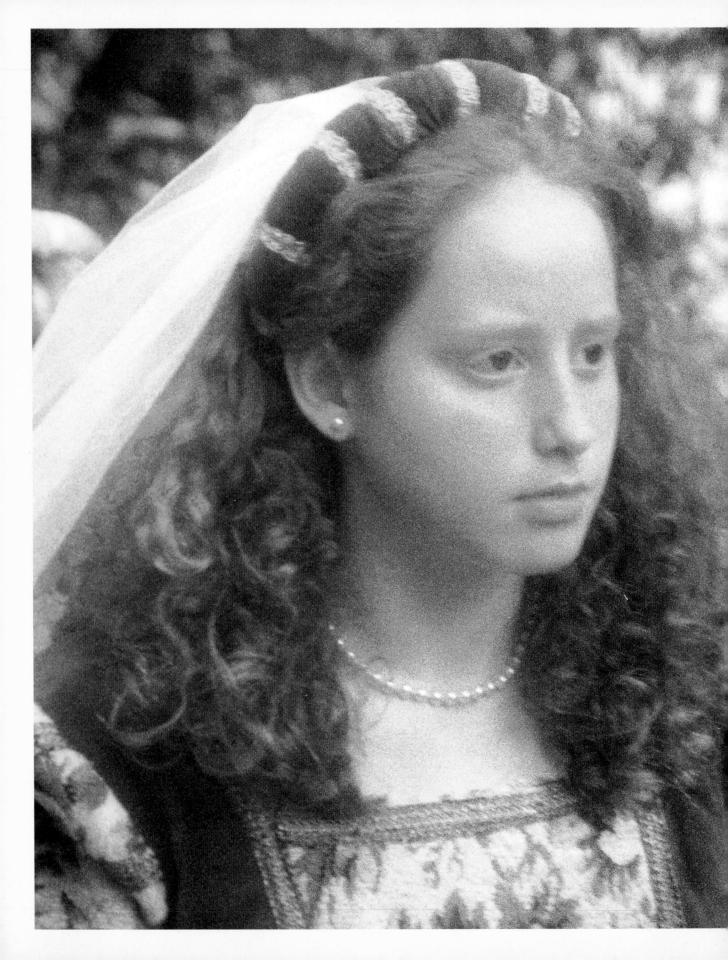

Faces. Looking at the beauty of Tuscany I realize that Tuscan art came straight from the place, from the interaction of light with the land, stone towns, and with the faces well known and loved by the painters. Everyone who comes to Tuscany notices that the backgrounds of paintings show scenes they still see as they drive through the countryside. If you stay awhile, you start to notice that the faces of people appear, too, over and over. That man with his hands in his pockets, looking skeptically at a tractor on market day, you saw yesterday on the just-cleaned Piero della Francesca fresco in Arezzo. How many fabulous Madonnas have I seen smoking in bars, pushing the baby carriage, or serving tables? For centuries, Italians didn't move from place to place. Geographically and politically fragmented, they stayed where they were born. To travel was to pay a tax at every little border. The restricted gene pool resulted in the faces Piero and Sodomo knew remaining in place. Obviously that has changed but we still could walk through Cortona this afternoon and round up familiar models for Signorelli or Fra Angelico.

An intense sense of *campanilismo* (under the same church bell) endures. I know people here who've never been to Lucca or Pisa. When we report that we've visited Ascoli Piceno or Norcia or Spoleto, often the response is, *"Meglio qui a Cortona,"* better here in Cortona. Andrea looks down on those people. He dismisses them as "afraid to stick their noses outside the town gates." At the same time, many people are big travellers, with the Mar Rosso, the Red Sea, beaches being,

Cortona's Chiara Sciarri in a medieval mode.

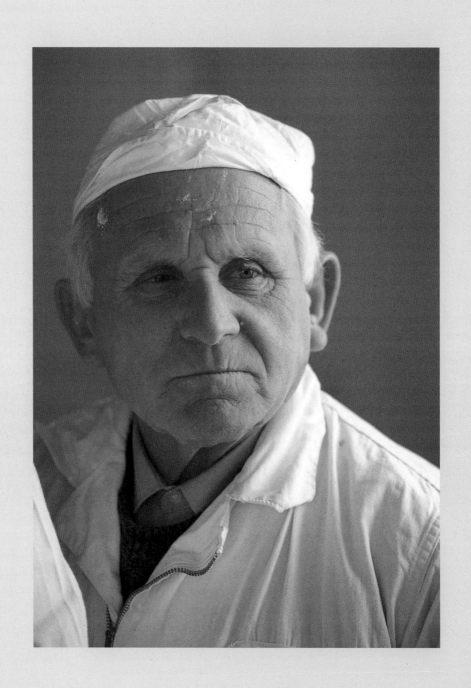

by far, the most popular destination. It's beautiful and strange that someone organizes a trip, gets a reasonable price, then thirty or so people go together, these people who work side-by-side in the small town every day of the year also choose to vacation together. My teaching colleagues and I are not going to do that, but I envy the sense of community that makes such a thing even plausible. The group returns, bronzed and relaxed, and for weeks photos are passed from hand to hand and we hear laughter over the fate of Armando, who caught a bug and spent the week on the "*vater*," water (toilet).

Besides the Renaissance girl with two thousand black ringlets to toss, or the man who could have just dismounted from a horse in a Raphael painting, the beautiful faces to me are those that show the force of character, a face full of who she *is,* that old *signora* gathering pinecones; who he *is,* the bent man barely four feet tall, with eyes dark as crude oil and a look that makes me think he's oracular. "There's Elizabeth Taylor," I whisper to Ed, as we pass a group of women sitting outside their doorways. She's Liz at forty, a plump beauty. To my surprise, I met someone in London who'd been to Cortona years ago. "Does Elizabeth Taylor still sit outside the shoe store?" he asked.

From a sidewalk table or the steps of the town hall, I have the unambiguous pleasure of seeing Nella speed into the *piazza* on her Vespa, her face planed as if sculpted, radiating strength in her midseventies; Donatella, with her Pompeian profile; I run into Roberto, very intense,

stroking his beard and swearing he will quit his university teaching job and open a pizzeria on a Greek island; then Francesco of the ambitious eyebrows and a gaze as gentle as the saint he's named for. Chiara emerges from her aunt's shop, her face bright as a sunflower. When she smiles, everyone turns her way.

We came to Tuscany for the art, the food, the wine, the Etruscans, the cypresses, the olives—*la bellezza.* Those things give us profound pleasure. But we *stayed* for the people. They are genuine, direct, courteous. It shows in their faces. We found ourselves feeling more expansive and open because people we know are expansive and open. They're strong and gentle at once, qualities *insieme,* together, that we like to feel seeping into ourselves. I hear joking in every shop, in the bar, in the *piazza.*

As all southerners know, place makes you who you are. Just as I am made of red clay, a heritage of belle-dom, black swamp water, Populism, fear-the-Lord religion, I've come to see my neighbors and friends in the Tuscan light that shaped them.

The faces are made of the permanence of the Etruscan walls, the solid body of the cypress in the mist, a fragmented history that makes people cling to those closest to them, the Etruscan-rooted philosophy of hospitality, raked light across the harrowed wheat field, a pagan kinship with nature, shadows in the narrow stepped streets into the upper town, the nights at a table where everyone is laughing.

Francesco Barboncini, volunteer at the Sagra della Ciaccia Fritta, near Cortona (left); a cook at the Sagra della Bistecca in Cortona (above); memory wall with photographs of deceased parishioners at San Pietro a Cegliolo (following pages 260–261).

RIPOSINO N...

PELUCCHINI ERSILIA
ved. SBANCHI

CAMILLONI RICCARDO

CAROLINA ARMINI
IN ACCORDI

CATERINI BRUNO

Mons.
Arcidiscono...

ZUCCHINI ROBERTO

A caro ricordo di
VITI ROSA nei CATERINI

Umbelici Giuseppe

CORRADO CATERINI
nato il 27 Gennaio 1922
morto il 10 Marzo 1956

BEMOCCOLI IVO

ANGELO...

BARDI PRIMO

DOMENICO CECCARELLI

CONTI MARIO

BALDOLUNGHI GIUSEPPE
N. 18 aprile 1905
M. 6 maggio 1977

NOVELLI FRANCESCO

BI...

Sandrelli Marietta

PIA MEONI
VED. SANDRELLI

GIUSEPPA DEL DURO
Ved. MUNICCHI

Municchi Brunetto

BRIGANTI GUIDO

GIUSEPPE MÁLE...

 LA **PACE**

Canonico TACCONI Mons. RENATO
Parroco di S. Filippo
Cancelliere Vescovile
n. il 25 Dicembre 1909
† il 28 Marzo 1972

Can. D. ROBERTO LUCIOLI
N. 17 Novembre 1911
M. 9 Gennaio 1971
CORTONA

Can. Don Aldo Gazzi
CORTONA
N. 26-8-1904 M. 23-1-1974

Padre ABRAMO GARZI
O. F. M. CAPP.
1909 - 1975

Don ANSELMO ZAPPALORTO
n. 1 - 1 - 1906
ord. sacerdozio 21 - 5 - 1937
† 17 - 10 - 1981
Parroco a S. Quirico dal 1937

P. ALESSANDRO MAMM...
nato a Cortona il 18 Gennaio 1907
morto a Poppiano il 15 Ottobre 19...

Zucchini Stella
nata il 14 luglio 1896
morta il 3 ottobre 1976

ANGIOLO BARDI
n. 10 Agosto 1919
m. 25 Giugno 1971

ELISA BRIGANTI nei ROMBOLI
n. 23 Ottobre 1889
m. 2 febbraio 1971

A ricordo di Sergio Ciufegni

VINCENZO ROMBOLI
N. il 25 Novembre 1921
M. il 27 Maggio 1944

ROMB...
n. 30 7 1856

BIAGIANTI GIUSEPPE
nato il 22 agosto 1905
morto il 18 febbraio 1981

ANGELICA SEGANTINI
in BIAGIANTI
N. 7 - 10 - 1936 M. 2 - 3 - 1977

PONTIFERI IDA
M. il 20 - I - 67 -

CAMILLONI ADALGISA
ved. CATERINI

FRANCESCA BRIGANTI
in VESPI
2 - 4 - 1912 m. 7 - 2 - 1978

ELISABE...
ve...

ROSA SEVERINI
ved. POGGIOLANI
nata il 25 Maggio 1885
morta il 16 luglio 1973

BASANIERI PASQUALE
nato il 18 marzo 1909
morto il 19 giugno 1978

Ugo Caterini
n. il 9 aprile 1918
m. il 12 maggio 1978

FRANCESCA MALENTACCHI
nata il 24 Marzo 1884
morta il 17 Luglio 1974

LORENZONI LEO
N. 8 Febbraio 1917
M. 3 Febbraio 1993

LORENZONI PALMI...
ved. ANTONELL...
n. 16-2-1926

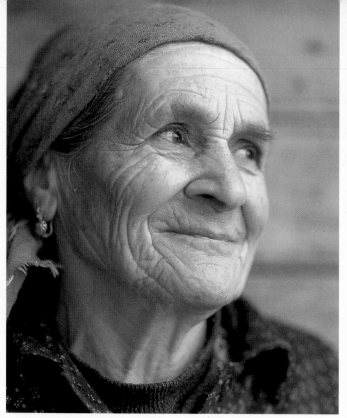

Tuscan faces, clockwise from above: Palma Paolelli; spectator at a pageant in Cortona; Gianni Mariotte and son; Cortona woman with food for her rabbits; Matteo Lodovichi; Giuseppe Moretti, stonemason; Ivan Botanici; Placido Cardinali with a wild upupa. *Facing page: Chiara Cardinali.*

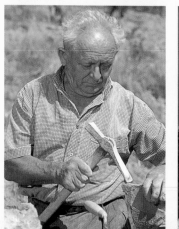

Celebrations and foods mentioned in the text are listed below, along with a few other discoveries. This limited list simply indicates the pleasures and surprises of travelling in the countryside. Check for vacation closings or possible new locations or other changes. The zero in every Italian area code must be dialed. The towns in parenthesis are the province capitals. Touring Club Italiano publishes excellent road maps. Up-to-date train schedules can be found on the Internet. Edizioni Multigraphic prints detailed walking maps, available in bookstores.

FEASTS AND FESTIVALS

Visit the tourist information offices in Tuscan towns for upcoming concerts, festivals, and feasts. Carol Field's *Celebrating Italy* (HarperCollins, 1997) creates a context for understanding Italian festivals, and the recipes are excellent, too. When in Italy, pick up the magazine *Oggi Verde* for a monthly list of celebrations. Even if you don't read Italian you can spot the towns with a *festa* or *sagra. Florence and Tuscany,* in the Eyewitness Travel Guide series, also publishes a list of major events. During the September and October wine harvest, celebrations occur in all the wine-growing areas. Greve's is the second week of September. Many towns, especially Viareggio, celebrate Carnevale. Viareggio's grand *festa* is on Shrove Tuesday. Almost every town has processions on Good Friday. Siena's Palio takes place twice, July 2 and August 16. The list on this page suggests less well-known festivals. Check the dates; though many festivals endure for hundreds of years, sometimes dates change.

Arezzo, first Sunday in September: Giostra del Saraceno, major jousting on horseback. The largest antique market in Italy takes place the first weekend of every month.

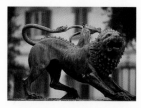

Asciano, February 5: Feast of Sant'Agata. Also, Il Mercatino delle Crete, a craft market of copper, ceramics, iron, and wooden products, takes place on the second Sunday of every month.

Bibbiena, last day of Carnevale: Bello Ballo, a fourteenth-century dance.

Chiesanuova, near San Casciano, Val di Pesa, first Sunday in June: Sagra di Pignolo (pine nut).

Cortona, August 14 and 15: Sagra della Bistecca. The Archidado, crossbow contest, takes place in early June. The National Antique Furniture Fair is the first two weeks of September.

Lucignano, last two Sundays in May: La Maggiolata, a parade of floats, each made of flowers.

Massa Marittima, first Sunday after May 22: Balestro del Girifalco, rival neighborhoods try to hit the metal falcon with a crossbow.

Montalcino, last Sunday in October: Sagra del Tordo, grilled thrush and other game birds.

Montepulciano, last Sunday in August: Il Baccanale, barrel races and wine tasting.

Montepulciano Stazione, first Sunday in September: Palio dei Somari, a donkey race, followed by dinner.

Pisa, last Sunday in June: Gioca del Ponte, rope-pulling contest on a bridge.

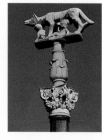

Siena, third Sunday every month: Antique market in the old *mercato.*

FOOD AND WINE

Salamis

Antica Macelleria Falorni
Piazza G. Matteoti, 69-71
50022 Greve in Chianti (FI)
Tel.: 055 854363

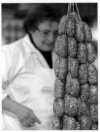

Azienda Agricola Massanera
Località Chiesanuova
San Casciano Val di Pesa (FI)
Tel.: 055 8242360

Lardo

Locanda Apuana
Via Comunale, 1
Colonnata (MS)
Tel.: 0585 768017

Artisan Bakeries

Panificio Caselli
Piazza Garibaldi, 5
Asciano (SI)
Tel.: 0577 718558

Pasticceria Banchelli
Via Nazionale, 64
Cortona (AR)
Tel.: 0575 601052

Wine-Tasting Bars

These generally serve various *bruschette*,
pastas, soups, salads.

Vinodivino
Via Cesalpino, 10
Arezzo
Tel.: 0575 299 598

La Torre di Gnicche
Piaggia S. Marino, 8
Arezzo
Tel.: 0575 352035

Taverna Pane e Vino
Piazza Signorelli
Cortona (AR)
Piazza Signorelli, 27
Tel.: 0575 631010

Restaurants

Da Antonio
Via Fiorita, 38
Castelnuovo Berardenga (SI)
Tel.: 0577 355321

Acquamatta
Piazza della Vittoria, 13
52040 Capolona (AR)
Tel.: 0575 420999

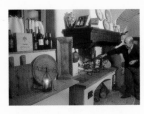

Le Antiche Sere
Sogna, near Ambra (AR)
Tel.: 055 998149

La Grotta
San Biagio, 15
Montepulciano (SI)
Tel.: 0578 757607

Il Falconiere
San Martino, 43
Cortona (AR)
Tel.: 0575 612679

Locanda dell'Amorosa
L'Amorosa
Sinalunga (SI)
Tel.: 0577 679497

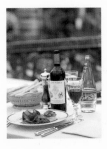

Trattorie

Trattoria del Sacco Fiorentino
Piazza XX Settembre, 18
Volterra (SI)
Tel.: 0588 88537

Al Travato
Piazza Umberto I, 21
Monterchi (AR)
Tel.: 0575 70111

L'Agania
Via Mazzini, 10
Arezzo (AR)
Tel.: 0575 295381

La Solita Zuppa
Via Porsenna, 21
Chiusi (SI)
Tel.: 0578 21006

Il Rifugio
Lama
Caprese Michelangelo (AR)
Tel.: 0575 793915

Fonte della Galletta
Alpe Faggeta
Caprese Michelangelo (AR)
Tel.: 0575 793925

Belvedere
Bano, 226
Monte San Savino (SI)
Tel.: 0575 849588

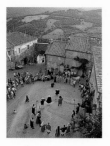

La Befa
Murlo (SI)
Tel.: 0577 806255

Da Ottorino
Via Sante Marie, 114
Asciano (SI)
Tel.: 0577 718770

Bruschetteria Toscana
Via di Tolletta, 14
Arezzo
Tel.: 0575 299860

Trattoria La Grotta
Piazza Baldelli, 3
Cortona (AR)
Tel.: 0575 630271

Trattoria Dardano
Via Dardano, 24
Cortona (AR)
Tel.: 0575 601944

Osteria del Teatro
Via Maffei, 5
Cortona (AR)
Tel.: 0575 630556

Latte di Luna
Via San Carlo, 2/4
Pienza (SI)
Tel.: 0578 748606

Romantic Hotels
Poggio Rosso, Relais San Felice
San Felice, near Castelnuovo
Berardenga (SI)
Tel.: 0577 3964

Il Falconiere
San Martino, 43
Cortona (AR)
Tel.: 0575 612679

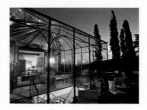

La Suvera
Pievescola 53030
Siena
Tel.: 0577 960 300

Locanda dell'Amorosa
L'Amorosa
Sinalunga (SI)
Tel.: 0577 679497

Relais Borgo San Felice
Castelnuovo Berardenga (SI)
Tel.: 0577 3964

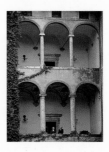

Abitare La Storia is an association of
hotels of character in historic buildings.
Contact them by fax at 051 236959.

Permission to reprint the following artwork
was granted by Scala/Art Resource, NY:

Page 21: Detail from the *Annuciation,* by
Fra Angelico, Museo Diocesano, Cortona.

Pages 47, 135: Details from the *Effects of
Good Government,* by Ambrogio
Lorenzetti, Palazzo Pubblico, Siena.

Page 107: Tuscan box depicting the story
of Alatiel, by the Master of Jarves Cassoni,
Museo Correr, Venice.

Page 175: *San Lorenzo,* by Bartolomeo
della Gatta, photographed by Nicolo Orsi
Battaglini, Chiesa di Badia, Arezzo.

Page 224: Detail from the *Scenes from the
Life of St. Benedict,* by Luca Signorelli,
Abbey of Monte Oliveto Maggiore, Siena.

Page 231: Detail from the *Birth of John the
Baptist,* by Domenico Ghirlandaio, Santa
Maria Novella, Florence.

Page 272: *The Muse Polyhymnia,* anony-
mous painter, Museo dell'Accademia
Etrusca, Cortona.

ACKNOWLEDGEMENTS

First thanks to Peter Ginsberg, my agent, to Charles Conrad, my editor at Broadway Books, and to Dave Barbor, Douglas Stewart, Shirley Stewart, Fiona Inglis, and Edwin Wintle, all of Curtis Brown, Ltd. Working with Rebecca Holland, Debbie Stier, Alana Watkins, Rebecca Cole, and the entire staff at Broadway Books has been a complete pleasure. To Steven Barclay of the Steven Barclay Agency, to Fiona MacIntyre of Ebury Press in London and Fiona Henderson of Transworld Australia—a big *grazie*. I am grateful to Barbara Fairchild of *Bon Appetit* and to the editors of *The Book* (Neiman Marcus) for publishing parts of this book. Good friends Josephine Carson and Madeline Heinbockel gave me cheer and suggestions.

I thank Bob Krist for his photographs, his rain-or-shine smile, and for the good times we had at the table in Tuscany. Jennifer Barry brought image and word together poetically and forcefully. I treasure the physical beauty of this book, thanks to Bob and Jenny.

Cortona awarded me the San Marco d'Oro prize in literature and thereby made me feel even more at home there. My particluar thanks to Il Sindaco Emanuele Rachini and Nicola Calderone. Edward Mayes and I are most grateful to these friends for sharing their opinions, feasts, faces, recipes, holidays, and laughter: Riccardo and Amy Bertocci, Donatella De Palma and Rupert Palmer, Giuseppina De Palma, Palma and Giovanni Paolelli, Vittoria and Giorgio Zappini, Giuseppe Agnolucci, the Molesini family, Riccardo and Silvia Baracchi, Giulio Nocentini, Antonio Giornelli, Lucio Ricci, Maria Petruccioli and Edo Perugini, Roberto Gnozzi and Veronique Albaret, Philancy Holder and Tom Pallen; Roberto Fratoni and Nunziatina Picciafuochi, Carlo Bruni, Ivan Botanici, Oreste Borghini, Gioia and Valentina Olivastri, Matteo Lodovichi, Giuseppe Moretti, Giorgio and Lina Lamentini, Isa Miretta Bennati, Don Ferruccio Lucarini, Francesca Vignarolli, and Stefania Serpi.

A special thank you to Lucia Fiorini at La Torre di Gnicche in Arezzo; Paola Ghezzi and Patrizia Falomi at Rosticceria La Migliore in Cortona; Fulvio di Rosa, Loretta Daffara and Vincenzo Interlando at La Antiche Sere in Sogna; Giancarlo Madon at La Grotta in Cortona; Paolo Trappolini and Ettore Falvo at Avignonesi Vine-yards; Elio Capecchi for his passsion for *farro*.

To Lorenzo Cherubini (Jovanotti) *grazie mille* for music, poetry, and friendship. Lines from the CD *"Per te"* are reprinted with his permission.

If there are thanks beyond thanks, they go to the Cardinali family, Placido, Fiorella, and Chiara.

—Frances Mayes

I'd like to thank Riccardo Bertocci for all his help during my assignments in Tuscany. You couldn't ask for a more enlightened guide to the beauty of the region and its people. I'd also like to thank David Lyman, of Maine Photographic Workshops, who first brought me to Tuscany, Carlo Roberti of Toscana Photographic Workshops, who keeps bringing me back, and Gianni Marriotti, a true Tuscan spirit.

—Bob Krist

ALSO BY THE AUTHORS

FRANCES MAYES

Bella Tuscany
Under the Tuscan Sun
Ex Voto
The Book of Summer
The Discovery of Poetry
Hours
The Arts of Fire
After Such Pleasures
Sunday in Another Country

EDWARD MAYES

Works and Days
Speed of Life
Bodysong
To Remain
First Language
Magnetism

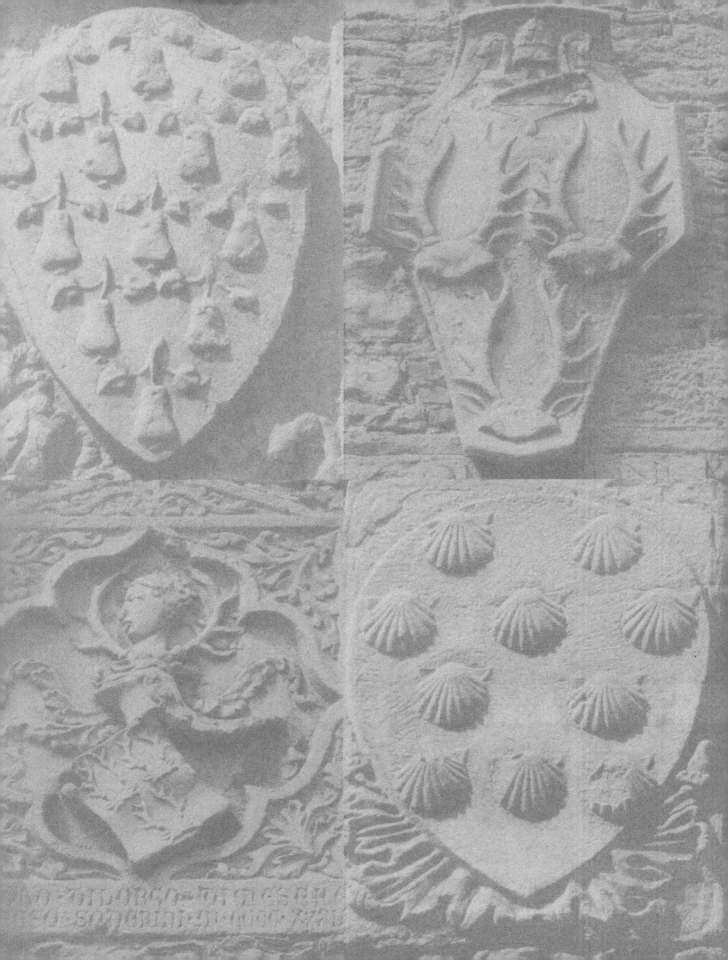